D0758973

DISCARDED

DISCARDED

Color in Outdoor Painting

16.95

Color in Outdoor Painting

BY ROGER W. CURTIS
EDITED BY CHARLES MOVALLI

OVERSIZE
ND
1488
C87
1977a

WATSON-GUPTILL PUBLICATIONS/NEW YORK
PITMAN PUBLISHING/LONDON

EL CAMINO COLLEGE LIBRARY

Photographic credit:

Charles Movalli
237 Western Avenue
Gloucester, Massachusetts

Copyright © 1977 by Watson-Guptill Publications

First published 1977 in the United States and Canada by Watson-Guptill Publications
a division of Billboard Publications, Inc.
1515 Broadway, New York, N.Y. 10036

Library of Congress Cataloging in Publication Data
Curtis, Roger William, 1910–
 Color in outdoor painting.
 Bibliography: p.
 Includes index.
 1. Color in art. 2. Painting—Technique. I. Title.
ND1488.C87 751.4'5 76-49653
ISBN 0-8230-0740-5

Published in Great Britain by Sir Isaac Pitman & Sons Ltd.
39 Parker Street, London WC2B 5PB
ISBN 0-273-01048-4

All rights reserved. No part of this publication
may be reproduced or used in any form or by any means—graphic,
electronic, or mechanical, including photocopying, recording, taping,
or information storage and retrieval systems—without
written permission of the publishers.

Manufactured in U.S.A.

First Printing, 1977

Edited by Bonnie Silverstein
Designed by Bob Fillie
Set in 10-point Laurel by Gerard Associates Inc.
Four-color section printed by Toppan Printing Company (U.S.A.) Ltd.
Black and white printed and book bound by Interstate Book Manufacturers

*This book is dedicated to my wife, Winifred,
and to my four children:
Hannah Joan, Alan, William, and David.*

Contents

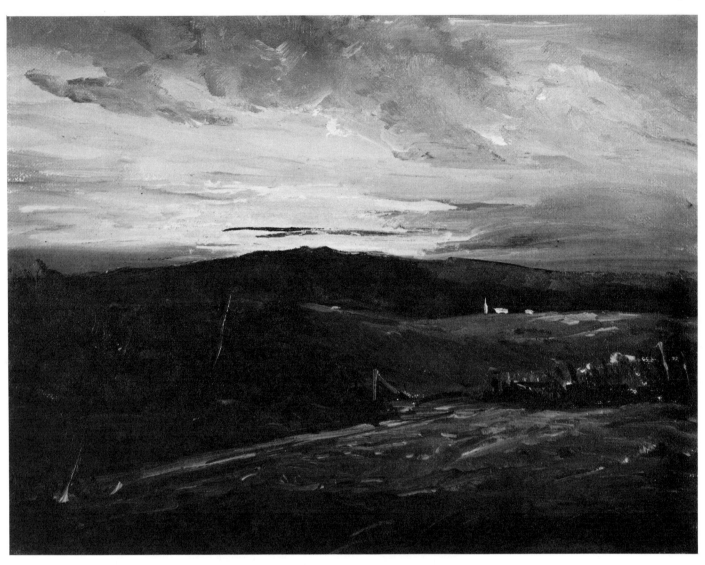

A sketch must be as quick as this one to capture the fleeting effects of a beautiful sunset.

Introduction

There's an old fable that I remember from my school days. Two knights met each other at a crossroads. A sign stood between them. The side of the sign facing one knight was painted white, and the side facing the other knight was painted black. So they fought all day over whether the sign was black or white. They were both right, of course; it all depended on where you stood.

It's the same thing with painting. There's no subject harder to talk about, because it's so intimately connected with the way people feel. Much of it's personal opinion—everything depends on where you stand. In what follows, I'll try to speak the truth as I see it. But remember that the truth is, really, only what you *think* is true. It's what you believe in. No one can say for sure that a particular method always works. If a teacher did, he'd soon be in the position of the TV weatherman: always sure, and always wrong—so no one trusts him. I want you to listen to me, but, in the long run, I want you to trust yourself.

The aim of this book is to get you to see. Too many students simply look. To them, a tree's a tree, and green is green. They don't see the relationship between shapes and colors. Nor do they realize how shapes and colors can be used in a work of art.

In this book, I'm not trying to teach you to match the colors of nature. An artist is more than a copyist. I want you to understand the colors both of nature and of oil pigments. By seeing the colors of nature, interpreting them, and then mixing them in terms of color pools, you'll slowly see how to move from the facts themselves to an interpretation of those facts. You'll begin to understand that a painting is really the result of the subtle interaction of the palette, the canvas, nature, and your own tastes — that your personal opinion and vision is as important as the trees and streams that you strive to paint.

In the chapter on materials we discuss the basic needs of the outdoor painter. We then look at some of the more important attributes of color. Armed with some basic definitions, we then see how the color pools work. A series of demonstrations further illustrate the approach. Then the four seasons are examined, with each season being broken into eight problems. These problems are designed to sharpen your eyes and your sensitivity to color and design.

I want you to love painting, and to enjoy your work. But, at the same time, don't be surprised if painting sometimes tires you out. That shows you've been working. After all, you have to solve problems all the time when you paint; you have to make decisions—something that many of us hate to do. Talent doesn't amount to much in art—especially if it's a talent that's lazy or that talks too much. Anybody who can hold a brush in his hand can learn to paint a picture. Hard work and study are the important things. So let's get to work!

CHAPTER ONE

Materials

Before discussing color, let's take a few minutes to talk about materials. The right equipment won't guarantee a good sketch—but it makes your outdoor work easier and frees your mind and hands so you can think about more important matters.

THE EASEL. The easel is probably the single largest investment you'll make. Remember that you'll be out on windy days so you need an easel that stands up. The ground won't always be even, so the legs have to be adjustable. And they should hold in position once you've determined their proper height.

The French easel (Figure 1) was designed for outdoor sketching. It folds into its own paintbox. The top of the box can hold two wet paintings, and the legs are easily moved up and down—you can use it on both level and uneven ground. The folded easel and your canvases can be carried on your back or over your shoulder—just attach straps to the metal rings on the side and top of the box.

The French easel is manufactured by a variety of firms, so shop around before you buy one. Don't be reluctant to check the easel in the store. Look at the wood, for example. Is it a strong material? How many parts are glued together, and how many are *screwed* together? The latter obviously will be more sturdy. Check the stress spots—the legs, for example. Unscrew the hardware; if the bolts come off easily then they'll be just as easy to lose. Move the sliding parts up and down. And —a really practical point—check for student discounts. They're offered by many art stores. See if you can get a thirty-day warranty, too. Above all, stick with a reputable dealer, somebody who stands behind what he sells.

Once you've bought an easel, remember to take care of it. Rub it periodically with a fifty/fifty mixture of linseed oil and turpentine—that's good for the wood. Then you can work over it with bowling alley wax. Also keep the moving parts oiled. But don't be *too* careful! Some people treat their easel as if it were made of gold. They spend half their time wiping specks of paint off it. It's a tool. It's supposed to get dirty!

PALETTE. The French easel comes with a wooden palette; but the brown color of the wood sometimes distorts the color, making it hard for you to judge how the color will look on a white canvas. You can easily replace this wooden palette with the same size piece of white Formica. It's non-absorbent and can easily be cleaned with a cleaning fluid like Renuzit. Steel wool can be used on really tough stains.

Try to clean your palette completely after each use. Some students let mounds of paint pile up—they think it gives the palette an "arty" look. But it only confuses the eye. And the new paint often mixes with the old, creating a terrible mess.

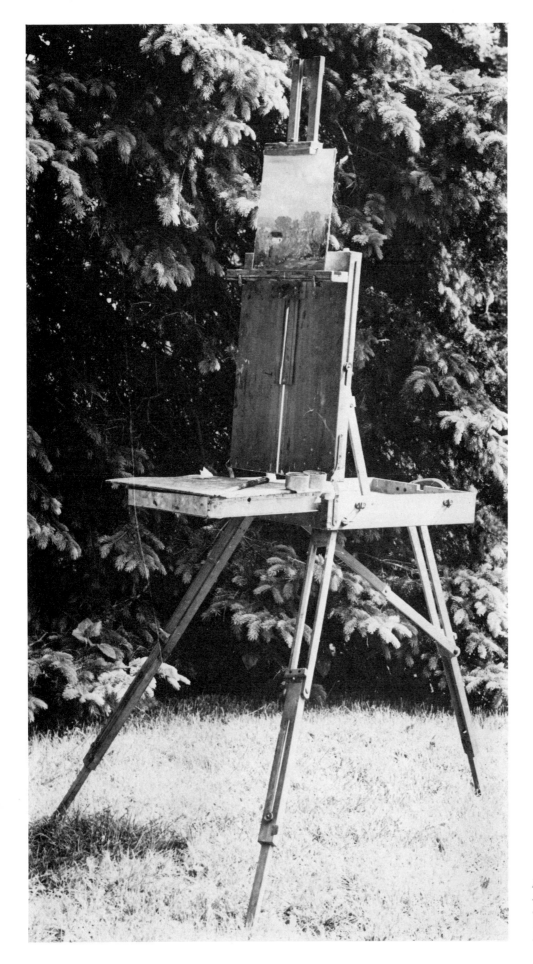

Figure 1. The French easel is solid, easily assembled, and convenient. It folds into its own box and can be carried on your back or over your shoulder.

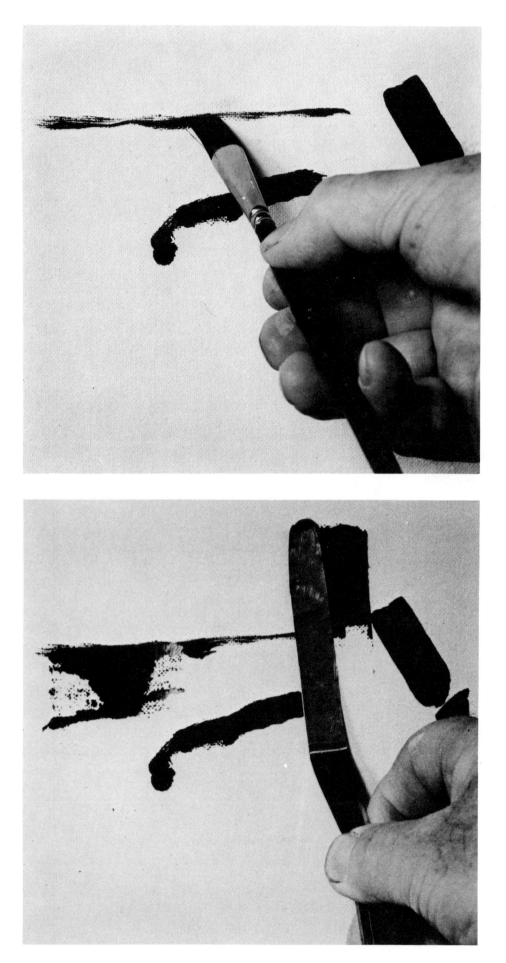

Figure 2. You can create narrow lines with the tip of the brush and broader lines with the whole brush.

Figure 3. A trowel-type palette knife lets you control the blade without getting your hand covered with paint.

MEDIUM. Equal parts of rectified turpentine and purified linseed oil make a good medium—with a small amount of damar varnish added to speed the drying time. It also eliminates the need for a final varnishing.

OIL CUP. Use one big oil cup for your medium—and don't worry about a brush cleaner. When you have a cleaner on your palette, it slowly gets into the paint, thinning the pigment and making it lose its richness of color.

PAPER TOWELS. Soft, absorbent towels are more convenient than rags. But when you use them outdoors, always remember to bring a paper bag with you so you won't mess up the landscape.

TUBE PAINTS. When you buy oil paint, stick with one brand so there'll be a consistent quality to the pigment. And get the best brand you can afford. In the long run, good paint is economical; because it's often stronger in tinting strength, you can use less of it than cheaper brands to get the same effect.

Students often read and worry about the so-called "fugitive" colors—colors that fade with the passage of time. They also wonder why paintings crack—and they want to know which pigments are poisonous. The subject is complicated and filled with controversial information.

The best thing to do is just go ahead and *paint*. Don't worry about how your sketches will hold up over the next fifty years. Just try to turn out good work—and hope that the world, if it likes your work, will do its best to preserve it!

BRUSHES. Half, ¾, and 1 inch/1.27, 1.90, and 2.54 cm brushes are the most useful. If you use bristle brushes, "brights" (the shorter bristles) give you a sharp line and good control of the paint. I personally prefer a fitch—a sign-painter's brush made from the hairs of a European polecat. In a previous book, *How to Paint Successful Seascapes,* I discussed the advantages of this brush at some length. Here, let's just say that it has a chisel point, can be used for fine and broad strokes, is extremely responsive to pressure from the hand, holds a lot of pigment, and is easily cleaned with brush cleaner. You don't need to use soap and water on the fitch, but you should use it after cleaning a bristle brush. The cleaner alone will not remove all the paint from the bristles and a buildup of dried, hardened paint will eventually coarsen them.

HANDLING THE BRUSH. In Figure 2, you can see how the fitch can be used to paint both broad and thin lines. The thin stroke is made with the tip of the brush, the broad one, with the whole brush.

You don't usually hold the brush as you would a pencil. Instead, cradle it in your hand and use the thumb and forefinger to control the movement of the tip; the little finger holds the brush in place. Of course, there are other ways to hold a brush— and some other grip may be more comfortable to your hand. That's a matter of personal taste.

PALETTE KNIFE. A palette knife helps you to scrape off paint—and it can also create interesting textural effects. We'll discuss some of its uses later. A trowel-type knife is best; it's bent so that you can place your thumb on the blade without getting the rest of your hand into the paint.

Figure 3 shows the knife in operation. You get different effects by running the knife over wet and dry surfaces and by applying varying amounts of pressure with your hand. I can't tell you exactly what happens. You have to experiment with the knife yourself if you really want to understand how it works.

CANVASES. All the sketches in this book are done on 8x10 inch/20x25 cm canvas panels. That's a good size, and the panels are durable and easy to store. If, however, you're going to be painting all afternoon, you may do five or six little sketches —and that can be a real problem when you try to find places in your car for the wet canvases. When you go out on a long painting session, try taking a 20x24 inch/50x61 cm canvas panel and dividing it into a series of different shapes — a few 8x10 inch/20x25 cm sizes, a few canvases 12x16 inches/30x40 cm, a horizontal shape, a vertical shape, etc. (Figure 4). You can outline the shapes with magic marker—or with masking tape (so when you pull the tape away, your sketch will have neat,

Figure 4. A 20 x 24 inch/50 x 61 cm canvas panel divided into different shapes is easy to handle—and lets you compare your sketches as you work.

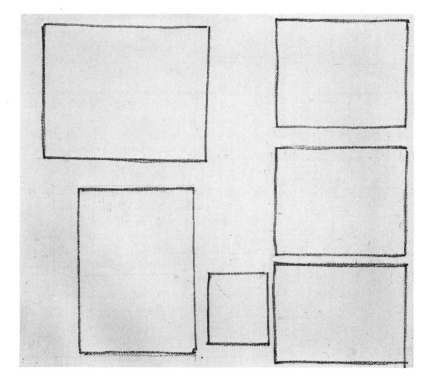

Figure 5. (Below) A broad-brimmed hat keeps the sun out of your eyes, a viewfinder helps simplify your subject, and dark clothing prevents the sun from bouncing off you and onto the surface of the canvas.

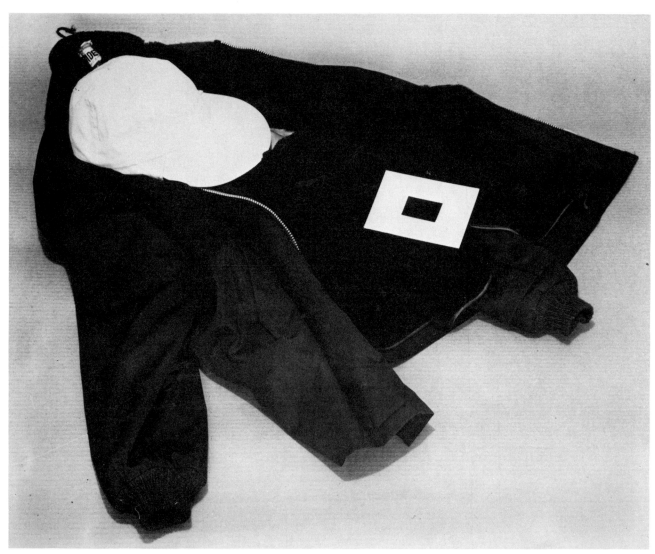

14

sharp edges). Be sure to leave a little canvas around each shape in order to frame it and keep it distinct from all the others.

When you paint outdoors, be sure to place your canvas and palette in the shade. Frequently a student gets so involved in his work that he doesn't notice the sun moving behind him. The light shines on his canvas and bounces into his eyes. He can't see the color, and his eyes become fatigued. The fatigue soon shows in his canvas.

Once you start to sketch, work till you tire of a theme. Then start another sketch. Since all the sketches are on one panel, you can compare them as you go along. By the time you get to the fourth or fifth sketch, for example, you may have solved one of the problems that plagued you in your first sketch. You can go back and touch it up. You can also evaluate all the sketches more easily when they're on one canvas panel. You can determine which is, in your opinion, the best—an important exercise that tells you a lot about your own tastes. And you may even decide that you've painted a good one. If you get one good piece out of five or six sketches, consider the outing a success!

CLOTHING. Dress comfortably when you go out (Figure 5), and get a hat with a good, long visor to keep the sun out of your eyes. Don't paint with sunglasses; they distort both the color and values of a scene.

Also try to wear a dark, neutral-colored coat or shirt. The sun bounces off light clothing and sends a glare onto the canvas, making it hard to see your color. The problem is worse when you're wearing a colored shirt. Light reflecting onto the canvas from a red shirt, for example, gives the whole sketch a rosy glow. That may look good on the spot, but indoors your painting will look completely different. Other bright-colored clothes will have the same effect.

VIEWFINDER. The viewfinder is a small piece of cardboard with a small opening cut in it that approximates the shape and proportions of your canvas (Figure 5). It isolates an area so you can study it more closely—it blocks out all of the confusing surroundings. One of my students took the idea a step further: she bought a piece of rigid, clear plastic (like Plexiglas) the size of her palette and used masking tape to divide it into a variety of shapes (just as she'd marked off her 20x24 inch/50x61 cm panel). She could look through the different openings to decide which shape best fit her subject. Since the plastic was thin, it easily fit under the palette in her paint box.

Although the viewfinder can be helpful, it's of real use only to the beginning student. After a while, you should begin to work without it—shifting your elements around to make an effective composition.

FRAMES. Keep a few old frames around for use when you want to evaluate a painting. A frame pulls the parts of a sketch together, and also separates it from everything around it. It focuses your attention. The old-time painters realized this, and many would work with their pictures in the frame—right from the first stroke.

THE CARPENTER. A carpenter once discovered his tools had been stolen. When he found out who took them, and accused the thief, the thief flatly denied it. Furthermore, he told the carpenter he'd have to prove his case in court.

The carpenter was fortunate. The judge in court had the wisdom of Solomon. He blindfolded the carpenter and set a box filled with tools in front of him. Some belonged to the carpenter, and some didn't. But the carpenter easily picked the ones he claimed were his. He'd worked with them for years and knew their heft, shape, and balance. He didn't need to see them!

Like the carpenter in the fable, in time you'll soon discover which materials best fit your purposes, and they'll become as much a part of you as the carpenter's tools were to him.

CHAPTER TWO

Color Terminology

Before we consider mixing colors, let's discuss some basic painting terms. Rather than bore you with a list of dry dictionary definitions on the pages that follow, I'd like to talk instead about a few basic concepts.

WARM AND COOL. In order to understand color, you have to understand the concepts of warm and cool. Reds, oranges, and yellows are warm, fiery, active colors. Blues, purples, and greens are cool colors, colors that remind us of water and deep shadows. Because they're not as vivid or as stimulating as the warm colors, they're easier to live with. Perhaps that's why paintings of blue skies are more popular than ones of flaming sunsets.

Remember that "warm" and "cool" are only relative terms. The color red is warm compared to blue. But among reds, themselves, alizarin crimson (which tends toward purple) is cooler than cadmium red light (which tends toward yellow). Similarly, green is a cool color, but permanent green light (which has a lot of yellow in it) is warmer than viridian green (which is very blue and, therefore, cool).

In Plate 1, I've exaggerated the warm and cool aspects of the scene in order to make the concept clear. Can you feel the warmth of the foreground field and the areas of sunlit foliage? I used a lot of yellow in both of them. In the shadow areas, however, you find that the color is much cooler. It tends toward the blue and the purple. Some of these purples have a warmish quality because there's some red in them. But the general, all-over effect remains that of warm sunlight played against a contrasting mass of cool shadows.

Most of nature is composed of just such warm and cool mixtures. And if you learn to feel the difference, you'll know the right questions to ask when you're on the site. When you look at a sky, for example, don't just think of it as "blue." Ask yourself if it's a warm blue (as the sky usually is when it's near the sun)—or a cool blue (as it might be near the zenith or on a stormy day when dark, purplish clouds obscure the sun).

DISTRIBUTION. By distributing color, I mean placing it in a balanced way throughout your painting so it harmonizes with the total design. Let's say you painted a sketch with only one spot of pure red in it. Because of its singularity, that red spot would attract an undue amount of attention. So to keep the red in its place (to prevent it from sticking out), you also have to put it somewhere else in the design. That gives it a context; it integrates it into the sketch so it becomes less obtrusive. When a picture is balanced, you'll no longer feel that something's out of kilter.

Plate 1. *In this sketch, I've accented the warmth of the trees and field by contrasting it to the cool shadow areas.*

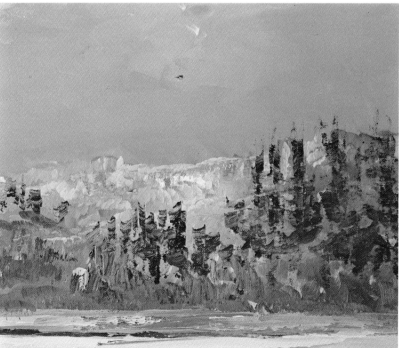

Plate 2. *The warmth of the sunlit orange bluffs is emphasized by the complementary mass of blue sky.*

Plate 3. *In this sketch, the purple mass of trees makes you feel the warmth of the yellow sunset.*

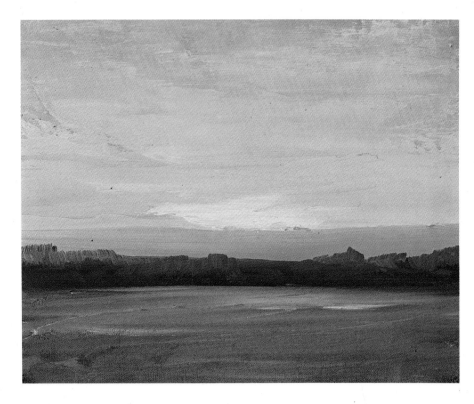

Plate 4. *(Below) On a sunny day, there's a strong contrast between areas of sunlight and shadow; most of the value range is present.*

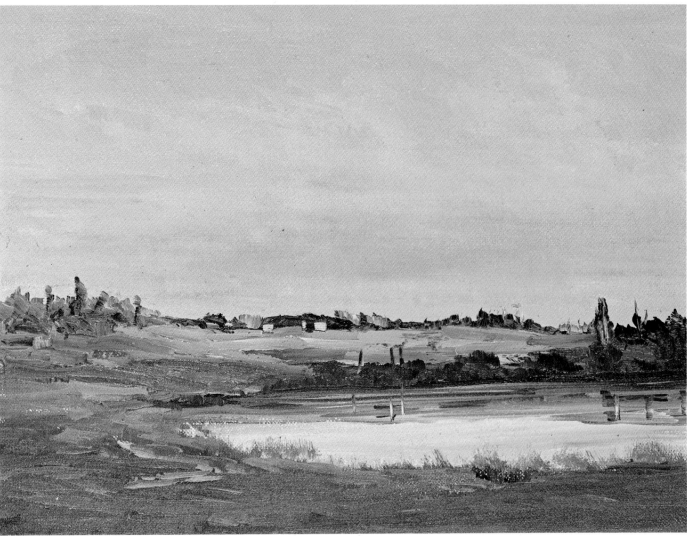

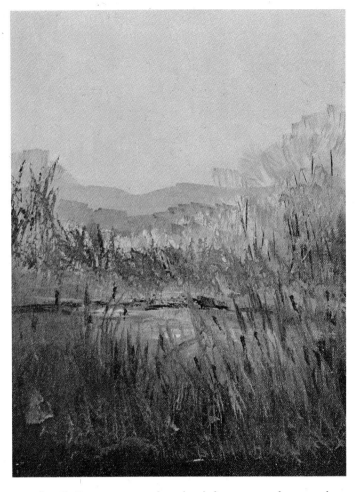

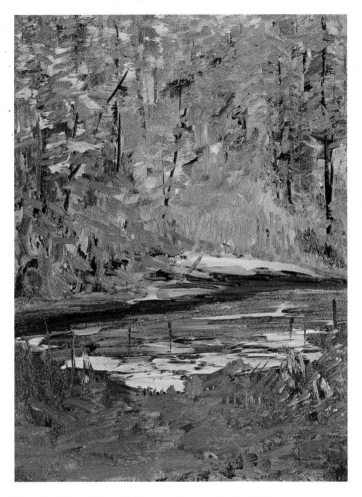

Plate 5. *On an overcast day, there's less contrast between the various objects in the landscape, so you see only a part of the value range.*

Plate 6. *The subject of this sketch is really the brilliant sunlight effect—not the trees or the pond. The highlights on the grass and the water are made more effective by the dark accent along the bank.*

Plate 7. A heavy impasto is used here to suggest the texture of foliage in the fall. Much of this color is "accidental"—the paint layers interact in a spontaneous, unpremeditated way.

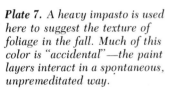

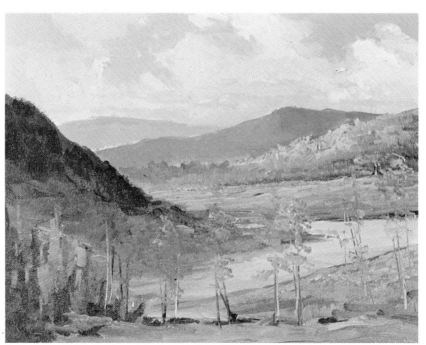

Plate 8. A sketch, unlike a photograph, evokes the artist's personal response to nature. It may be as finished as the one here or as unfinished as some of the other sketches in this book.

Plate 9. *In this sketch, the main subject is the contrast of the warm sky and the cool distant mountain. The variations of warm and cool color in the snow form a subsidiary area of interest.*

Plate 10. *The mixing of complements creates a series of neutrals in the pool; their color temperature can be changed by increasing the volume of the appropriate warm or cool color.*

21

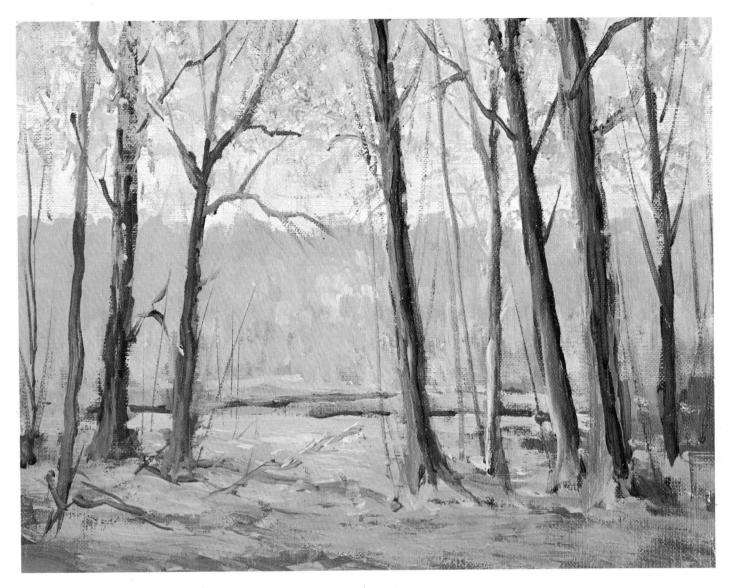

Plate 11. Spring colors are gentle and pastel-like. Here, they form a backdrop for the decorative pattern of the trees.

Plate 12. Warm color dominates this broken-color palette—the addition of white gives the color an added delicacy.

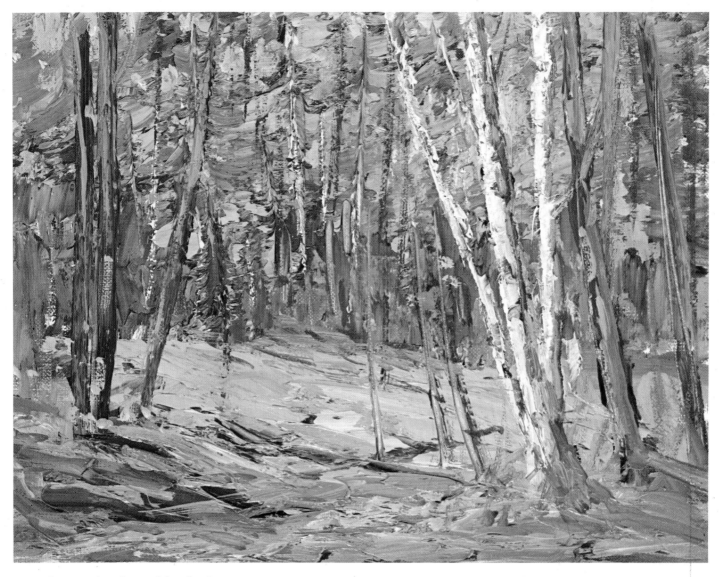

Plate 13. *The subject of this sketch is the texture of the clearing and of the distant foliage. The white birches were added to create a variety of color.*

Plate 14. *Less white is used in this color pool than the one in Plate 12. The blue is pulled deep into the center of the pool, creating a variety of greens while also increasing the depth and strength of the color.*

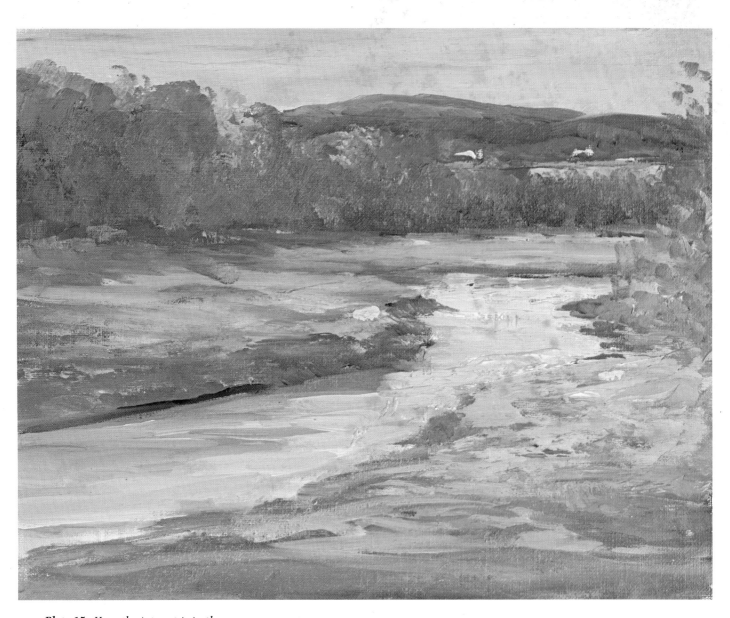

Plate 15. Here the interest is in the contrast between the colors of the warm foliage and the cool mountain and stream. The picture is held together by the way the light falls diagonally across the trees and the foreground bank.

Plate 16. Warm color dominates the pool—but green tempers the color and blue provides the necessary cool relief.

Figure 6. The color wheel conveniently summarizes a lot of information about color. You can easily see complementary and split complementary relationships and can observe how colors cluster in analogous groups.

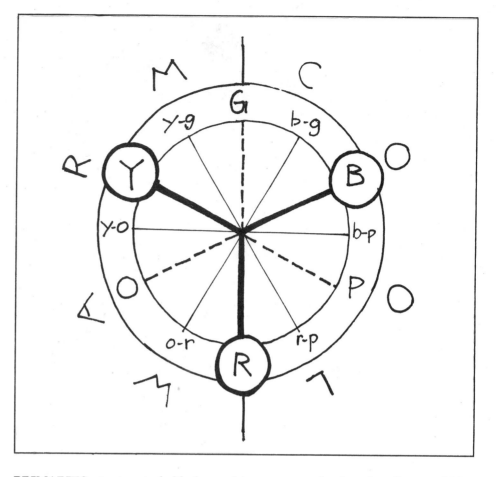

PRIMARIES. As you probably learned in grammar school, red, yellow, and blue are the primary colors. They're called "primary" because they enter into the mixtures of all other colors, but can't be mixed themselves. No combination of other colors is going to give you a red, a blue, or a yellow.

SECONDARIES. The secondary colors are orange, purple, and green, and are created by mixing together any two of the primaries. To make the relation easier to understand, take a look at the simple diagram of a color wheel in Figure 6. Notice that each secondary falls between the two primaries that compose it.

TERTIARIES. On the color wheel, tertiary colors fall between a primary and a secondary color. They're really secondary colors in which one primary is dominant. For example, purple is a secondary color, but blue-purple and red-purple are tertiaries. Green is a secondary color, but blue-green and yellow-green are tertiaries. Orange is a secondary, but red-orange and yellow-orange are tertiary colors.

COMPLEMENTS. Taken together, the primaries and secondaries share what is called a "complementary relationship." The complement of a color is directly opposite it on the color wheel. So the complement or opposite of red, a primary color, is green, a secondary one. By the same reasoning, purple is the complement of yellow, and orange is the complement of blue. To get the complement of a primary, you mix the other two primaries together. Warm colors have cool complements, and vice versa.

Complements have interesting properties. When you put them side by side, they accent one another. An orange mass of sunlit bluff, for example, looks particularly vivid against a cool blue sky (Plate 2). Similarly, a warm yellow sunset looks even warmer when placed near a purple mass of trees (Plate 3).

When you mix complements together, however, they temper or neutralize one another—the warm and cool tones cancel each other out. If you want to mute a color, don't use black—that only muddies it. Instead, just add a touch of the color's complement. The color will be tempered—but it will also retain a certain richness of tone.

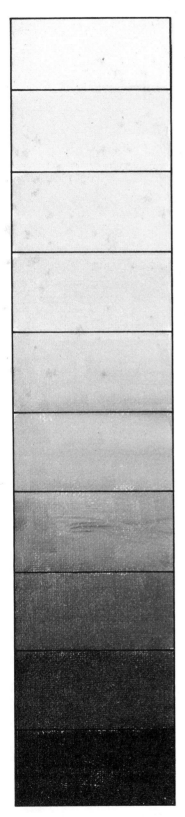

Figure 7. The value scale is usually divided into ten parts. The half tone is in the middle. The quarter tones appear a quarter of the way from the top and the bottom of the scale.

SPLIT COMPLEMENTS. Tertiary colors are connected through a split-complement relationship. The split complement is opposite the tertiary on the color wheel. Red-purple for example, is the split complement of yellow-green. You can find the other split complements by studying the color wheel. Split complements act the same as complements, accenting and muting one another, depending upon how they're used.

NEUTRALS. If you experiment with mixing a color with its complement or split complement, you should be able to balance the proportion of each color in order to obtain a neutral. Take the complements red and green, for example. Add white, so you can see the color, and try to mix a gray in which neither the red nor the green predominates. Such a gray is neither warm nor cool; it's neutral.

There's an interesting property possessed by all grays that are made by mixing complements. If you add this gray to other colors, it doesn't muddy them; the gray simply tones them down. A yellow modified by a neutral made of red and green, for example, doesn't turn orange or yellow-green; it remains a yellow, but a slightly muted one.

As long as you work with a knowledge of complements, you don't have to worry about "mud"—the mess of dull, indifferent color that often destroys the student palette. The way I see it, "mud" usually exists where there's black. Let's say, for instance, you create a gray by mixing Payne's gray and white instead of using two complements. If you then use this gray to tone down a yellow, the resulting mix turns green—it picks up some of the coolness (or blue) in Payne's gray. The black (with its underlying tones) is always lurking in the mix, waiting to cause just such distortions of color.

A pile of complementary colors, on the other hand, can always be of use—no matter how hopeless the mishmash on your palette may look. Add white to it, swirl it around till the complements have all mixed into a gray, and then add color to the pool. The mix would give your color a nice, subtle character. You've turned mud into gold.

TINTING STRENGTH. When you try to mix a neutral, you'll soon discover that the colors you use differ in tinting strength. Some colors are strong and must be used in small quantities or they will dominate a mixture. Many are dyes, or behave like them. Once they're on your brush, you never seem to get rid of them. Others are weak and must be used in quantity in order to have any effect at all. If you mix equal amounts of two complements—ultramarine blue and burnt sienna, for example—you find that the burnt sienna dominates the mix. It has much more tinting strength than the blue.

Experience with color mixing will teach you which pigments are strong and which are weak. Phthalo blue, for example, can easily get into every other color on the palette—it's notoriously troublesome. But that's no reason to banish it from the palette. You just have to learn to add it to a mixture carefully and in small quantities. It's useful when you want a deep, dark accent. And when you mix it with a lot of white, it becomes a clear, luminous blue-green. So don't throw a color off your palette just because you're frustrated by your first encounter with it. Once you understand the nature of each pigment color, you'll be able to control it.

ANALOGOUS COLORS. Colors that bear a family resemblance to one another are analogous. On the color wheel, orange-yellow, orange, and orange-red are analogous colors. They all share a common component: orange. Similarly, yellow-orange, yellow, and yellow-green are analogous. And so on, all around the color wheel.

The important thing to remember about analogous colors is that they can add life to your picture. If you're painting a red barn, for example, you can make the barn much more interesting by adding touches of warm red-orange and cool red-purple to the basic red tone. The touches of analogous colors create variety within the main color and excite the eye.

VALUE. The value of a color is its degree of lightness or darkness. It's how the color would look in a black-and-white photograph. Value isn't always an easy thing to gauge; the eye is often distracted by the hue itself or by its intensity (brightness). A red, for example, may seem light to you because it's so colorful—but it may actually be quite dark in value. Be careful not to confuse intensity and value. Pink

is actually a red that's light in value (that is, if you add white to red, you'll get pink). Maroon is a red that's dark in value. Cadmium red light has a value about midway between light and dark. If you have a color TV set, you can study values by simply turning the color on and off. The results will probably surprise you.

VALUE SCALE. The value scale is the range of grays between pure white and deep black. In Figure 7, I've followed the traditional procedure and divided the range into ten parts. The value in the middle of the range is called the half tone. Halfway up from that value to white is the quarter tone; halfway down is another quarter tone. Most painters begin their work by quickly establishing their lightest and darkest values — the main contrasts. Then they search for the half tones, and finish the picture by adjusting the more subtle quarter tones.

On a sunny day, more of the value range is present in nature than on a gray day. In the former, you have plenty of contrasts (Plate 4); in the latter, the values are closer together (Plate 5). As you paint, you'll slowly develop a feeling for values — just as you develop a feeling for warm and cool and an understanding of the tinting strength of the various colors.

HIGHLIGHT. The highlight is the lightest light in your picture. In Plate 6, for example, the sun, breaking through the masses of foliage, throws highlights on the bank and in the foreground water. In this particular picture, the highlights are really the subject of the sketch; they tell a lot about the nature of the light on that particular day.

ACCENT. The accent is the darkest dark in the picture. Again in Plate 6, the main accent is the shadow cast by the pond's bank. This dark, falling near the highlights, accentuates them, making them seem all the brighter by contrast. Without such darks, the sketch would lose much of its impact.

ATMOSPHERIC PERSPECTIVE. If you learn to understand and to gauge values accurately, you'll come a long way toward giving your pictures a sense of the third dimension. For as colors go into the distance, two things happen. They become cooler (the atmosphere colors them), and they get lighter in value. A dark shadow in the distance is never as dark as the shadow at your feet. In Figure 8, the water in the foreground is dark. But the thick atmosphere of the day has greatly reduced the value of the background rocks and trees. The ability to see and record values accurately will, in the long run, be much more useful than an ability to see and record specific colors. Knowing that something's red isn't as important to a "realistic" painter as knowing what value the red is.

WET-IN-WET. When you paint one layer of wet color into another wet color, you're using the wet-in-wet method. It's a straightforward, no-tricks way of working, perfectly suited to the kind of sketches we'll be doing throughout this book. The method lets you work rapidly and make easy adjustments. You push and shove the paint around till you get the effect you want. The results may be quite surprising. The wet paints often blend in unpredictable ways.

IMPASTO. Impasto refers to a painting technique where thick paint is applied to canvas with brush or knife using no medium or only enough to allow the paint to be manipulated. The more thickly the paint is piled on, the heavier the impasto. Many modern painters like impasto so much that they dispense with the subject altogether and simply concentrate on pulling one "loaded" brushstroke of paint into another.

For the more traditional painter, impasto is useful for creating all sorts of textures. In Plate 7, for example, I slashed color over color in a series of rapid movements with the palette knife. I wanted to suggest the texture of the brilliant autumn foliage. Throughout the following problems, I'll be using impasto — sometimes laying the paint on thickly and sometimes thinly.

BROKEN COLOR. When you paint wet-in-wet with full impasto, you create what is called "broken color," areas where the colors aren't thoroughly mixed. Let's say you mix a green by using blue and yellow. If you pull the two colors together, blending them till both the blue and the yellow disappear, you'll get a flat green

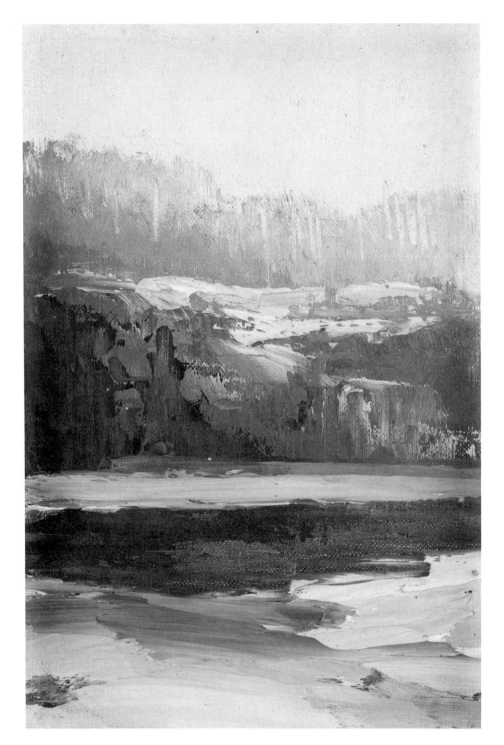

Figure 8. On a day that's heavy with atmosphere, foreground darks will be much darker than those in the background. This effect also occurs on clear days, but its presence is much more subtly felt.

tone—like commercial house paint. It isn't an exciting color, especially when applied over a large area of canvas. If, on the other hand, you quickly brush the blue and yellow together without blending them thoroughly, the result is a color in which (1) some areas are pure green, (2) some areas are a green mixed with strands of yellow, and (3) some areas are a green mixed with strands of blue. That kind of color—broken color—is exciting to look at and is also more like the varied color of nature. The green foliage of a tree, for example, is never one flat tone. You *think* you see a flat green—but that's because you don't really look. Plate 7 is a particularly clear example of the use of broken color, and of the "accidental" mixing of different tones.

ACCIDENTS. Accidents are the special joy of the wet-in-wet technique. When you pull one color into another, you're never sure just how the different paint layers will interact. Let's say you're brushing color into a sky; a stroke suddenly suggests a cloud. You hadn't planned it that way, but it looks good. Don't think, "That isn't what I intended"—and scrape it off! Be alert to the new development, evaluate it, and if it's really *better* than what you had in mind, leave it alone. It may even suggest a whole new way of working. You should be thankful for accidents; without them, painting would just be a mechanical matter of filling up space.

COMPOSITION. Everybody has his own favorite rules of composition, usually listed as a set of "don'ts." Don'ts such as: don't divide the canvas in half, either vertically or horizontally by your composition. Don't have activity in the corners, where it detracts from the center of interest. Don't repeat shapes and spaces. Don't let abrupt transitions in design and color break up and separate different areas of the canvas.

We'll talk a lot about composition in the pages that follow. But for now remember, while rules are useful, plenty of fine painters have broken them at one time or another without hurting their pictures. The real goal of most composition is simple: to keep the eye of the viewer in the canvas while providing variety and interest within the unifying idea. *Simplicity is the keynote to good design.* Everything else is a matter of personal taste. I have students that live in Lexington, Newton, Milton, Gloucester, or any of a dozen small towns around Boston, Massachusetts. When they want to go to the city, they all take different routes—but they all end up at the same goal. That's composition in a nutshell: knowing where you want to go and getting there by the most convenient and direct route.

THE SKETCH. To many people, a sketch is an "unfinished" piece of work. It's done quickly and seems a "trivial" part of the art experience. But nothing could be further from the truth. Sketching—especially the kind of sketching we'll be doing in this book — is one of the most intensely personal activities in art. In a good sketch, the artist works rapidly. He's either inspired or excited, and the end product is loose, free, and spontaneous. It cries out: "This is what I saw!"

I've seen fifty-year-old sketches that look as fresh as the day they were painted. They radiate energy, as if charged by the excitement the painter originally put into them. That's how you should approach your own sketching. Learn as you work— but also have an exciting experience. If the sketch communicates this excitement, it's a success. Your pleasure should show. The viewer should feel as if you've savored each brushstroke—like a kid enjoying each lick of a lollipop (Plate 8).

CHAPTER THREE

Mixing the Color Pool

Now that we've discussed some basic terms, let's look at color mixing and its problems. Most students, when setting up their palettes, are overly concerned with economy. They squeeze little spots of color all over the place. And in order to make the pigment go further, they dilute it with medium, thinning it to a runny, wishy-washy consistency.

This kind of approach causes a number of problems. By sticking paint wherever there's a convenient space on your palette, you don't develop a "sense" for where your color is. You have to search for it. That not only distracts you from the job at hand—painting—but it causes you to lose valuable time, time that could be better spent trying to capture the swiftly changing effects of nature.

By being "economical" with the paint, you thin it to the point that the color loses its identity. You also sacrifice the ability to use impasto in creating textures and areas of broken color. Remember that paintings are made with paint!

When you look at a palette filled with separate spots of unrelated color, the chaos affects you psychologically. It creeps first into your mind and then onto your canvas. In your picture, either (1) the color is poked and teased until everything's a muddy, nondescript mass, or (2) you have a series of color spots that bear no relation to one another—the paint is splattered everywhere.

To avoid many of these problems, try premixing your color in a series of big, interconnected areas called a color pool. Let's say you want to sketch a clump of trees in midsummer using a simplified palette. You can mix a color pool easily by following a series of simple steps.

STEP 1. ANALYZE THE COLORS IN THE SCENE. Looking at the scene in front of you, analyze the colors in the trees, grass, and sky. Remember that the pigments you put on your palette should bear some relation to the colors you want to mix. This sounds obvious, but many students paint from their paintbox without really looking at nature. They rummage around in the paintbox and decide they haven't used such-and-such a color for a long time, why not use it today? Or they may take a series of reds—because they like that color—and supplement it with a burnt sienna (a reddish earth tone). Then they set out to paint a green summer scene!

In our hypothetical sketch, you know there'll be a lot of green; you're dealing with big masses of foliage. So first ask yourself some questions. What are the greens like? Is the foliage cool or warm? Does it have more blue in it, or more yellow?

STEP 2. ANALYZE THE PIGMENTS YOU OWN. You could, if you wish, choose a warm green (like permanent green light) or a cool green (like viridian) as the dominant color in the composition—depending upon what the color temperature of the scene is. The important thing to remember is that you don't start with viridian green when you're trying to get a primarily warm effect.

Some students do just that. They think that green is green—and don't consider the variations within pigment colors. I'm reminded of the problem some people have when they read that red and blue make purple. They go right out and mix cadmium red light and cerulean blue, and they get something that has a strangely greenish cast. There's a lot of yellow in both colors, and that affects the final mix. If they mixed ultramarine blue and cadmium red medium, on the other hand, they'd get a fine purple—the red is a strong red and the blue is a strong blue, so they work well together. (To get a sense of the variety in pigment colors, pick up a manufacturer's color chart at your local art store. It's free and it shows you the firm's complete color line, arranged from the warmest to the coolest tones with the earth colors usually tacked on at the end. Compare two or three different charts and see how the colors of one company differ from those of another.)

STEP 3. ARRANGE THE COLORS ON YOUR PALETTE. First you have to place the colors on your palette. As you squeeze them out of the tubes, put them along the edge of the palette in some kind of systematic way. It doesn't matter what your system is, so long as it has a logic that you understand and use whenever you lay out your paints. I like to place my colors across the top of the palette, with the cool colors to the right and the warm ones to the left. No matter how many more colors I might add to the palette, I stick with this general arrangement. A cerulean blue, for example, would go to the right. Warm burnt sienna would go to the left. And so on. I always know exactly where my warm and cool colors are. White can be placed off to one side. This arrangement leaves the entire center of the palette—a large, clean area—free for mixing colors.

STEP 4. SELECT THE HUES FOR THE COLOR POOL. Let's say you decide the greens in your subject are mainly warm, with some cooler areas in the shadows and on some of the bushes. As I've said, I'm trying to keep this discussion as simple as possible. So let's try painting the scene with three pigment versions of the primaries: cadmium red medium, cadmium yellow medium, and ultramarine blue.

STEP 5. START MIXING THE COLOR POOL. Since you've already decided that a warm green is the main color in your sketch, you therefore start your color pool with this color—which is actually a mixture of yellow and blue. Pick up yellow, then blue paint on your brush, one at a time (always start with the weaker color first), and place them next to one another in the center of the palette. Pick up lots of paint so you'll have plenty to work with! (Be sure to wipe off your brush on a clean rag before picking up each new color and adding it to the pool.)

As you slowly work the two colors together, they mix "accidentally" (because you're not blending them thoroughly and forcing them to become a single color, like housepaint). You now find yourself creating a great variety of greens. Those nearest the yellow area are, of course, warm; the ones nearest the blue section are cool. You can cut in white (that is, add it to a section of the pool, taking care not to overblend it) to lighten the colors in the pool.

The schematic diagram at left, which is similar to the ones we'll be using throughout the book, describes what the color pool should look like at this point. Remember, it's just a diagram—you won't be painting in such neat circles. You may place your colors anywhere you wish in the color pool and not necessarily in the positions or order they appear here in this book. These diagrams only show how I arranged my colors for a particular sketch. Painting the same scene on another day, or sketching a similar scene, I might arrange them differently. Just as the placement of colors on your palette is personal, so is the arrangement of colors in your pool. Just keep your potential mixtures in mind as you put the colors down, since their position should be influenced by the colors they'll mix with most often. For example, since I anticipate mixing many greens here, blue and yellow would never be too far from each other.

STEP 6. COMPARE THE POOL TO NATURE. As you work the blue into the yellow, your eye is constantly going from the clump of trees, to the palette, and

1 ULTRAMARINE BLUE
2 CADMIUM YELLOW MEDIUM
3 WHITE

back again to nature. The original decision to make the pool warm (with a predominance of yellow in the mix) came from your analysis of the subject. As you look at the color pool on your palette and see the analogous colors develop, those colors themselves will sharpen your vision. For example, in one corner of the pool there may be a very warm mixture of green. You look at it, then back to the scene—and discover it in nature, too! You hadn't noticed the shade before, but seeing it on the palette alerted your eye to it. Your eye, nature, and the palette are subtly interacting with one another.

STEP 7. MUTE YOUR COLORS. As you develop vivid greens on your palette, you may notice that the colors in nature aren't quite as bright. They have a more muted quality, even when hit by sunlight. To neutralize the greens on your palette, therefore, you introduce their complement, red.

Some literal-minded students might complain that there isn't any red in the scene before us. All they see is green. But remember that there's a distinction between nature and pigment colors—they're not the same thing. You know that red is the complement of green and will mute or gray the green without muddying it (as would the addition of black). So you use your knowledge of the pigments to get a natural effect. The more you know about your pigments, of course, the more you'll understand how they work.

STEP 8. APPLY A KNOWLEDGE OF OPTICS. In addition, you may discover—if you really look—that there *is* red in the green trees. It's an optical fact that wherever there's a lot of one color, especially an intense color, the complement is bound to be generated near it. If you look at the tops of green trees against the sky, for example, you'll see that the sky appears to redden as it gets near the foliage mass. Similarly, there'll be a suggestion of red in the darkened shadow side of the green trees. It's as if the eye generated this complementary color in order to find some relief from the overall green tonality.

We've already noted how this works in the warm and cool contrasts of Plate 1. If your sketch of a group of trees was all green—and nothing but green—the eye would be quickly fatigued. The painting actually demands a touch of red, whether or not it's really in the scene. Remember that harmony isn't simply a matter of interplaying analogous colors; it also comes about from the subtle interaction of complementary tones.

STEP 9. DEVELOP MORE COLOR MIXTURES. As the color pool shown on page 31 is developed and enlarged, it soon begins to look like the diagram shown at left as new mixtures begin to emerge within the color pool. Red, the complement of green, not only works into the green and mutes it, but parts of it also mix with the blue to form a variety of purples, and with the yellow to form a variety of oranges. The number of complements and split complements increases. The white is always nearby, ready to be added to the pool whenever a lighter tone is desired.

Also notice that at the outer edges of the pool there's always a bit of pure primary color, color that's never pulled into the central mixes. These colors are ready whenever you need to pull more color into the pool—or want a touch of pure red, blue, or yellow.

STEP 10. KEEP THE POOL FILLED. Keep adding more color whenever any of the areas of color begins to run low. You must have a large volume of pigment to make the mixes work, or else one color may overpower another, or all the pigments may be hopelessly diluted by the medium. Your palette is like the oil tank of your car; to get any place, you have to keep it filled.

STEP 11. REFINE YOUR COLOR MIXTURES. You're now beginning to work with a full gamut of color. You not only have the primaries, but you've mixed the complements and, as you pull color into color, you're creating all sorts of split-complement relationships. Your eye continues to move from the pool to nature. The purple you've created in the pool, for example, makes you sensitive to purple—and you may notice a similar color in the shadow side of a tree. Maybe it's a little cooler than the purple on your palette—so you pull some blue into the mix from the outer edges of the ultramarine blue area. Or you may notice a very muted green—so you pull more red into the mix until you begin to approximate the color in front of you.

1 CADMIUM RED MEDIUM
2 ULTRAMARINE BLUE
3 CADMIUM YELLOW MEDIUM
4 WHITE
5 PURPLE
6 ORANGE
7 GREEN

STEP 12. USE THE POOL CREATIVELY. By this time, your eye is sharpened and your mind is beginning to think in terms of color. It takes time to get the mind in gear—but after a few minutes of mixing, you'll begin to feel some of the excitement that's the foundation of all good sketches. Nature was the inspiration for your first color mixes. Now nature and what you see on the palette are working together, sharpening your eyes and sparking your emotional response.

In addition, the areas of color in the pool have worked into each other so that each color has slight touches of all the other colors. This creates a subtle harmony between them. The challenge is to transfer the felt unity of the color pool on your palette to the picture that you're going to paint on canvas. This is basically what Whistler meant when he said that to paint a beautiful picture you had to have a beautiful palette.

STEP 13. WHEN TO STOP MIXING—AND START PAINTING. Of course, you can't keep mixing color forever. You'd eventually mix all the complements and split complements together into a mass of neutral gray. Most students, however, don't spend enough time on the mixing process. They're anxious to "get to work"—which, to them, means copying what's in front of them. They rush to catch their subject, and lose everything in the process. Remember that you can go too far with a picture too fast. It's as if you put a cake in the oven and after half an hour remembered you'd forgotten to put in the baking powder. You can take the cake out, pull it apart, and add the missing ingredient, but that won't help the cake.

There's no way I can tell you exactly when to start painting—just as I can't tell you exactly when to stop. That's largely an intuitive matter. But there are two situations that indicate the time is ripe to start work on your sketch. In the first situation, you find you have a good match between the colors on your palette and the colors of your subject. In our hypothetical sketch, that means you've mixed the main varieties of greens and have enough warm and cool colors to block in the big masses of the design. You don't have to have every color on the palette that will be in the final picture. Some of the mixing should be done on the canvas itself—that will allow room for the creation of further interesting "accidental" mixtures.

In the second situation, the colors on the palette don't exactly match those of the scene, but the harmony of the color pools appeals to you. You have something very personal on your palette. Here too you can begin to paint! And see if you can carry that color harmony into your sketch. Plate 6 is the result of just such a personal response to my color pool. The yellows of nature weren't quite as yellow as I painted them—or the greens quite as green, or the reds quite as red. But I liked the way the colors developed on the palette. The scene had started me thinking in terms of warm color; then my personal taste took over and led me to exaggerate a part of the scene that appealed to me.

Most students understand the first situation. But they feel uncomfortable with the second. They feel as if they have a moral obligation to copy the colors they see before them. If they don't get the greens just right, for example, they think they've failed to do their job. If your conscience bothers you, just remember that the colors of a scene never remain the same for very long anyway. The sun is moving through the sky, shadows are changing, different colors are reflected onto your subject. The color changes from minute to minute. No matter how accurate your eye, the most you'll ever get will be an approximation. So don't try to turn your sketch into a colored photograph.

STEP 14. BEGIN THE SKETCH. Now begin to paint, blocking in the large masses of your subject first. From here on, everything depends on the nature of your subject—as you'll see in the four demonstrations that follow.

CHAPTER FOUR

How the Method Works

To show you how a color pool really works, let's look briefly at the relationship between four different sketches and the color pools I mixed for each picture. These sketches—like all the other work in this book—were done on 8x10 inch/20x25 cm panels and took about a half-hour each. Remember that if you work too long at such a small scale, fatigue takes over. Your color begins to get muddy—and you forget why you started the sketch in the first place!

Each sketch has a different theme. In the winter sketch, the subject is the contrast between the warm sky and the cool mass of the distant mountain. In the spring sketch, the stand of dark trees makes a decorative pattern against the sunlit background. In the summer sketch, the foliage forms a mass that's rich in color and texture. In the fall sketch, the subject is again color—but in this case, there's a strong contrast between the warm trees and the cool mountain and foreground water. Contrast, design, texture, and color—these are the real subjects of the sketches, not snow, trees, leaves, and water!

SAMPLE SKETCH 1: WINTER

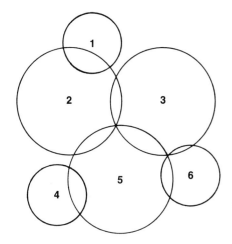

1 CADMIUM YELLOW MEDIUM
2 WHITE
3 ULTRAMARINE BLUE
4 CADMIUM RED LIGHT
5 VIRIDIAN GREEN
6 BURNT SIENNA

Plate 9 is a sketch of a crisp winter's day. The mountain in the distance stands out sharply; because of atmospheric perspective, it's also very cool in color. The sketch's interest lies in the contrast between the bright orange-yellow sky and this blue mass. The shadows that fall across the foreground and background are a second, subsidiary area of interest. Throughout the snow, there's a fascinating interplay of warm and cool color.

The color pool used in painting the winter sketch in Plate 9 is diagrammed at left and shown again in Plate 10. (The latter is actually a simplified version of my original color pool; that is, here the areas of color are neater and more precise than were those on my actual palette. As I've already explained, you can't expect to paint in neat circles when you're outdoors!)

The pool is dominated by two different complementary mixes. Looking at both Plate 10 and the diagram of the pool, you can see how ultramarine blue (cool) and burnt sienna (warm) mix on the right of the pool, while viridian green (cool) and cadmium red light (warm) mix on the left. Each of these mixes creates an interesting series of neutral tones, tones that can be made warmer or cooler by the addition of more of the appropriate complement. White is added to lighten the color. (I use Permalba white, a titanium/zinc blend manufactured by Weber.)

The neutrals form the basis for the shadow areas in the picture. In Plate 10, you can see that by using two sets of complements rather than one, I obviously have more color variety. Notice also that there are still bits of pure color at the outer edges of the pool—this is a reservoir of color, always ready whenever I need to make a particular mix warmer or cooler.

Since some especially warm color will be needed in the bright sky, cadmium yellow medium is cut into the white pool. This warm color also mixes with the nearby areas of ultramarine blue and red, forming muted, greenish-blue tones. These tones are added to the sky as it gets farther from the sun and loses some of its brilliance.

The first step is to decide how and where to place your principal masses. The way you place them determines your design. After that, your main job is to adjust your values and the warm and cool relationships of your colors. Once these decisions are made, it's time to start painting.

Block in the main areas of contrast first: the sky, sunlit warm trees, and cool, distant mountains. Keep the sky warm and the shadows cool. The bare canvas represents the sunlit areas of snow. Add cool color to the shadow sides of the background trees; that accentuates their warmth by way of contrast. To keep the composition from splitting into a warm top half (sky) and a cool bottom half (snow), work warm touches of red, yellow, and blue-green into the foreground shadows. At the site, the snow has a variety of warm and cool areas anyway—but when you put the color down, think less of making "snow" and more of *distributing* the warm greenish-blue color of the sky. Use color to unify your design.

In Plate 9, the big value areas are established, the warm and cool color is varied —yet the simple masses hold together. They don't break into isolated spots of color. Ask yourself: "Would more detail help or hurt the design?" In this case, I approximated the effect I wanted—so the picture was "finished." Someone else might want to work on it for another half-hour. That's the prerogative of the individual painter; a picture is finished when the painter feels he's said what he wants to say.

SAMPLE SKETCH 2: SPRING

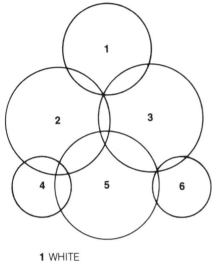

1 WHITE
2 CADMIUM RED LIGHT
3 ULTRAMARINE BLUE
4 CADMIUM YELLOW MEDIUM
5 BURNT SIENNA
6 VIRIDIAN GREEN

Plate 11 is a sketch done in the early spring. Plate 12 shows the working palette—a palette that I diagrammed at left. The palette is composed of the same colors used in the winter sketch. But, as you can see, the pools are arranged differently. I did this on purpose. Where you place the color within the pool isn't important—what counts is that you keep the color in a series of interlocking and related pools.

Compare the color pools of winter with those of spring (Plates 10 and 12). Can you see the difference in the way I mixed the color on my palette? In the palette for winter (Plate 10), I applied pressure to my brush, mixing the tones rather thoroughly. The cadmium yellow was also greatly reduced in brightness, so that it wouldn't be a strong yellow spot in an otherwise sober painting. The winter subject falls into a few simple masses; the main interest is in the subtle variations of warm and cool color within these masses.

In Plate 12, the palette for spring, I pulled the color together with a lighter touch; the mixing isn't as thorough. As a result, there are large areas of broken color. The pastel-like shades match the tenderness of new spring growth; and the broken color is appropriate to a season that's composed of small, juxtaposed tones. Buds, new leaves, and tufts of grass form a subtle, natural tapestry.

Two basic areas, a warm and a cool one, are first placed on the palette (Plate 12). The neutral tones play a smaller role in the spring palette. Instead, the mix is dominated by the clear, warm cadmiums. Burnt sienna, red, and yellow are added to the warm area. Blue and green are mixed in the other, cool area. Then the two areas are worked into one another. The reds, blues, greens, and yellows in Plate 12 form—with the addition of white—an intriguing series of warm and cool mixtures. Look at the colors on the palette and try to enjoy them in and of themselves. Stop thinking about the "subject"—concentrate on color relationships.

In Plate 11, the sketch breaks into four basic divisions: sky, distance, water, and foreground trees. These areas are quickly blocked in, using broad areas of color. As with the winter sketch, the variations within these masses come only after the main masses are established. A blue-purple, for example, is used to establish the somewhat hazy distance. Then into this purple mass is inserted a series of subtle blue-greens, yellow-greens, and oranges. The wet purple color tempers all the other colors that are painted into it. Similarly, the foreground is painted with a green. Its complementary color, red, is pulled into it, muting some of the areas and creating a suggestion of shadows. At the very end of the painting session, a few strokes of clean yellow are pulled over the green, giving it the look of new grass. This yellow must be placed only once, and then left untouched. If you tease it, the color quickly mixes with the undercoat.

The trees are painted last. They're worked right into the wet background and sky; and these lighter areas affect the dark accents, giving them added variety. The buds are then added by poking at the surface of the canvas with the tip of a color-loaded brush. Notice that these "buds" are primarily a means of distributing color. They bring some of the green of the foreground up into the primarily orange-yellow sky. There's a touch of blue at the zenith of the sky; it's also distributed, recurring in a few touches in the immediate foreground.

SAMPLE SKETCH 3: SUMMER

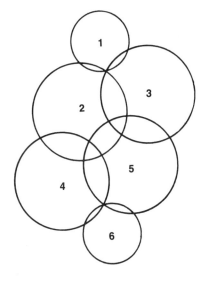

1 WHITE
2 CADMIUM RED LIGHT
3 ULTRAMARINE BLUE
4 CADMIUM YELLOW MEDIUM
5 BURNT SIENNA
6 VIRIDIAN GREEN

Plate 13 was done in the middle of summer. At the site, the first thing I noticed, of course, was the presence of a number of analogous greens. So I know the palette will need that color—and lots of it.

Taking the same basic palette that I used in the winter and spring sketches, I increase the size of the cadmium yellow pool (see diagram at left and Plate 14). It now has more of a chance to mix with the ultramarine blue and viridian green, thus forming a greater variety of greens. As you can see in Plate 14, the cadmium red helps mute these greens. Burnt sienna does the same—and also provides some warm, earthy tones for use in the land mass.

Pay particular attention to the difference in the character of the spring and summer color pools. The key to the mixing of both pools is the volume of paint involved and the force applied to the brush. In the spring palette, white, red, and yellow are used in volume, while the other colors subtly work into them. As a result, the palette is mainly warm in tone—the color of new grass and buds. In the summer palette, on the other hand, both yellow *and* blue play an important part. Can you see how the blue in the spring palette is just touched into the central mix, while, in the summer one, it's forcefully drawn right into the center of the color pool? The result is an added depth of color—solid greens replace the lighter pastel shades.

In Plate 13, the large masses are blocked in first: the sky, tree foliage, and foreground. Concentrate on the masses and feel your way into the picture. A heavy impasto is developed by applying the paint with the palette knife. That gives you an opportunity to play with color; you can watch for the greens that look right. If a blue-green is created—by accident or choice, check to see if it's in nature. At the same time, check with yourself, too. Do *you* like the color? You may find a green in nature that your eye rejects. I've always had trouble working with yellow-greens, for example. Modify the color till it satisfies your personal taste. If literal "truth" were your only goal, you'd bring a camera—not paints and canvas.

After the large foliage areas are blocked in, I add the white birch trees. They're not there for "picturesque" effect—rather, they give the eye a relief from all that green. Without touches of white, the sketch would be too monotonous. By the time I get the textural effect of the leafy background, I stop. I've said what I wanted to.

SAMPLE SKETCH 4: FALL

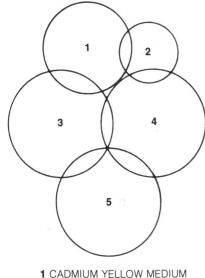

1 CADMIUM YELLOW MEDIUM
2 WHITE
3 CADMIUM RED LIGHT
4 ULTRAMARINE BLUE
5 VIRIDIAN GREEN

Plate 15 is a fall sketch—it is, of course, dominated by warm color. The palette, shown at left and in Plate 16, is begun by mixing two warm tones together—cadmium red light and cadmium yellow medium. A quick mixing creates a variety of analogous warm tones. But you can't paint a picture with warm color alone. Viridian green is introduced into the bottom of the mix; since it's the complement of the red, it helps to tone it. (You can see how this works by looking at Plate 16.) Then, more cool color is added to the right of the pool by the addition of ultramarine blue. You need this cool color to balance the warmth of the reds and yellows.

In Plate 15, the sketch itself, the warm tones are first put down in big masses; then cool blue is worked into the distant mountain. It contrasts with the orange-toned trees and makes them look brighter and warmer. More of the dark tone from the color pool is used in the deep shadows. The basic pattern soon emerges. The sun is on the left; the shadows, too, are on the left. The light cuts diagonally across the picture, catching the trees and hitting the right foreground with a strong blast of warm color.

After fifteen minutes of rapid work, it's time for analysis. Looking critically at the picture, I find it seems too hot; it demands touches of cool color, for both contrast and balance. So I paint the river with the need for this relief in mind. Cool touches are also added to the foreground river bank.

At this point, the picture begins to look overworked, so I use a palette knife to add the clean color of the distant blue water. This color freshens the painting—and also jolts my fatigued color sense. Some highlights are also added at this point; they're just touched onto the canvas and left alone. Keep fooling with them, and you'd force them into the underpainting.

I stop work, feeling tired and not really knowing if the piece is any good or not. After staring at mistakes for half an hour, my eye stops noticing them. It needs to rest for a day or so; then it can take a fresh look at the picture. That's when I'll be a better judge of its success or failure.

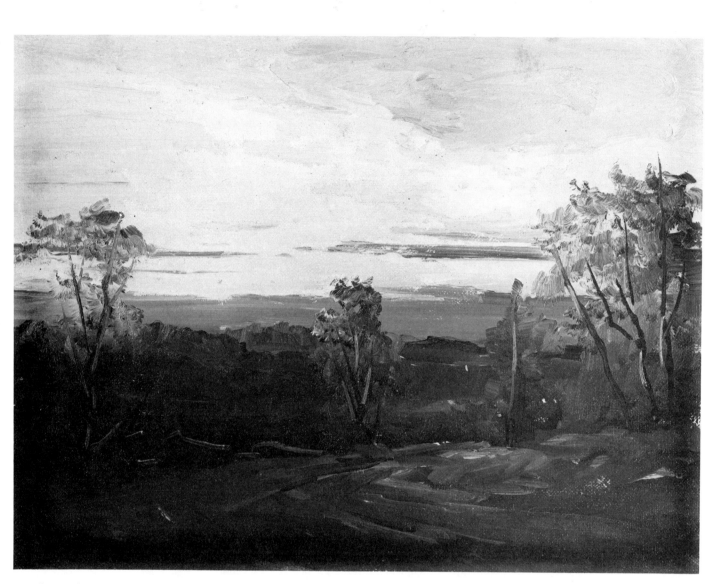

The sun has just set, but the sky is still bright enough to light up the larger shapes and tones of the landscape.

CHAPTER FIVE

Suggestions for Sketching the Seasons

We've talked about basic painting materials and tools. And we've discussed color terminology and the use of the color pools. Before we begin our study of the seasons, I want to say some preliminary words about your attitude toward your subject matter.

PICTURE-MAKING. Sketching should be a learning activity. Whether you get a good "picture" or not is a secondary concern. You're experimenting with composition, values, and color. You're trying to broaden your knowledge of the world, of painting, and of yourself.

Many people, however, want to make a finished picture every time they paint. Before joining a class, some students ask me how long it would take to become a professional. They want to be doing saleable paintings by the end of the year — otherwise, they feel they'd be wasting their money! They think exclusively in terms of the final product — of the picture they hang on the wall for neighbors and relatives to praise. Their main source of satisfaction is this friendly praise.

But the painter's real pleasure comes less from the final product than from the fun of painting, the excitement he feels before nature, and the self-satisfaction he receives from learning and from improving his work. Nothing ever equals the joy of the first few moments on the site — not even the most successful sketch. Yet the adventure of painting lies in the attempt to capture, even in a rough way, a part of this initial excitement.

FEELING. Many people become uneasy whenever the words "emotion" or "feeling" are mentioned. They don't want to appear "soft" or "poetic." They're determined to be cold, objective, and analytical — and they insist that they can see only the hard facts of a subject: rocks, water, trees. When they paint, they say, they're only copying what's in front of them.

Yet if you place a half dozen of these people in front of the same subject, they'd all paint it differently. Why? It's not because their technical abilities differ. Painting has little to do with technical skills. Being able to draw helps, of course; and you should take drawing courses or go to sketch classes whenever you have a chance. But the better artist is simply the one who's more open to his own responses—who paints what he likes and feels rather than what he thinks everyone wants him to paint.

These supposedly hard-hearted people paint differently because their emotional responses to the scene are different. As they become more absorbed in their work —and forget about their "common sense" façade—they paint with the responsiveness that's the foundation of the fine arts. They begin to be themselves.

INCIDENTS IN NATURE. As we go through the sections that follow, we'll see that nature is rich in a great variety of moods. There's the fleeting and dramatic light effects you sometimes find on cloudy days (Figure 13). And there are the subtler effects of overcast and rainy days (Figure 9). You may be struck by the rugged grandeur of a scene (Figure 10)—or by its peacefulness (Figure 11). At some sites, you'll be interested in the texture of the rough and irregular foreground (Figure 14); and at others, you'll be attracted to the atmospheric effects in the far distance (Figure 12).

If you keep your eyes open and aren't afraid to let your feelings show, you can find something of interest no matter where you set up your easel. I'm reminded of the painter who searched all over the world for "material" and came home disappointed. Then, one day, he glanced out his window and suddenly discovered the beauty of his own backyard! The subject isn't the most important thing in a picture —what counts is your attitude toward it.

FUNDAMENTALS. The following chapters discuss the various problems I encounter while painting outdoors. I'm not primarily a landscape painter, nor do I claim much for the sketches in this book. They're just food for thought. In some of them, only a few square inches are of any interest—maybe a nice relationship of color or of value. But every time I see those small sections, they give me a jolt. They inspire me to do better. That's how your sketches should affect you.

The sketches also let me talk to you about a few basic design and color ideas. No one ever masters these subjects; but once you *begin* to understand them, you'll have tools that can help you interpret any subject. Painting often reminds me of a long drive through the countryside. It's fun to go down new roads and see new sites —but after a while, you begin to feel lost. Then you see a familiar road sign and breathe a sigh of relief. In painting, too, it's fun to try new ideas and new techniques. But whenever you're lost, your best bet is to return to the fundamentals— for they apply to any technique and to any subject.

PLAN OF THE SEASONS. The plan of the following four chapters is very simple. Each chapter—one per season—is divided into eight parts, and each of these parts, thirty-two in all, roughly corresponds to one of thirty-two color plates. The parts are called "problems" because the painter is always a problem-solver. He sees something that moves him—and he has to figure out how to put it on canvas for a maximum effect. That requires making decisions—which, in turn, makes painting hard work. Pictures aren't created by the wave of a magic wand. If, however, you really think about a subject, you can usually paint it. Each problem discusses the palette, the use of the color pools, and ways to develop a specific theme. The problems end with a short critique—sometimes you'll be warned about dangers inherent in the subject, sometimes you'll get a pep talk, and sometimes we'll just discuss attitudes and ways of thinking.

ATTITUDE. We'll talk about color and design in the following sections—and I'll show you a few technical "tricks." But I hope you get an attitude from this book— and not a way of working. You can imitate someone else's mannerisms—but that doesn't help you to think for yourself. Investigate your own feelings—and do your own thinking!

Watch out, also, for the dangers of overconfidence. When I was forty, I thought I knew everything about nature and about painting. Then I met a real painter—and he showed me how much I had to learn. He taught me how to see. We'd drive along a road, and he'd suddenly make me pull over; he wanted to study some clouds, or the way the light hit a group of trees. He was an elderly man when I knew him, but he still had a youthful enthusiasm for nature. He was always ready to be surprised and delighted. And that's probably the single greatest blessing the painter has: he has learned how to see and to appreciate the world around him.

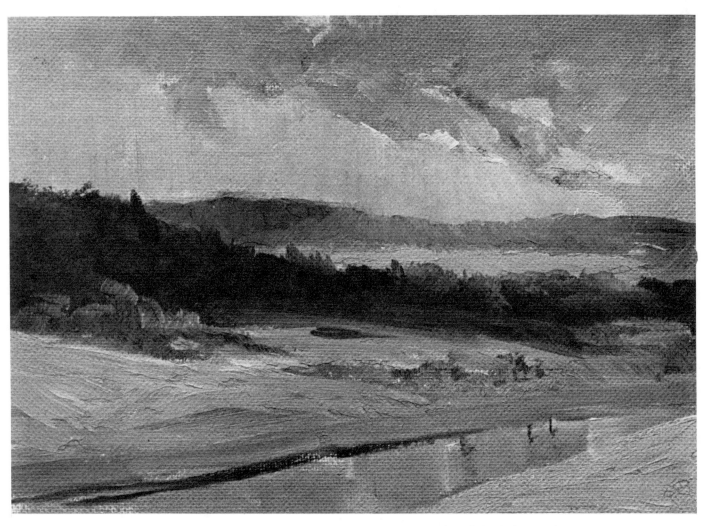

Figure 9. On a rainy, overcast day, there's a subtle relationship between the clouds and the darkening sky.

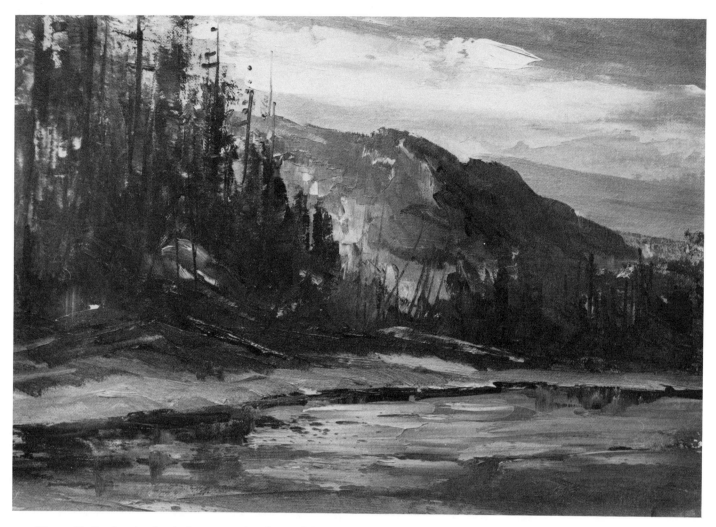

Figure 10. In this sketch, the large, angular shape of the mountain immediately captures your attention.

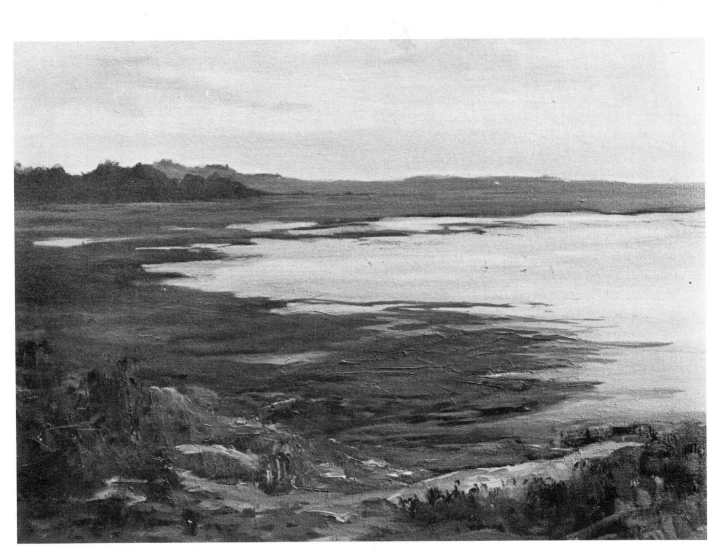

Figure 11. *The peacefulness of this scene is reinforced by the lazy rhythm of the line where water and marsh grass meet.*

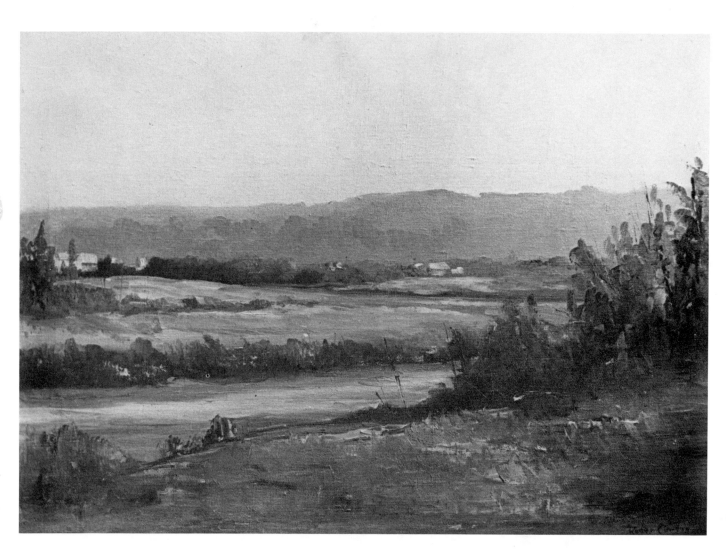

Figure 12. Morning light and the heavy atmosphere of the day veil the background, creating a subtle and interesting series of values.

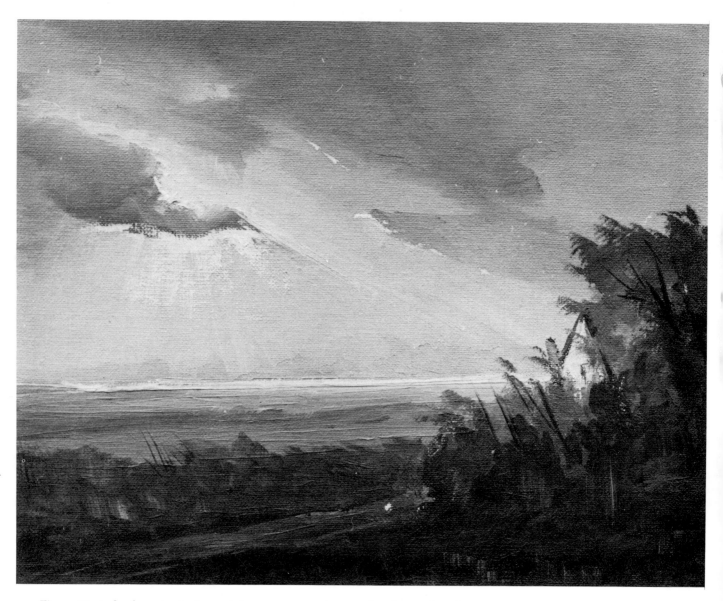

Figure 13. *A cloud passing in front of the sun creates a dramatic but fleeting "incident in nature."*

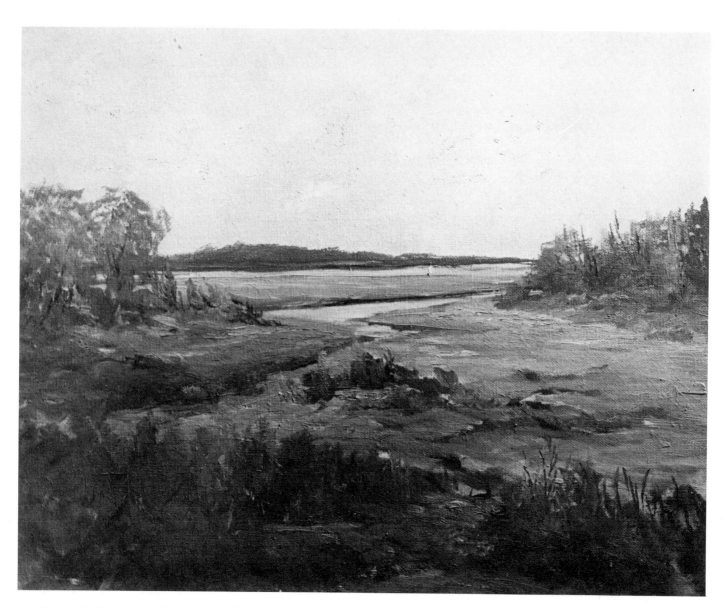

Figure 14. *Bushes and the uneven surface of the foreground make a subject rich in textural variety.*

CHAPTER SIX

Winter

Winter is a good time to begin our study of the seasons. There are no bright yellows, reds, or greens at this time of year, so the color will neither distract us—nor overpower us. Of course, the snow reflects light and creates a thousand different effects, but these effects are really too subtle for us to discuss here. For now, let's just say that winter is a time of muted color. Your emotions tell you as much; outdoors, you feel that the world is asleep. We can therefore use this season to study the fundamental relationships of value and color temperature.

The blanket of white snow also makes the *design* of the season particularly clear. There are the dark, vertical accents of bushes and trees. And there's the diagonal and horizontal movement of the land. In addition, the masses are large and simple. You can see how the parts of nature fit together.

As we look at winter, notice the variety of moods and effects that characterize the season. When you learn how to see, you'll find that every season has its particular charm—as does every day and every hour. Everything depends upon your openness to what's happening around you. Remember: to see a subject, you must first learn how to feel it.

PROBLEM ONE

1 WHITE
2 ULTRAMARINE BLUE AND
 BURNT SIENNA

INCIDENT IN NATURE. Let's set up on the afternoon of a slightly overcast day. The sky is gray, but there's still enough light to give shape to the snow-covered forms.

PALETTE. Since such a day doesn't require the use of a lot of color, we can experiment with a restricted palette. Let's take the simplest palette possible and see what it can do. Remember that the aim of all these problems is to have a good time exploring. Two complements are sufficient: an *ultramarine blue* (our cool color) and *burnt sienna* (our warm, orangy color). Of course, we also have white.

COLOR POOL. Before beginning the pool, ask yourself what matters most in the scene. Don't say, "I want to draw the mountain correctly" or "I want to get the clump of trees right." Mountains and trees are just parts of the scene — and not necessarily the most important parts. Instead of focusing on a single segment, try to look at the subject as a whole. What are its main characteristics? Think for a minute about the nature of snow itself. It's made up of tiny ice crystals, each working like a little mirror. A large area of snow is a reflective surface. The snow facing the sun reflects warm sun color. Snow facing away from the sun reflects the cool color of the rest of the sky. The relationship of warm to cool color is a basic part of the scene.

As you look over the panorama, you'll also notice the effect of atmospheric perspective. Distant mountains will be lighter in value than foreground mountains and trees. The interrelation of values is another fundamental part of the scene.

Your sketch will be based on these two primary relationships: (1) warm and cool color and (2) light and dark values. Turn your attention to those relationships first. Don't worry about mountains and trees till you've solved the more basic problems.

Your color pool should be directly related to your analysis of the scene. The basic pool is a mixture of the two complements, both put on *in volume* so you'll have plenty of paint to work with. To one side, start a second pool of white. As the two pools are worked into each other, edge-to-edge, you create a simple value range — such as the one illustrated in Figure 7. The white lightens the color and makes it easier to see. Is the mix dominated by the burnt sienna or the ultramarine blue? If you've used equal portions of each complement, the burnt sienna will dominate; it has more tinting strength than ultramarine blue.

It's usually best to start a pool with the weaker color. Begin with the blue and add a touch of burnt sienna; you can increase the amount after the white lightens the color and gives you a chance to see how the mix is going. Add more burnt sienna or blue, depending on whether you feel the scene calls for a warmer or cooler color. Try to keep the dark central part of the pool uncontaminated by white. It will form a reservoir, ready to use whenever you need a strong accent.

DEVELOPMENT. Start the sketch by establishing your basic light and dark pattern. You can always adjust the values as you go along. Try to make this pattern simple, yet interesting. The important thing to notice about Figure 15, for example, is that the darks and lights are interconnected; one value leads to another. Nothing is isolated. Remember that whenever you isolate an element in a picture, the viewer's eye goes right to it. Sometimes you may want that to happen. But usually you're more interested in moving the eye through the entire composition.

As you place the masses, consider whether they're warm or cool. In Plate 17, for example, the areas of snow facing the sun have a touch of burnt sienna in the white for warmth. But just a touch. Burnt sienna is a strong color and works best when used in small quantities. Make the snow too warm and you lose your effect — the snow begins to look like the ground. In the shadows, of course, the ultramarine blue dominates the mix. If you learn to see and understand this basic relation of warm and cool color in sunlight and shadow, you'll find that it applies to a variety of different situations. The relation is obvious when we look at snow on a hillside in winter. But, as you'll see, it's present in spring, summer, and fall scenes, too.

Notice also that the masses in Figure 15 form lines of direction — paths that the eye follows through the sketch. In this case, the composition is made up mainly of diagonal lines (the sloping hills) and vertical lines (the upright tree masses). If the sketch were all horizontals, or all verticals, or all diagonals, it would be monotonous. The eye would have only one thing to look at. You'd have a picture that was full of weak, parallel lines. Parallel lines don't support one another — and, as a result, they never give the viewer a sense of strength or solidity. By interweaving

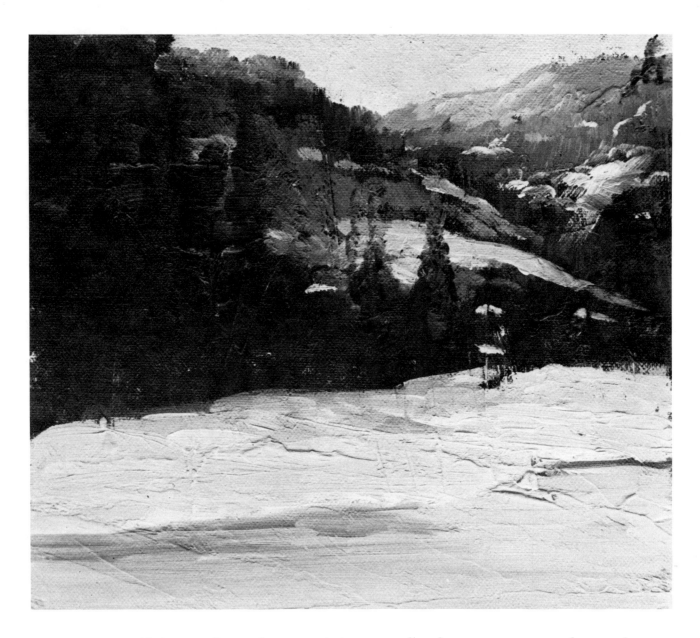

Figure 15. When you block in the design, try to interconnect your lights and darks. The eye then moves from one to the other and the elements of the picture function as a unit.

lines and counterpointing one to the other, you create strength — exactly as you would by weaving strands of material into a piece of cloth.

Figure 16 is a simple example of this point. The trees form the vertical lines of direction; the mountains and areas of snow, the horizontal lines of direction. Do you see how I've cut one into the other, tying them together? By themselves, the trees would be a boring group of parallel lines. But by creating variety, you create visual interest.

After the basic pattern has been blocked in, you have to determine your darkest dark. It's usually in the foreground. In Figure 16, for example, the nearby trees are dark; the distant mountain, affected by atmospheric perspective, is much lighter. The nearer things are to you, the less atmospheric perspective affects them.

Remember that this darkest dark won't necessarily be the same as the darkest dark on the value scale. Everything depends upon the nature of the day. It may be a quarter tone, or a half tone, or a number of other possible values. But once you've decided what it is, you should use that darkest dark as a standard for judging all the other lights and darks in the picture. Value is a relative matter. A distant mountain may look dark when it's compared to the light sky above it. But it's not dark at all when compared to a mountain a mile or so nearer to you. And even that mountain won't be very dark compared to a bush or shadow in the immediate foreground. So learn to make constant comparisons.

You may say that you can't carry a value scale around in your head, so how can

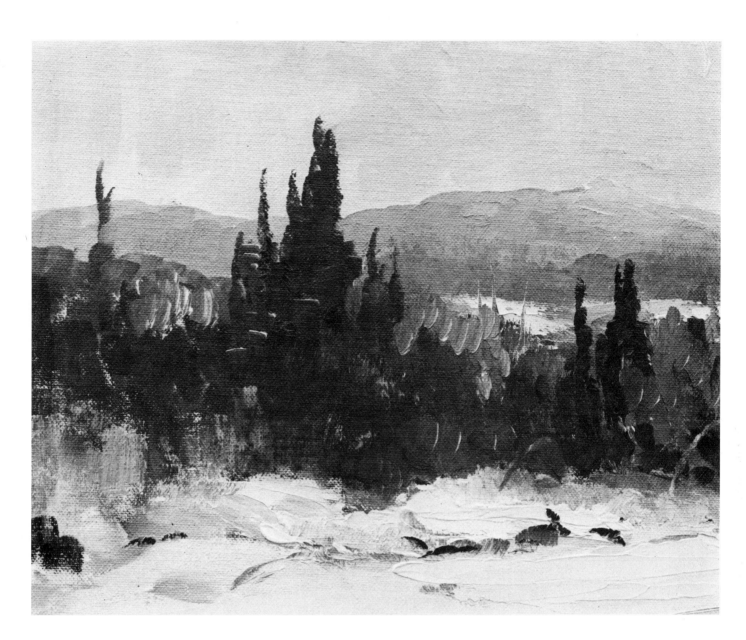

Figure 16. By interweaving horizontal, vertical, and diagonal elements, you unify the sketch and give it a feeling of strength.

you judge your darks? If you think for a second, you'll remember that you've created a value scale on your palette. The ultramarine blue and burnt sienna, without white added, form a very dark dark. Compare the objects before you to one another. Then compare them to the light and dark color that you have on your palette. Once you've established the value range or key of the sketch *on your palette,* it's a little easier to transfer it to the canvas.

CRITIQUE. Although I've talked a lot about organizing the masses in your sketch, I should point out that you can overdo it! Take another look at Plate 17 and tell me if there's anything that bothers you about it. To my eye, it's *too* composed. I was so interested in getting a pattern that the result looks mathematical. The solution to such overcomposing is to break some of the lines of direction with patches of snow. By breaking these lead lines, you make the movement more subtle and thus more interesting to the eye. These snow patches aren't added to make the scene look more like winter!

Think of snow as a value first, as an element in a design. Think of it as snow—as the white stuff that fills your backyard—and you'll end up trying to paint a "picture of snow." As soon as you start to do that, you'll forget all about composition, values, and the interaction of warm and cool color. Those fundamental considerations should come before any effort to "copy" what's in front of you.

PROBLEM TWO

1 WHITE
2 ALIZARIN CRIMSON AND
VIRIDIAN GREEN

INCIDENT IN NATURE. In the first problem, we discussed simple light and dark patterns. We then got our effect by adjusting the values and the warmth and coolness of the color. Now let's look more closely at value relationships. We'll study a site shortly after the passing of a storm. Snow is still in the air, and the effect of atmospheric perspective is exaggerated. The lights and darks are fairly close together. This subtlety of value gives the day its mystery. You don't see mountains and rivers on a day like this; instead, you *feel* a sense of loneliness and solitude.

PALETTE. We can continue our experimentation with the restricted palette by using a different set of complements: *alizarin crimson* and *viridian green*. White lightens the color.

COLOR POOL. Start the pool with the mixture of viridian and alizarin. The result is a dark value, much like the one we got when we mixed ultramarine blue and burnt sienna. Do you need such a strong dark in your picture? In Problem One, the sun was weak but it cast shadows and created a contrast of light and dark. Now the contrast is much less. Comparing Plates 17 and 18, for example, you'll see that the first covers a much wider value range. Pick out the darkest dark in the second. Of course, neither day is necessarily "better" to paint on. Gray days, overcast days, and sunny days are *all* interesting; each has its own particular quality. Part of the fun of painting is trying to see what makes each day different from all others.

Adding white to the pool creates a value range, and the process of comparing value to value begins again. Remember: compare — and keep comparing! Many students put color on the canvas — and then become so anxious to make that color spot into a "tree" that they forget all about value. They may end up with a wonderfully drawn tree. But it's too dark or too light — it's out of key with the rest of the picture and disrupts the whole design. They prove they can draw — but it hasn't done them any good. It's more important to get a correct value than a correct drawing.

DEVELOPMENT. Before putting paint on canvas, ask yourself a question: What characterizes the day? Is it misty? Is it wet? Is it snowy? The first thing you'll notice is the heaviness of the atmosphere. To suggest such a day, you have to get the feeling of form melting into form. So you'll have to pay special attention to your edges and make sure they're soft.

Always begin by thinking of your big masses. On a misty day, you have just a few bands of color, all closely related. Figure 17 shows this effect. The foreground ele-

Figure 17. In the foreground, contrasting values create hard edges. In the distance, close values create softer edges.

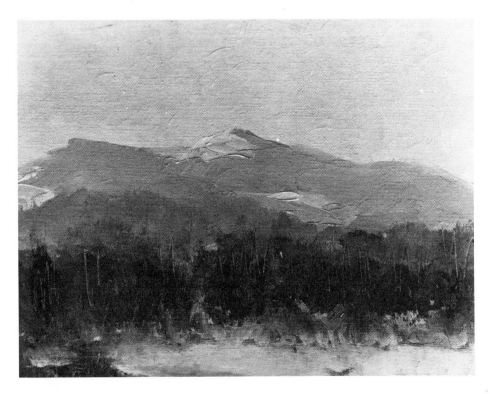

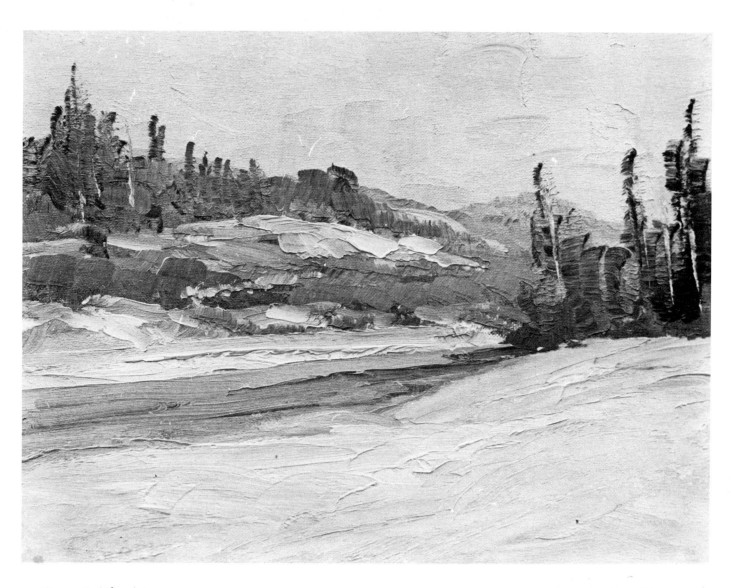

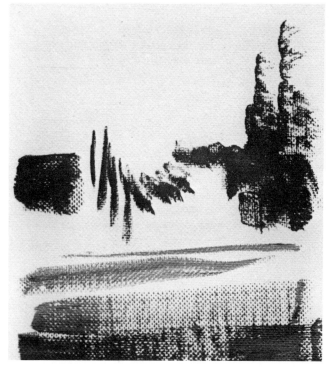

Figure 18. *(Above) A brushstroke becomes "descriptive" when it is related to its subject. Horizontal strokes indicate the land masses; diagonal and vertical strokes suggest hills and natural growth.*

Figure 19. *(Left) This simple diagram summarizes some of the descriptive strokes used in Figure 18.*

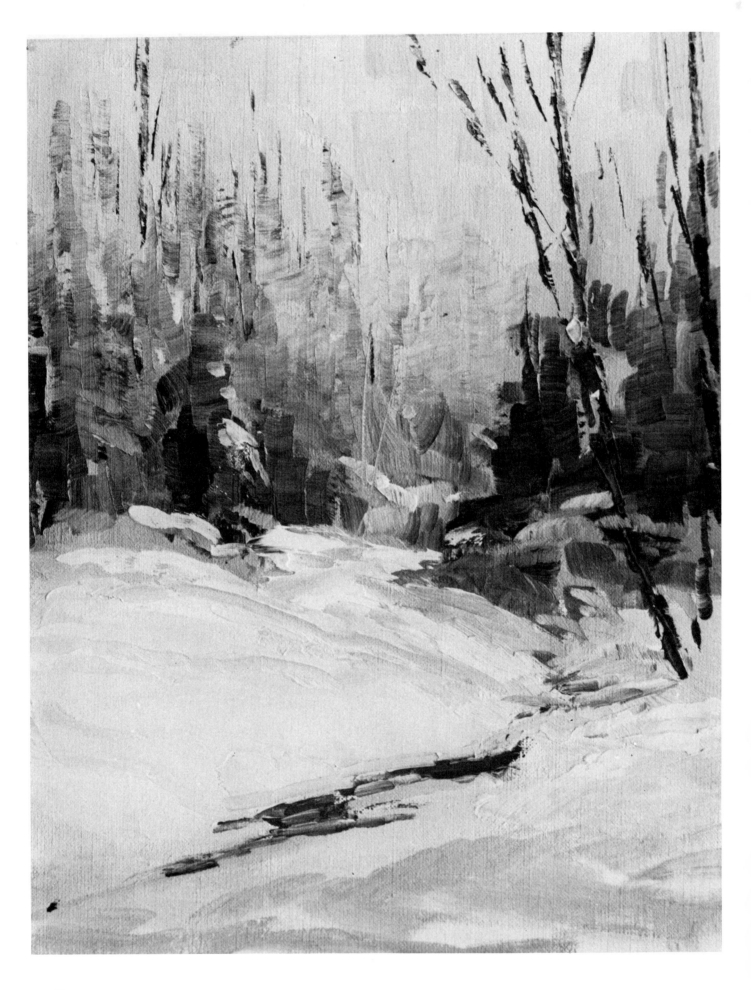

ments are dark; the distance is much lighter in value. The close values in the distance soften the edge where sky and land meet. Since there's no strong contrast, the area doesn't jump out at you.

As you develop the masses, let your brushstrokes tell part of the story. Figure 18 was done at the same spot as Plate 18, but on a clearer day.

Figure 19 summarizes some of the strokes that I used in the sketch. In the foreground, large horizontal strokes suggest that the area is close to you; the strokes get smaller as they go into the distance. In addition, the direction of the stroke suggests the shape of the land. The trees to the right are simple vertical masses made of short horizontal strokes. In the distance, horizontal, diagonal, and vertical strokes suggest hills, trees, and shrubs. A horizontal slash of white, for example, tells you that there's a clearing on the side of the hill. You subconsciously connect the stroke with what you know about nature.

CRITIQUE. Remember that gray days are studies in edges, masses, and values. If you go wrong, it's bound to be in your handling of one of these three elements. If you're after a peaceful mood, keep your masses large and simple—don't break them up. You want to get a sense of mystery in the scene and should sacrifice everything to that. Don't feel as if you have to show the world how well you can draw. Figure 20 is a quick, five-minute sketch of a misty forest interior. There's hardly any "drawing" in it. Look at the simplicity of the tree on the right! It's just a few lines, but you know it's a tree. I didn't spend a lot of time on it, because I wasn't interested in it. I was more concerned with the mood of the day. Your ability to draw doesn't mean much if you don't communicate a feeling to the viewer.

Figure 20. You'd be surprised at how little drawing is needed to create a mood. In this sketch, what counts is the subtle value relationships.

PROBLEM THREE

1 CERULEAN BLUE AND
VIRIDIAN GREEN
2 WHITE
3 ULTRAMARINE BLUE AND
BURNT SIENNA
4 RAW SIENNA
5 CADMIUM YELLOW MEDIUM AND
CADMIUM RED MEDIUM

INCIDENT IN NATURE. Let's leave mountains and hills for a minute and explore a more confined area—a clump of trees and a stream. Such sites are interesting; they let us work with a set of contrasts. There's the "busy," complicated texture of the tangled mass of trees, shrubs, and brambles that you find in a forest. And there's the more open, quiet area of the bank and the meandering stream. Each area accents and relieves the other. When the eye tires of the busy background, it can rest in the foreground. And when it's had its fill of the foreground, it can seek variety in the background.

PALETTE. Now that we've experimented a bit with the complements, we can begin to expand our palette. Let's start with *cadmium red light* and *cadmium yellow light,* two brilliant tones that, when mixed with white, are useful in creating strong sunlight effects. There are two blues: *ultramarine* and *cerulean.* The latter blue is a snappy color; the eye picks it up and follows it through the design. Touches of it can give a sketch added life and vitality. *Raw sienna* works with the cerulean blue to create the rich greens of winter. *Viridian* is a green that also works well with raw sienna. *Burnt sienna,* of course, mixes with ultramarine blue and serves as the base for all our neutral tones.

COLOR POOL. The pool starts with ultramarine blue and burnt sienna. White is added to create a value range. Cerulean and viridian are added to one side of the pool, while the cadmiums are added to another. Where the blues and yellows meet, you get a series of greens. The cadmium red and the burnt sienna mute these greens, as does the addition of raw sienna. This is important. Winter greens are subdued, and you wouldn't want to paint a winter scene with trees as green as those in the middle of summer. The eye would sense that something was wrong.

DEVELOPMENT. State the big masses first, using greens from the pool to block in the background pines. Don't let these colors mix too thoroughly—the result will be a flat, uninteresting tone. To keep the color from overmixing, try putting it on with a palette knife. Use a diagonal stroke and you'll find that the paint works for you; the paint strands imitate the way evergreen needles grow. Then you can suggest tree trunks by pulling a few vertical lines over this mass; your eye immediately senses that it's looking at a forest. In Figure 21, a complicated background has been suggested by just such simple means. Diagonal and vertical strokes tell the story.

When developing the foreground area of snow, work from the cool side of the pool. But remember that you don't want pure blue in the shadows. If the color in the shadows is too bright the viewer would then see the color first—and only later

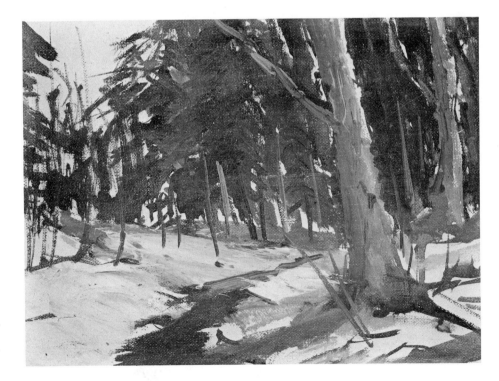

Figure 21. Although the background of this sketch looks complicated, it was created by the interaction of a few simple vertical and diagonal strokes.

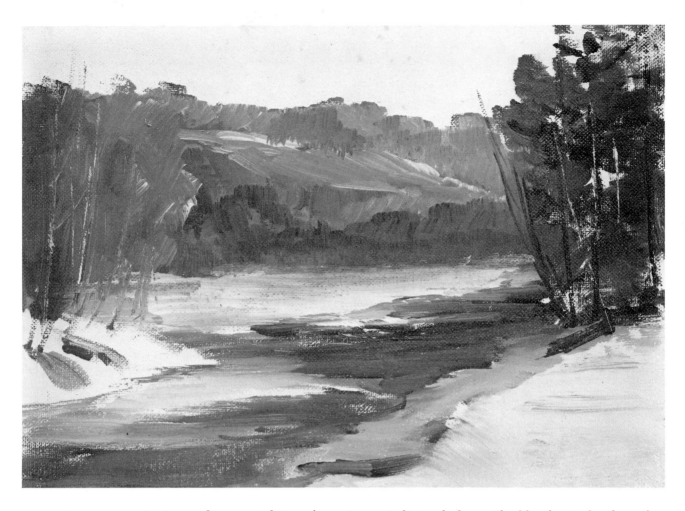

Figure 22. Spontaneous brushwork gives the foreground stream a character that it wouldn't have if I'd planned everything in advance.

figure out that you're trying to indicate shadows. The blue has to be there, but muted, so that the viewer sees the effect first and the color second.

The color pool provides you with just this sort of tempered color. It's usually easier to put in the shadow mass first and then, as in Plate 19, cut a few bright spots into it. The cadmium colors, mixed with white, create these brilliant highlights. White paint by itself is never enough to suggest sunlight; it has a pasty look. Besides, snow is hardly ever white. It picks up all kinds of reflections and can be a hundred different colors.

In Plate 19, I experimented: the foreground was done with the brush and the background with the palette knife. I felt that if both areas were developed with the knife, they'd be too similar, and thus the perspective would be confusing to the eye. As it is, quick palette-knife strokes suggest the busy background — while the brush smooths out the foreground mass and makes it simpler and more restful. The water is then stroked in, taking full advantage of the accidental interaction of color. The result is the kind of color relationships that you'd never get if you *tried*.

In Figure 22, a large stream has been developed in this way. Notice the light and dark areas of the water. Sometimes they blend into one another — while at other times they're starkly contrasted. This not only suggests a natural fact — there are areas in the stream of solid and melting ice — but it also creates an interesting variety of edges for your eye to look at and enjoy.

CRITIQUE. In a picture of this sort, the hardest problem is making one area subordinate to the other. If you don't do that, your eye will jump back and forth between forest and stream, unsure of which area you mean to emphasize. In Plate 19, the stream is supposed to be the main area of interest. It has the most pleasing colors and is surrounded by the darkest accents and the brightest highlights. Your eye naturally goes to it. In Figure 21, on the other hand, the forest is the main area of interest. The stream is merely a way into the picture; it's not the reason for the composition. Decide which you like best, and then work to make that preference clear to the viewer.

PROBLEM FOUR

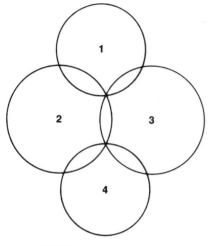

1 CADMIUM YELLOW MEDIUM
2 ULTRAMARINE BLUE
3 WHITE
4 CADMIUM RED LIGHT

INCIDENT IN NATURE. Now let's find a simple spot. Perhaps a stream—partly iced over—with a bank in the background, some snow, and a few trees. We'll be concentrating on the middle distance, so don't worry too much about the sky or the foreground.

PALETTE. Instead of starting with the complements, let's work with three pigment versions of the primaries: *cadmium red light, ultramarine blue,* and *cadmium yellow medium.* We can use these primaries to mix the necessary secondaries and complements.

COLOR POOL. Start the pool with ultramarine blue: a cool blue for a cool season. Cadmium red and cadmium yellow can then be added to the edge of this dark pool. The yellow and blue make a green. The red and blue make a muted purple. And since the red and yellow are opposite one another, the red can easily be pulled into the green to temper it—just as the yellow can easily be pulled into the purple. The nearness of the red and green will be of particular importance in a picture of this sort; again, muted greens match the winter mood. After the red, yellow, and blue have begun to interact, you can add white to draw the color out and to create a range of values.

DEVELOPMENT. What kind of feeling does the spot have? Ice, water, trees: the sensation is probably one of quiet and peacefulness. It's a feeling that's typical of winter—a dormant season, the pause before the growing activity of spring. The natural design of the site will also have a lot to do with the mood. Are there lots of horizontal and vertical lines present? Such lines inevitably create a feeling of peacefulness and solidity—just as diagonal lines suggest activity and restlessness.

Figure 23 is a sketch of a site that's mainly composed of horizontal and vertical masses. The only strong diagonal is the line of the background slope. Looking at a line like that, you should immediately ask yourself: Is it too strong for the desired mood? Is it too dynamic? Does it disrupt the sketch? More often than not, it isn't faulty drawing that ruins a sketch, but errors in the use of line and mass. In Figure 23, I kept the eye from sliding down the slope and right out of the picture by breaking the line with a series of vertical elements. Tree trunks were handy, so I used them. When you use trees in this way, don't think of them as trees! Instead, think of them as vertical accents, and decide what these accents can do for the general movement of your composition.

As you place these elements, consider the relationship of each vertical line to the others. The trees you're viewing may be equally spaced and all of the same thickness. But that doesn't mean you have to paint them like that. Figure 24, for example, shows a group of trees along a stream. Notice that the thickness of their trunks varies. A bunch of thick, equally spaced trees looks like a picket fence; they're distracting. Vary the spaces between them for variety and interest.

The site we're exploring is a very simple one. There aren't many diagonal lead lines to move your eye through the picture. Instead, you can direct the eye by the way you place your values. In Figures 23 and 24, for example, the brightest areas are at the top of the sketch; the foreground is largely dark or in shadow. Your eye thus moves directly to the lighter values, and you investigate the prominently silhouetted groups of trees.

In Plate 20, I was less interested in the pattern of the trees (though that's important) and more in the bank and the foreground water. So that's where I kept the light values. At the actual site, the shadows won't always fall the way you want them to. Some highlights might appear at the edge of the canvas. Should you put them in? Think for a minute; use compositional logic. Do you want the viewer to spend time looking at bright spots near the frame? Or do you want him to get into the middle of the piece, where most of the *interest* is? You have to take control of the site, changing it so that it makes sense as a composition.

CRITIQUE. A constant problem to the painter is the question: What should I do with my foreground? If the background is active—as in the sketches here—don't feel that the foreground also has to be interesting. In Problem Three, you learned that the eye needs a resting place. So keep the foreground simple and avoid the temptation to say too much. Just paint what's necessary for your statement and let the rest go.

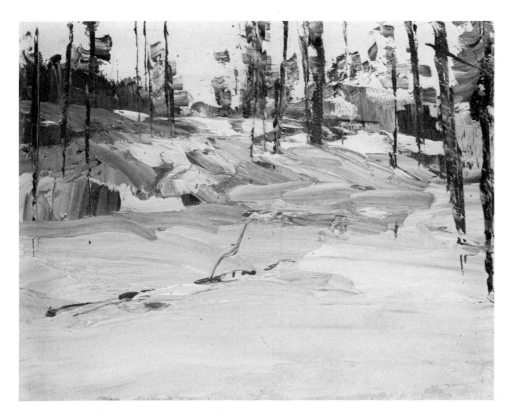

Figure 23. This sketch is made up of restful, horizontal lines. The diagonal slope of the bank is controlled by carefully placed vertical accents.

Figure 24. Interest is added to this quick sketch by varying the thickness of the vertical elements.

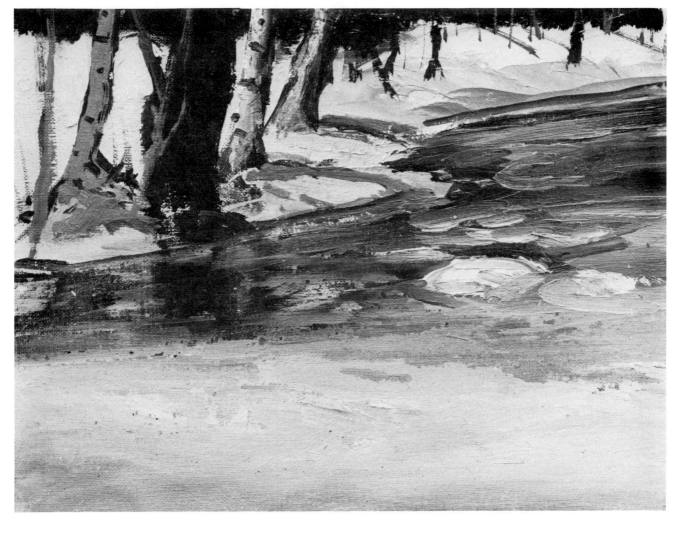

PROBLEM FIVE

1 CADMIUM RED MEDIUM AND CADMIUM YELLOW MEDIUM
2 ULTRAMARINE BLUE VIRIDIAN GREEN AND CERULEAN BLUE
3 WHITE

INCIDENT IN NATURE. So far, we've been primarily concerned with the overall mood of a picture: softness, quiet, solitude. Now let's look for a strong light effect. Go out early in the morning or late in the afternoon. The sun is low in the sky, and your lights and darks are exaggerated. Strong effects are the result of contrast; a strongly lit mass, for example, near a deeply shadowed one.

PALETTE. *Cadmium red medium* and *cadmium yellow medium* are selected for the pool. They're darker than the cadmium light colors and have greater depth— yet they're still bright enough to create strong sunlight effects when mixed with white. *Cerulean blue* is a clear, brilliant blue — good, when tempered, for snow shadows on a bright, sunny day. *Ultramarine blue* is darker than cerulean and mixes well with the red and yellow to form good purples and greens. *Viridian green* is a cool green whose temperature matches the season.

COLOR POOL. The main interest in this picture is the effect created by a sunlit mass and a shadow mass. The contrast is one of warm against cool, but more strongly stated than in any of the previous problems. The pool reflects our strategy. Begin it with two side-by-side mixes. One mix contains most of the light, warm color: the red and yellow. The other, cool mix contains the two blues and the green. Both areas are, of course, only partially mixed. At first, the light one is much too light and the dark area much too dark for the picture. But as you work them into one another, they slowly create the right value relationships. Of course, a part of each pool is kept pure so there's always brilliant color ready when needed.

DEVELOPMENT. What's your main interest in this picture? An *effect.* So begin to paint by going for that effect. This sounds obvious, but you'd be surprised at the number of students who know what they want to paint—and paint everything but the subject! They get bogged down in an effort to make some unimportant part of the sketch "correct." When they finally get to the subject, the effect is no longer there; the sun has moved and the character of the site changed.

In Figure 25, for example, I might easily have spent a lot of time drawing every tree. But I wasn't interested in the trees as individual parts of the composition. I was struck by the contrast of the dark tree mass against the sunlit snow. The shape of the trees as a whole was my main concern. So I went directly for that shape and didn't worry about anything else. Similarly, the key to Plate 21 is the contrast of the light, warm atmosphere and the dark, cool tree mass. Details were added only after I blocked in that fundamental relationship.

When you *do* begin to think about details, add only those that enhance the main effect. If you want to pull the eye into the background, don't lovingly draw tufts of grass and lumps of snow in the foreground. They'll distract the eye. In Figure 26,

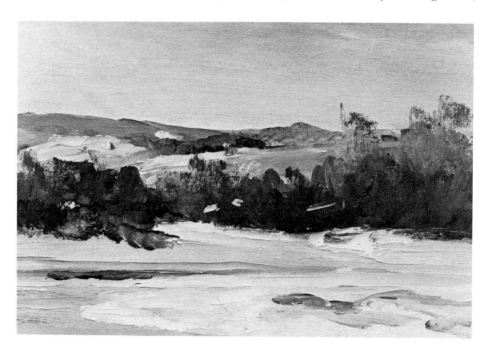

Figure 25. When you're interested in a particular effect, paint the effect first. In this sketch, I went for the big shapes, without worrying about the details of every tree.

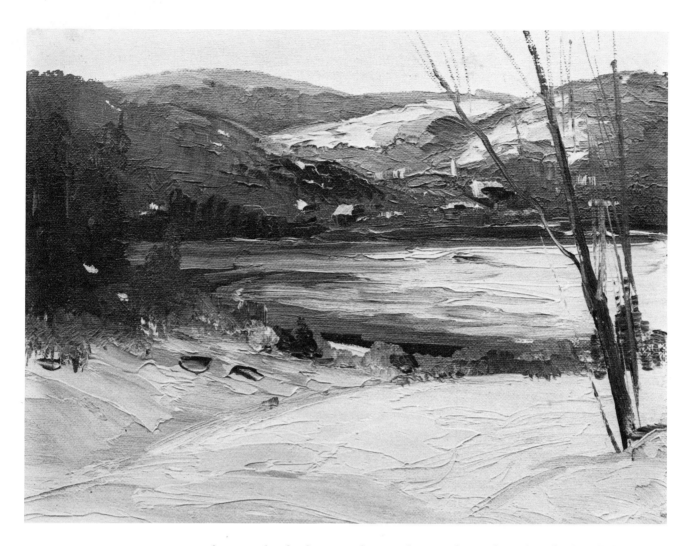

Figure 26. A few suggestions of houses in the distance are enough to make the viewer think he sees an entire town. He can use his imagination.

for example, the foreground is simply swiped in with a palette knife. All the interest is kept around the main areas of light/dark contrast in the background.

By "activity," I don't necessarily mean a collection of hard facts. You don't have to paint carefully drawn houses—houses with windows in them and candles in the windows—to know that they're houses. These details don't add anything to your theme—which is how light strikes certain objects. The background in Figure 26 is just a collection of vertical, horizontal, and diagonal strokes, developed in a more or less abstract way. But a pattern like that is interesting. And as you look at it, you can imagine a town. I used the same approach in the background of Plate 21. At a distance of four miles, you don't see individual houses. You see masses and dots. Paint what you actually see, not what you *think* you see.

CRITIQUE. As you develop your masses, there's always a danger that the contrast will be too strong, and the sketch will break into warm and cool halves. Use color to hold the picture together. In Plate 21, for example, some of the warmth of the mountain appears in the dark tree mass. And some of the coolness of that tree mass is introduced into the mountain. The sky is cool—so as to accent the mountain's warmth—but some of the mountain's color appears in the upper left-hand side of the sky. That bit of warmth tells you where the sun is. It also creates a relation between mountain and sky, binding the two together. That unites the upper part of the picture. To keep the foreground from being isolated, you should immediately give it a similar touch of warm color. In Plate 21, the warmth appears in the areas of sunlit snow. When you're sketching, put down these color notes as a reminder to yourself. Get into the habit of distributing your color while it's still on your brush. It's easy to put it off; you may be attracted to some area that needs work. But if you don't do a thing when your "inner voice" tells you to, you'll forget it and never do it. It's like planning to move an old rollerskate. You keep putting it off—and finally end up tripping over it!

PROBLEM SIX

1 WHITE
2 CADMIUM RED LIGHT AND
ULTRAMARINE BLUE
3 CADMIUM YELLOW MEDIUM

INCIDENT IN NATURE. Let's turn our attention to the part in a painting played by the viewer's imagination. Usually, all you hear about is the imagination of the artist; but if you can engage the viewer's imagination, you've made your pictures much more interesting for him. This time, let's put in the minimum amount of information, and let the viewer do the maximum amount of work. We'll paint a day in the city, toward the end of the winter. The air is misty. There's been a cold rain and the streets and walks of the park are covered with a mixture of ice and water.

PALETTE. Since the sketch will be very simple, we can use a restricted palette: *cadmium red light, cadmium yellow medium,* and *ultramarine blue.* The cadmium red light mixes with the blue to form a grayish purple—not the vibrant purple that you get when you mix ultramarine blue with cadmium red medium or deep. You wouldn't want that kind of bright purple in a gray-day picture.

COLOR POOL. The pool is also very simple. Three pigment versions of the primaries interact, creating a variety of muted analogous and complementary tones. Red and blue are mixed to form a dark color. White is added to create a value range —and to help us see if the mix is warm or cool. Yellow is added to a corner to form a green—and that green, in turn, is muted with red. That's just what we want: a series of muted tones.

DEVELOPMENT. You can mute your color and assure soft edges by painting value into value, wet-into-wet. For example, as you develop your design, try painting the sky first. Bring it far down the canvas. Then paint the darker value of the city skyline *into* the wet sky. The two layers of paint interact; the lighter value lightens the darker one—and also blurs the sharpness of the stroke. Figure 27 is a simple example of this method. It's a view looking down a wet Boston street. A fairly light mass of buildings was worked into an even lighter sky. As a result, the value relationships are very subtle.

In Plate 22, I used the same procedure. The buildings were painted into the sky. And then the area of dark trees was painted into the mass of buildings. Much of the effect depends on how you handle your brush. A light stroke, barely disturbing the undercoat, will leave an edge. If you bear down on the stroke, however, it will pick up more of the wet underpainting and lose its sharpness.

Even in a simple design, you must have variety. In Figure 28, for example, I tried to make use of the characteristics of my subject. The foreground park, with its curving natural forms, is contrasted to the sharp, square mass of the distant buildings. Plate 22 is built on a similar relationship; it has angular buildings and rounded tree forms.

All that's needed to give the sketch interest is a few figures. Since the figures are subordinate elements, you don't need to spend a lot of time on them. In Figure 29, for example, a few upright lines are enough to suggest people out on a stroll. In Plate 22, a figure is made up of a vertical stroke for the body, a horizontal stroke for the umbrella, and a quick vertical stroke for a reflection. Given such small amounts of information, the eye creates a city, a park, people walking in the rain, a pond, and reflections. Even the coldness of the air is communicated by keeping the colors on the cool side.

CRITIQUE. I hope these sample sketches show how unimportant literal facts are in communicating a mood or feeling. At the site of Plate 22, there was a park bench in the foreground. It would have been a challenge to draw. And many students would put it in, just because it's there. But what would it have added to the design? It would have been a big, dark shape, a shape so strong that the viewer wouldn't have been able to see anything else. Was my subject the bench? Or was it the mood of a gray, rainy day?

*Figure 27. (Right) By working
directly into a wet underpaint-
ing, you can control your values
and the hardness and softness
of your edges.*

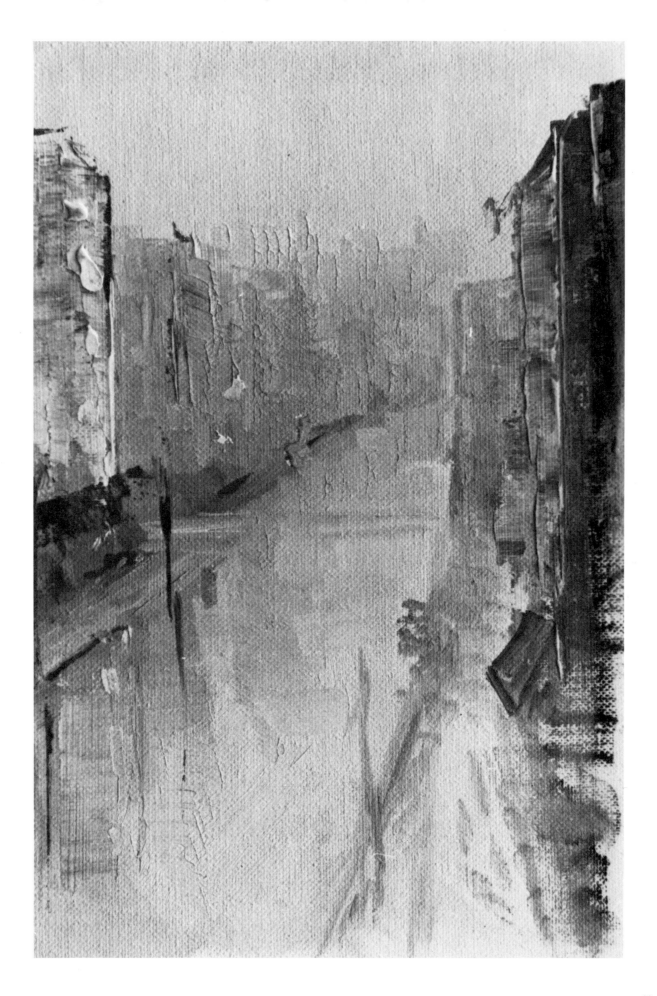

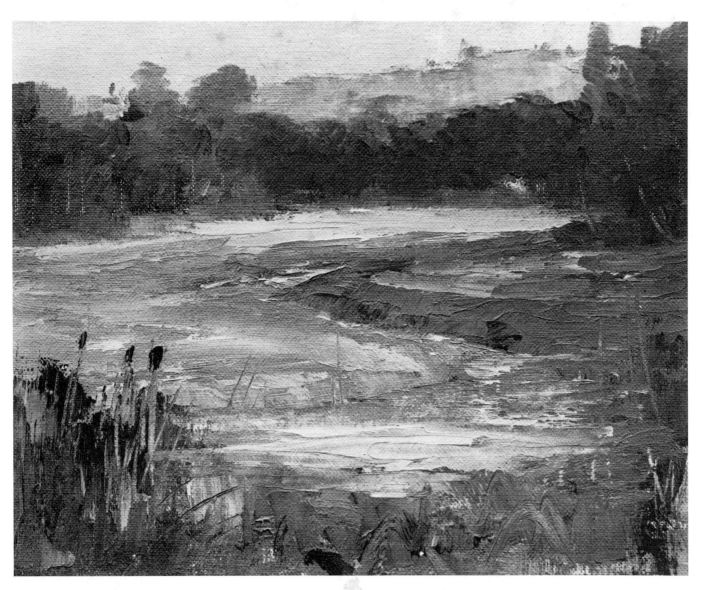

Figure 28. *In this sketch, the rounded and curved shapes of nature—the trees and stream—are contrasted to the angular shapes of the city skyline.*

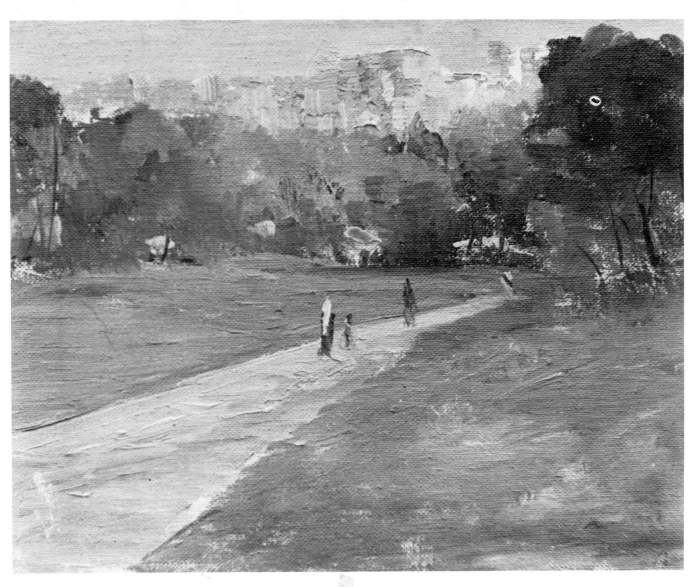

Figure 29. A few simple strokes suggest strolling figures.

PROBLEM SEVEN

1 CADMIUM RED DEEP AND
 CADMIUM YELLOW MEDIUM
2 WHITE
3 ULTRAMARINE BLUE AND
 BURNT UMBER
4 CERULEAN BLUE AND
 VIRIDIAN GREEN

INCIDENT IN NATURE. Let's carry the approach of Problem Six a step further by looking at a city shopping plaza—one of those places where the pushcarts congregate. The rain has stopped and the ground is wet. There's mist in the air and it's cold; but shoppers are still out looking for bargains.

PALETTE. We'll expand and modify slightly the palette used in Problem Five. *Cadmium red deep* replaces *cadmium red medium* because it makes a stronger purple when mixed with *ultramarine blue.* We can use a more vivid purple now that the rain no longer hangs in the air, veiling the colors of the scene. Because it's a busy, colorful scene, we can also add *cadmium yellow medium, cerulean blue, viridian green,* and *burnt umber* to the palette. The burnt umber mixes with the two blues to give added variety to the darks.

COLOR POOL. The pool is started with ultramarine blue and umber; white is added to make a value range. Separate areas of warm color (reds and yellows) and cool color (cerulean blue and viridian green) are cut into the side of the value range. The neutral tone of the main pool tempers all the color cut into it, thus creating the muted tones suitable for a misty day.

DEVELOPMENT. Think about the subject for a minute. It's a wet street, with pushcarts and people, buyers and sellers. What impresses you most about it? Are you struck by the masses and shapes, or by the interaction of warm and cool color, or by the shifts in value? All these are important; but if you think about the nature of the subject, you'll probably decide that you're most impressed by the dots, spots, and splashes of light and dark that suggest people and reflections. The subject is a busy one, quite different from the scene in Problem Six. There the key to the work was simplicity. Now we'll apply the paint in a more hectic, nervous manner.

You can start the sketch by again working wet color into wet color. First block in the mass of the sky and the buildings. As you paint, think about how you're going to use your color. As an example, consider the windows in the buildings. They're glass and will reflect cool color from the sky. You can suggest them by pulling a few swipes of cool color over the building mass. What color should you use to block in that mass? If you use a cool tone for the building, the cool window color on top of it won't register. It will simply disappear. So block in the buildings with a *warmish* tone. Then when you run cool color over that tone, you're able to see its coolness. The contrast works for you.

This is a very simple example of the need to think ahead as you paint. Don't work

Figure 30. Simple calligraphic strokes, worked into a big mass, give it an added definition.

Figure 31. By taking care in the drawing of one figure, you can make the viewer's eye see less-detailed shapes as figures, too.

from minute to minute. When you apply paint, consider (1) the color that's already on the canvas, (2) the color that you're now putting on the canvas, and (3) the color that you're going to put on the canvas. Plan your effects.

The buildings should be kept simple; they're subordinate elements. But adding a certain amount of detail won't hurt. Figure 30, for example, is a closeup of Plate 23. After the paint dried, a few strokes from a rigger brush (a long, thin, soft-haired brush—usually sable) helped define the shapes. The rigger brush makes brisk lines that are "calligraphic" in character; that is, they're a bit like handwriting, and can be quite quick and personal. They suggest details—without nailing everything down.

Figure 31 shows how the figures were painted in Plate 23. Notice how the lamp posts, bridge, and buildings form an interlocking, geometric grid. All this angularity suggests a city. The figures were then quickly, almost accidentally placed—a few dots and dashes with reflections. Such figures don't tell the viewer much; but they suggest things. I drew one figure—the one in the middle—a little more carefully than the others, and your eye takes the hint and quickly reads all similar splotches as people—no matter how roughly they're done!

CRITIQUE. Don't let the complexity of the city confuse you. Just think in basic design terms. In Plate 23, for example, the perspective of the buildings isn't exact. You could spend all day trying to get it right. But in this sketch, it serves its purpose; the lines of the buildings pull you into the composition. In the lower left-hand corner of the sketch, there's a dark mass. What is it? I don't know! It's there because the area had to be broken up; it had too many parallel lines in it. More important, the shape points your eye toward the center of the painting—and it also conditions it. When you see this dark, your eye becomes aware of darks and so jumps to the dark next to it. It soon explores all the darks in the picture. In a similar way, your eye will pick up a red and trace reds through the piece—then yellows, then greens, and so on, weaving back and forth among the various objects, values, and colors, enjoying itself without worrying too much about the exact nature of what it's looking at. If your eye is having fun in your picture, it will be satisfied. It won't ask for a catalog of every lamp post and street sign.

PROBLEM EIGHT

1 CADMIUM RED LIGHT AND WHITE
2 ULTRAMARINE BLUE AND VIRIDIAN GREEN
3 CADMIUM YELLOW MEDIUM

INCIDENT IN NATURE. In the previous problem, we studied structure—the way the objects fit together—in a city. This time, let's explore structure in nature. A good area to paint is one with a pronounced rock formation, like a ravine or a quarry.

PALETTE. Since we'll be concerned with large, simple rock masses, we won't need an elaborate palette. *Cadmium red light* and *cadmium yellow medium* are the warm colors. *Ultramarine blue* works well with the orangy cadmium red, creating a basis for the grayish rock color. *Viridian green* works with the red to form another variety of gray. It's also useful in painting the cool, greenish color of melting ice.

COLOR POOL. The pool begins with a mixture of red and white—that will be the basic warm underpainting for the rock in sunlight. The other colors are worked into the pool to create analogous and complementary tones. Blue, worked into a corner of the pool, makes a series of partially mixed grays. Yellow is worked into another corner; it mixes with the blues and reds, warming the color and also creating a variety of muted greens.

DEVELOPMENT. Figure 32 is a quick sketch of a quarry. It began with a statement of the basic masses. The sunlit area of rock, for example, was quickly blocked in with a warm tone. The shadow area was then painted with a cooler tone. Finally the water and the dark trees were added, framing the main area of interest.

In Plate 24, the sunny side of the rock was underpainted in the same way. A light, warm red was used. Touches of blue and green were added to mute the color. By itself, the red would have been too strong; you'd have seen the red paint and not a rock. When muting color, however, remember not to overdo it! Touch color into color without mixing it so thoroughly that you kill the sunlight effect.

You can see in Figure 32 that the quarry is marked by an angular rock structure. It's hard rock that chips rather than crumbles. As a result, the picture is really a study in sharp lines and angles. This interaction of line is more interesting to me than the rock itself. Be careful not to become too interested in the structural details. If you try to paint every crack and cranny, and work methodically from part to part, you end up with four or five different pictures on the same canvas. It's better to squint at the scene. You then see the big, characteristic shapes—and can make a broad, easily understandable statement about the nature of your material.

In Figure 32 you can see how the stroke follows the shape of the rock; a few calligraphic lines emphasize the structure. The paint itself does much of the descriptive work. In Figure 33, the stroke does even more. The quarry becomes a simple, horizontal band; and a few diagonal strokes indicate the direction of the rock masses. Your eye interprets these clues and makes sense of the whole. Notice that the area of sunlit rock is kept toward the center of the sketch. Sunlit areas aren't spread all over the canvas. If you learn to paint things *in groups*, rather than individually, your pictures will have a stronger impact. You'll concentrate the viewer's attention.

CRITIQUE. You're bound to go wrong if you don't take a good look at your subject. In order to suggest an object with a few strokes, you have to have a thorough understanding of it. If you're not familiar with rocks, when you start to paint them, you'll paint what you *think* they look like. But when you're more familiar with them, you begin to sense their planes—the parts in light and the parts in shadow. Then you get a sense of their solidity and geometry. You see how granite differs from shale. You look to see if the rock is hard and chips along a ragged edge; if it's brittle and splits in long crevices; or if it's soft and crumbles. In short, you learn to understand the texture of the substance and then paint that texture.

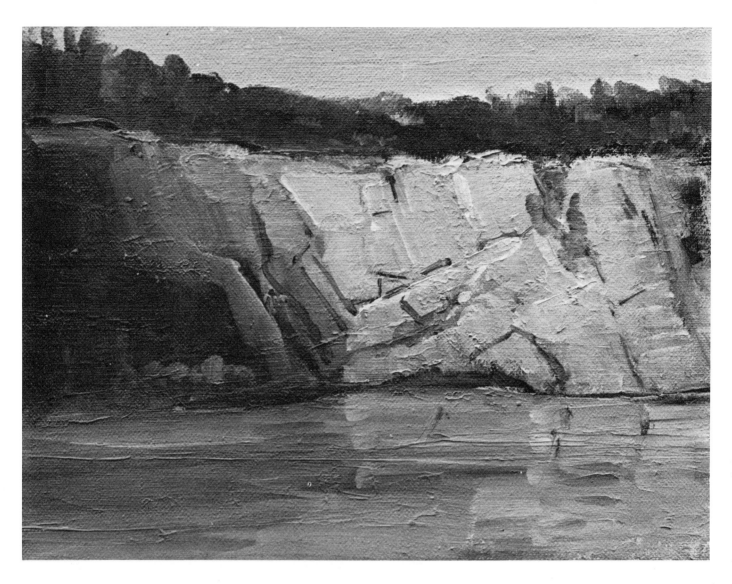

Figure 32. (Above) When painting rocks, let the stroke follow the structure of the material. Let it do some of the work for you.

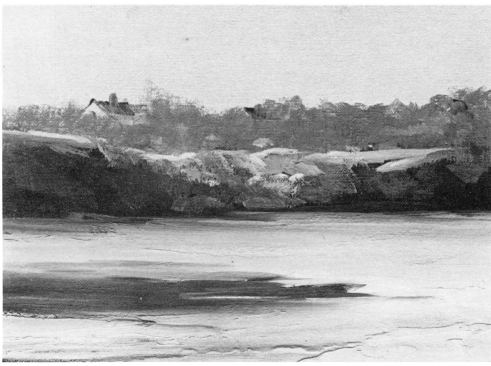

Figure 33. Group your lights and darks so that the attention of the viewer is directed to a few key spots.

Spring

Winter is a stark season. We studied it largely in terms of a few simple values. There was warmth and coolness to the color we used, but the range of color was limited. Design was paramount. Lines of direction, big masses—everything stood out strongly and obviously.

As winter passes and life returns to the land, the amount of strong color in our pictures also increases. The color peaks, of course, in the fall. But spring begins the process. The colors of spring are new and delicate—a collection of gentle, pastel-like shades.

In addition, the blossoms, leaves, and new tufts of grass create a kaleidoscopic effect. In a field, for example, you see dead grass, dying grass, and new sprouting growth. During the winter, the area seemed one large mass; now it sparkles with the different colors. It's broken up—and, as a result, you may find a broken color technique more appropriate than the broader handling that characterized most of the winter. The technique should fit the subject—rather than the subject twisted to fit a technique.

PROBLEM NINE

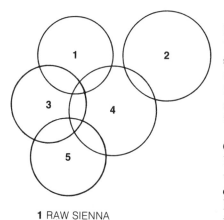

1 RAW SIENNA
2 CADMIUM RED LIGHT AND
 ULTRAMARINE BLUE
3 YELLOW OCHRE
4 WHITE
5 RAW UMBER

INCIDENT IN NATURE. Let's begin our study of spring by visiting a marsh early in the season. Marshes are full of subtle color changes; some of the marsh grass is dead, some dying, and some just beginning to sprout. At first, dead grass predominates. The scene has a sober character. There's a hint of spring—but winter still seems to be in control.

PALETTE. This time of year is characterized by warm, muted, brownish colors. We can use strong earth colors on the palette: *raw sienna, yellow ochre,* and *raw umber.* Raw umber is the basis for a good dark; yellow ochre, when added to white, suggests the warm color of sunlight. Raw sienna is a deeper tone of yellow ochre. Since we don't want to paint a picture with earth colors alone, *cadmium red light* is added, along with *ultramarine blue.* The blue mixes with the yellow ochre to create tempered greens. The blue and red form a dark, grayish purple.

COLOR POOL. The pool starts with the cadmium red light and the ultramarine blue, mixed fairly thoroughly. Cutting white into the side of this dark pool creates a value range. By adding yellow ochre to one side of the range and raw sienna to the other, you can create a variety of warm, earthy tones, the restrained coloring of land and trees in early spring. Since one color is pulled into another, there's an interesting, "accidental" quality to the mixes—and that's important. Partially mixed color suggests the different kinds of growth—without your having to draw every blade of grass. Raw umber cut into the side of the pool makes a deep dark and further helps to suggest dead grass.

DEVELOPMENT. As in the previous problems, begin by massing in the main land and sky areas. The marsh grass has a certain uniformity of tone within it, despite the different kinds of grasses. As you mass them in, however, notice the difference between the colors near you and those far away. In the distance, atmospheric perspective affects the warm grass color. The slight veil of blue atmosphere makes the area look cooler—a grayish green. In the foreground, the grass retains its strong, warm character.

The warm color in the foreground makes that area seem near. The blue in the distance makes that area recede. In Plate 25, for example, if the grass were all a uniform yellow-brown, the scene would look flat; your eye would be conscious of the surface of the canvas and wouldn't penetrate into the sketch. Also notice in Plate 25 that there's a lot of warm red in the dark mass of the foreground bank. The red pulls the area forward and distinguishes it from the dark mass of trees in the distance. Those distant darks have hardly any red in them. They're cooler and so stay in the background.

Remember that the brushstroke can play an important part in your sketches. In Figure 34, for example, the foreground is thickly painted. You can see the texture, and so the land appears close by. The stroke becomes smaller and less obtrusive as your eye moves into the distance; and on the far mountain, there's no discernible stroke at all. In Figure 35, the same method is at work: horizontal, bulging strokes suggest the lay of the land. Diagonal strokes suggest the angle of the bank. Long, simple strokes suggest the far distance.

As you look at Figures 34 and 35, pay particular attention to the way the sketches are broken into horizontal areas of color. Since the designs are very simple in concept—they don't have any single, big form to attract and hold the eye—you have to *make* the designs interesting. Notice, for example, that in both sketches the light and dark bands are of different widths and values. The spaces between the bands vary, as do their shapes. Part of a band may have a sharp, hard edge, while another part is blended into the background or broken by suggestions of trees or grass. Dark areas break up a light area and light areas break up a dark one.

This last point is of particular interest. In Figure 34, for example, a few light daubs suggest houses and distant trees. Your eye now has a focal point, a place to rest in its journey back and forth over the horizontal masses. Figure 35 uses a similar group of highlights: the distant water is bright and a few dots suggest distant houses, barns, a sailboat—or whatever the viewer's imagination wants to see. The dots don't describe anything in particular. They serve as a relief from the dominant horizontal nature of the design.

In Plate 25, the same idea is at work. A few bright touches of yellow ochre and white suggest light falling on a house and on the distant field. Cover these two

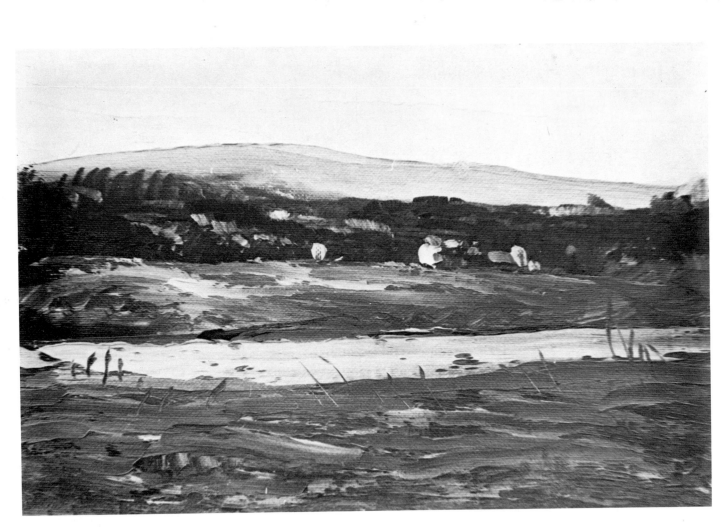

Figure 34. *Bands of different size, value, and shape add interest to a very simple composition.*

Figure 35. *Highlights in the distance give the eye something to look at; they break up what might otherwise be a monotonous series of horizontal bands.*

72

highlights with your thumb, and you'll see that the quick sketch loses much of its interest.

There's also a technical trick in Plate 25. Because the sky needed a certain purity of color, I painted it with a palette knife. I used yellow ochre near the sun, and grayed the sky as it moved toward the left. But the result didn't look right; the area lacked a transparent, airy feeling. So I took the knife and scraped the middle of the sky. That bared a part of the canvas, stained by the yellow ochre. The stain had more shimmer than a fully loaded area of paint could ever have. The "accidental" swipe of the knife did the trick. Then I added dark trees to emphasize, by contrast, the effect of light.

CRITIQUE. One of the main dangers in a picture of this sort is that you may become so interested in the subtle color of the grass that you ignore the placement of your masses. In Plate 25, for example, the area of water cuts the picture right in half! I didn't notice this mistake till long after the sketch had dried. One way to remedy this problem would be to reflect the large tree mass on the left into the water. That would darken the area and make the line of water less noticeable. But that's only *one* way. If four painters were asked to suggest a way to improve the sketch, they'd each come up with a different idea!

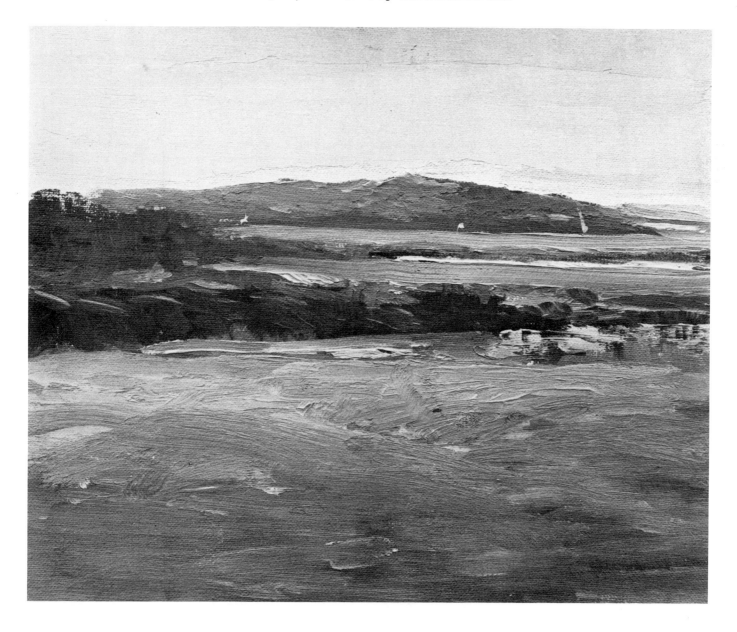

PROBLEM TEN

1 CADMIUM RED MEDIUM
CADMIUM YELLOW MEDIUM
PERMANENT GREEN LIGHT AND
WHITE
2 ULTRAMARINE BLUE
CERULEAN BLUE AND
VIRIDIAN GREEN

INCIDENT IN NATURE. The effects we studied in Problem One were subtle. As a change of pace, let's look at what's probably the most striking and obvious light effect in all of nature: a sunset. It's early spring; the day may have been warm, but the setting sun brings with it a cold, chilly night.

PALETTE. The color at sunset is strong and vibrant. Let's start our palette with *cadmium red medium* and *cadmium yellow medium,* two bright cadmiums that also have depth and richness of color. *Ultramarine blue* makes a good dark; *cerulean blue* is a clean color that adds coolness to the distances and also matches the greenish blue you often see in the evening sky. *Viridian green* is a cool green that also tempers red. *Permanent green light* is a warm green, good for use in foreground growth.

COLOR POOL. A sunset is really a study in warm and cool color that dominates the sky at sunset: the warmth of the sunlit clouds is contrasted to the coolness of both the sky and the shadowed earth. So let's experiment by setting up a warm area and a cool area, side by side. The warm area has the red, yellow, permanent green light, and white in it. The cool area has two blues (ultramarine and cerulean) and viridian. A touch of red is added to the latter area in order to form a purple—that will be useful when you want dark accents. The edges of the two areas are worked into one another, creating muted grays, purples, and greens for use in those parts of the sky and land that are neither in full light nor in full shadow. Parts of each area are left uncontaminated; they serve as the reservoir for the scene's stronger, more vibrant colors.

DEVELOPMENT. Since we're really doing a "sky piece," I want to talk a bit about skies before moving on. Don't be sidetracked by a desire to know the names of the clouds. You're not a meteorologist. The wind makes all kinds of shapes appear and disappear. Just look at what's in front of you and try to see which shapes are characteristic of the day. Try to record the general movement of the cloud mass rather than the individual clouds.

Figure 36, for example, is a very quick sketch of the movement and value of a cloud mass. Only the basic facts are noted. As the clouds get further from you, they look smaller—so the stroke is smaller. Overhead, you see a lot of the clouds' dark undersides—the stroke is broader and the value darker. Remember, though, that the darkness of these clouds is a relative matter. In Problem One, you saw that a mass may look dark against a bright sky—but won't be dark at all compared to a foreground area in shadow. Note that in Figure 36, the dark sides of the clouds are

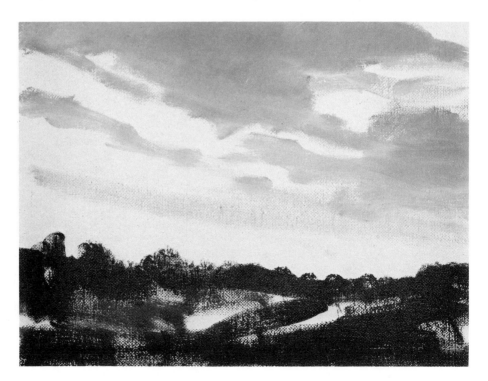

Figure 36. A few simple strokes capture the value and movement of a cloud mass.

nowhere near as dark as the values on the earth.

In Figure 37, interest is added to the cloud areas by the way the brush is manipulated. Paint layers of different values and colors are painted into one another, wet-in-wet, creating "accidental" effects. I kept my hand and arm loose when applying the paint; you can see and sense this looseness in the resulting stroke. As a result, the whole cloud area has a sense of freedom that is appropriate to the subject. You've all seen paintings where the clouds look as if they'd been carefully drawn in charcoal, then filled with color. The result is always lifeless — like a picture in a coloring book. The clouds hang heavily on the canvas; they don't *move*. A spontaneous, energetic brushstroke, on the other hand, always communicates its energy to you.

Now that I've said a few things about clouds, I'd like to say a few words about color. Let's first put everything in its proper place. The individual colors of a sunset are what immediately strike you. But when you paint a sunset, an ability to see these individual colors is less important than an ability to see how one color is related to another. What color accents what color? What colors *make* color? The sky is warm; reds and yellows predominate. But these colors are strong because they're accented by their complements. The sky itself is usually green near the horizon, for example, and purple toward the zenith. The greens accent the reds; the purples accent the oranges. Warm and cool colors constantly interact. A similar principle was at work in the winter problems: warm color (the snow in sunlight) was contrasted to cool color (the snow in shadow). Remember: if you train your mind to think in terms of complements and in terms of warm and cool color, you'll find outdoor painting that much easier. You'll have a way to see and analyze color.

The idea of warm/cool contrast is the foundation of Plate 26. It's at work throughout the sky area. And it's also used in a broader way. Note that the sky is basically a warm unit. In order to further emphasize this warmth, the sky is sharply contrasted to a dark, cool, purple mass of evergreens. This greatly increases the sketch's impact. Imagine, for example, what the effect would be if these trees were warm — if they were painted in the fall. There'd be no contrast, and the sketch would lose most of its power.

CRITIQUE. The main danger in a picture of this sort is that you can try too hard for an effect. If the complements are handled crudely, the result could be garish. As an example, look at the purples in the upper part of Plate 26. They're handled with some subtlety. But the purple mass of evergreens is overstated. I wanted a snappy contrast — but the result is harsh. The viewer becomes too aware of my strategy. And the entire picture is in danger of falling apart.

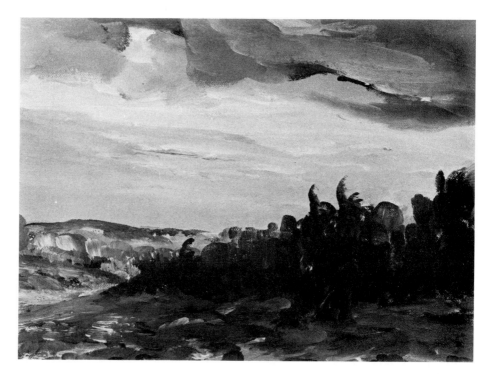

Figure 37. A loose manipulation of the brush gives the cloud mass shape and a look of freedom.

PROBLEM ELEVEN

1 CADMIUM RED MEDIUM
2 PERMANENT GREEN LIGHT
3 WHITE
4 ULTRAMARINE BLUE AND
 BURNT SIENNA
5 RAW SIENNA

INCIDENT IN NATURE. We've seen how strong light effects can be in late afternoon. Now let's look at a less vibrant, but equally striking effect: that created by the early morning sun. The sun is low in the sky; and as it rises, it lights just the top of the trees and hills. The effect reminds me of poetry or music; it's delicate—almost dreamlike.

PALETTE. *Cadmium red medium* works well with white to suggest areas hit by warm sunlight. *Raw sienna* has a yellowish tinge and makes a fine, muted green when mixed with *ultramarine blue.* This blue also makes a subtle lavender when mixed with cadmium red. *Permanent green light* is a warm, spring green. *Burnt sienna* works with the complementary color ultramarine blue to make a variety of neutral tones.

COLOR POOL. The pool is started by mixing ultramarine blue and burnt sienna. The addition of white pulls this dark into a value range. Red is cut into one side of this neutral pool, green into another, and raw sienna into yet another. The neutral mutes almost all the color used in the sketch, though on the edges of the pool, brilliant color is always ready when needed. When strong highlights are later added to suggest morning light, you'll be able to see them. They won't compete with a lot of powerful color.

DEVELOPMENT. Through careful emphasis of some effects and the subtle underplay of others, a painter can direct your attention to any area of his painting he wants: foreground, middle distance, or background. Let's say, for example, you want to pull the eye into the background of your sketch. See how it was done in Figure 38. The sun had begun to climb into the sky, throwing a strong light on the misty distance. To direct attention to that area, the foreground of the picture was kept dark—just a big, simple mass. Because there's nothing in it to interest the eye, you look right over it.

In addition to directing the eye, the picture as a whole must hang together, too. There are several ways to unify a sketch. First, you can use the same color to represent the light. In Figure 38, the sunlight playing on the foreground tree relates to that on the mountains in the distance. You know they're all under the same sky, lit by the same sun. The idea is also at work in Plate 27: the warm light on the distant bluffs is related to the light that warms the top of the tree in the right foreground. Then, a large mass, such as the tree in Figure 38, can also unify foreground and background. Try covering the tree with your fingers. You end up with two unrelated areas: one light and the other dark.

Then there are the integrating effects of atmospheric perspective. Like light, the color of the atmosphere pervades a sketch and unifies it. Also, the more distant the masses are, the lighter they become, until they appear to melt into the sky. In the background of Figure 38, you can see that the atmosphere has greatly reduced the value of the distant masses. These masses were painted much like those in Problem Six. The most distant mountain was worked into the wet sky, and the nearer hills were also painted wet-in-wet. You just manipulate the layers of paint until you get the value that looks exactly right. The background of Plate 27 was developed in much this way, though more cool color is added in order to suggest the dense ground fog.

Notice in Figure 38 that the foreground tree not only holds the picture together—its verticality also provides a relief from the horizontal movement of the main masses. This point is made even more strongly in Figure 39. In fact, there the trees break the horizontals so forcefully that they become subjects in themselves. Compare Figures 38 and 39. In the former, you move into the background and explore it. In the latter, the interest is all in the foreground; and that's where the eye stays. The compositions are similar—but the effects are quite different.

CRITIQUE. Figures 38 and 39 are both valid ways of handling a subject. But as a student, you have to make sure that you don't start a sketch in the spirit of Figure 38—and end it in the spirit of Figure 39. Somewhere along the line, you would have lost your initial idea. In Plate 27, trees like those in Figure 39 would be out of place; they'd compete with the main light effect.

Now in reality, the trees—and, in fact, the entire foreground—at the site of Plate 27 were all very interesting. But when you're confronted by a number of

interesting subjects, you have to choose the one that interests you most.

A painter friend of mine once told me about a painting he made of a Vermont village. As he painted, the townspeople watched him work. Pretty soon the woman whose store occupied the center of his canvas came along. When she saw his painting, she liked it—but she wondered how he could have overlooked the bright red pump in front of her door. In her opinion, a painter does his job properly when he makes a faithful copy of what he sees. My friend, on the other hand, realized that a brilliant red spot would disrupt his whole canvas—so he left it out. He knew what the picture needed—and, more important, what it *didn't* need.

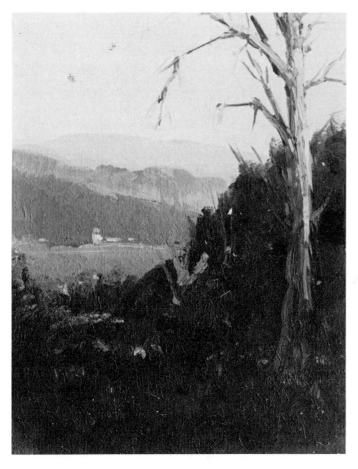

Figure 38. The sunlit tree on the right of this sketch helps unite the foreground and background.

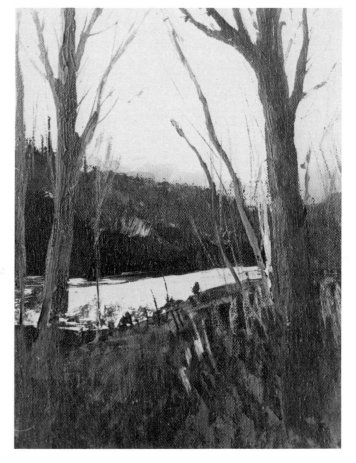

Figure 39. Large, dark, detailed trees dominate the canvas and keep the viewer's eye in the foreground.

PROBLEM TWELVE

1 WHITE
2 ULTRAMARINE BLUE
BURNT SIENNA AND
CADMIUM RED DEEP
3 CADMIUM YELLOW LIGHT AND
RAW SIENNA

INCIDENT IN NATURE. Let's continue the study of effects by looking at the strong light and dark contrasts sometimes found on a gray, stormy day. You've seen days like that. Clouds roll over the sky, giving it a dark, ominous look. The sun occasionally breaks through, dramatically illuminating the scene with a blast of light.

PALETTE. As in the previous problem, a sketch of this sort is dominated by a few key highlights. The rest of the picture is sober in its coloring. So the palette is correspondingly muted. *Raw sienna*, a mellow color, is used to temper *cadmium yellow light* — a color that will still have reserve strength for the highlights. *Ultramarine blue* mixes well with both these colors to form muted greens. *Burnt sienna* helps suggest the dead, brownish foliage of early spring. *Cadmium red deep* is a solid color, useful in further muting and enriching the various greens in the sketch.

COLOR POOL. Ultramarine blue, burnt sienna, and red are mixed to form a dark pool that mutes the color mixed with it. Adding white brings out the color and creates a value range. Yellow and raw sienna are tipped into one corner (that is, added to a small section of the larger pool), making a variety of warmish foreground greens. An uncontaminated part of this warm pool can be used for your highlights. The color for the sky comes from mixing all these colors and adding white; you'll have a neutral tone which favors the cooler side of the palette. Stormy skies tend to be cool; and, in addition, a cool sky is a good foil for the warm highlights.

DEVELOPMENT. When you're trying to capture rapid light effects, you have to work fast, keep your eyes open, and try to maintain the excitement of your first, quick reaction. Figures 40 and 41 are examples of sketches of this sort — quick notations to myself about the light and the character of the day. When I was painting Figure 40, for example, the dark clouds in the sky didn't stand still. They had to be rapidly brushed in. There's more bright sky than clouds in the sketch, so the effect is a pleasant one. It looks as if the storm is passing away. A few houses—just spots scraped off the canvas with the tip of the palette knife — give scale to the design and add interest to the somewhat monotonous horizontals.

The mood in Figure 41 is more dramatic and ominous. Here the clouds dominate the sky; and the land, largely lit by the sun in Figure 40, is almost all in shadow. Light specks suggest a few houses perilously located under the darkest thunder clouds. In both illustrations, the sky is painted with agitated strokes—big swipes of the brush suggest the shapes of the clouds. But in Figure 41, this agitation is carried into the land mass as well. The changing direction of the stroke is meant to

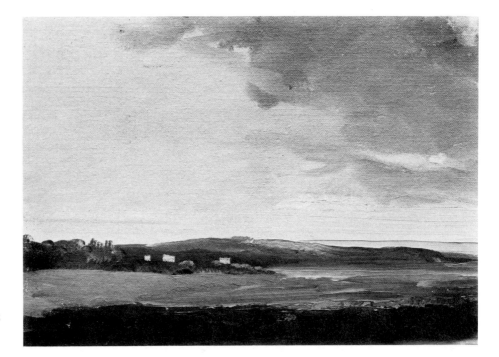

Figure 40. Clouds occupy only a part of the sky; you feel that the storm is over.

suggest masses of grass, blown back and forth by the wind.

In Plate 28, the sky is completely clouded over, though light breaks through somewhere outside the picture and hits one spot. At the actual site, the clouds would break every few minutes, sending shafts of light into the foreground, then the background, and then the distance. But there's no way you can paint all those effects. You have to look and decide which you like best—and paint only that one, no matter how the light changes. I've seen some students work for hours on a sketch, even though they caught the effect in the first half hour. They spend the rest of the time changing the shadows and highlights as the sun moves across the sky!

In Plate 28, the sky and land were massed in quickly. The interest is on the land, so the sky is kept simple. The land starts as a dark mass of earth color. Cool color is then added to the far mountains, while warm color is used in the foreground. At the same time, a warm touch is added to the sky, thereby creating a color relationship between the upper and lower halves of the picture. The sunlit middle distance is swiped in with a palette knife. Dark tree masses frame the sunlit spot, accentuating its brightness. A few light spots suggest houses or a farm. These light spots keep the eye from sliding rapidly down the slope and out of the picture. They also hold and interest the eye. Block out the suggestions of houses in both the color plate and Figures 40 and 41; you'll see how, without them, your eye finds almost no interest in the land masses.

CRITIQUE. When painting the effect of light, you must be conscious of how your eye is moving over the canvas. After painting for a half hour or so, close your eyes for a minute and rest them. Then open them, look at your sketch, and try to note where they go *first*. Do they go to a subsidiary corner? Do they drift to the right or to the left? Or do you find that you look right at the focal point? In Figure 41, for example, I want your eye to go to the dramatic spot where light breaks through the clouds. After your eye sees that, it can look at the houses, the water, the foreground—and so meander around the picture. But I want to keep returning to the main, dramatic contrast of light and dark. Close your eyes, then open them and see where they go when you look at Figure 41. Where do they go in Figure 40? Where do they go in Plate 28?

It takes a real effort to *see* what you're seeing. You almost have to be two people. But you'll gain by developing this sort of objectivity. Just remember to be honest and admit when your eye feels a strong pull away from what you thought was your main theme. And then be ruthless enough to subordinate the distracting part of the picture—even if you think you did an unusually fine job painting it. That may be the trouble: you did *too* good a job. The viewer's eye sees only the nicely painted detail—and misses the picture's subject!

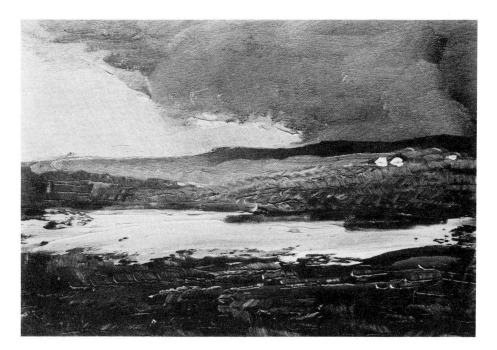

Figure 41. Dark clouds cover almost all the sky; you feel that the storm is about to begin.

PROBLEM THIRTEEN

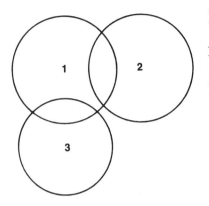

1 WHITE
2 INDIAN RED AND
 ULTRAMARINE BLUE
3 VIRIDIAN GREEN AND
 YELLOW OCHRE

INCIDENT IN NATURE. Problems Nine to Twelve dealt with the early part of spring. Now let's look at the later part of the season—when the plants start to take on color. Find a panorama, a view that has a variety of grasses, shrubs, and trees. You'll find that such scenes have a special interest on grayish days. There are no strong contrasts and we can concentrate on the interplay of color. Colors weave together on gray days—like strands in an oriental rug.

PALETTE. Because it's a quiet, somewhat gray day, you can use a subdued palette. So substitute *Indian red* for the cadmiums. It's a muted red—a rich earth color that's also good for tempering greens. When mixed with white, it makes subtle pinks and also suggests the dull red color of trees just beginning to bud. *Viridian* is a cool green. *Yellow ochre* is used sparingly to warm the cool tones—it's a color that's easy to control and good for suggesting diffused sunlight. *Ultramarine blue* completes the palette. It mixes with yellow ochre to make green and with Indian red to form a nice, restrained purple.

COLOR POOL. By interplaying the colors in the pool, you create the basis for the subtle harmonies of the final picture. The blue and the red make a dark that white draws out into a value range. Into this range, cut viridian (to mute the reddish purple) and yellow ochre (to warm the mix and create additional varieties of green).

DEVELOPMENT. In a panorama, details aren't of much interest. You see the large mass as a whole, and have a feeling of bigness and expansiveness. Yet a panorama is also full of different kinds of trees; the variety in their color is what attracted you in the first place. How do you reconcile your feeling for the beauty of the details with your equally strong feeling for the bigness of the mass? One way to do it is to weave your elements together so that both form and color work as a unit. You've probably seen pictures in which every tree was done in detail, each with its own shadow and highlight. Tree stood next to tree, like a row of toy soldiers. The painter was so interested in the trees that he forgot to paint the forest. The result is both monotonous and confusing. You don't know why so many trees are in the picture; and you're exhausted by a sense of the time and patience it took to paint all those leaves.

Figure 42 isn't concerned with such details. It's a quick sketch of some trees on a hill. The sketch tries to capture one particular quality of the trees—the ragged pattern that their almost bare branches make against the sky. Of course, trees have more facets than this one. But in a sketch you don't have the time—or space—to worry about everything. In the illustration, a palette knife is scraped lightly over the canvas with an up and down motion. The paint catches the tooth of the canvas and creates a ragged texture that I like. So I leave it alone! Once you get an effect, don't keep poking at it. Don't try to "make it better."

Notice that there are no individual trees in Figure 43, just a texture. But the eye reads this texture as a group of trees—whether it sees ten or twenty is up to the particular viewer. Figure 43 works in the same way. But this time, the fir trees are the subject. The palette knife moves horizontally and the paint is applied more thickly. Note, however, that the tree masses are still interconnected. The eye sees the interesting mass first—then the individual tree.

The method is clear in these simple black and white sketches; but it also can be applied to work in color. For example, look at Plate 29. This mass of trees began very simply: reds and greens were blocked in, playing one color against the other. At some points, the greens were contrasted to the reds. At others, they were mixed to form a neutral tone. You can see how warm yellow-greens and cool blue-greens were worked all over the canvas, no green confined to any one area. The eye wanders over the whole mass, enjoying the various colors. The sky was added after the land area had begun to develop. Notice that the sky in Plate 29 is quite flat. It doesn't distract your attention from the main area of color interest.

CRITIQUE. Remember, you're after a particular color effect. If you forget that, you'll begin to paint "trees" and "hills"—lots of little details. And your sketch will be a jumble. When you try to squeeze miles and miles of landscape onto an 8x10 inch/20x25 cm canvas, something has to be eliminated, something subordinated, and something emphasized. There's no way you can get everything in.

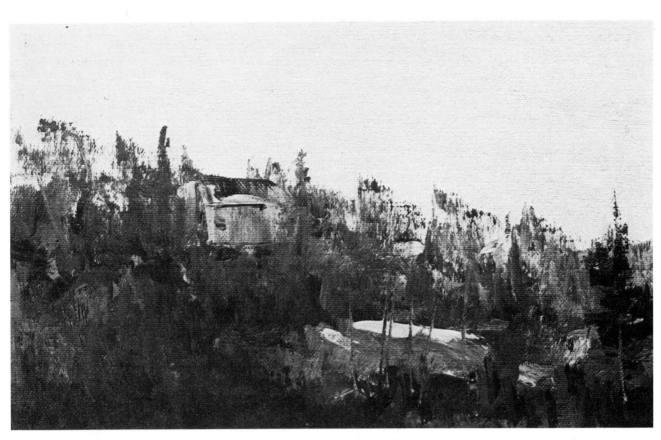

Figure 42. A few vertical strokes of the palette knife can suggest tree branches.

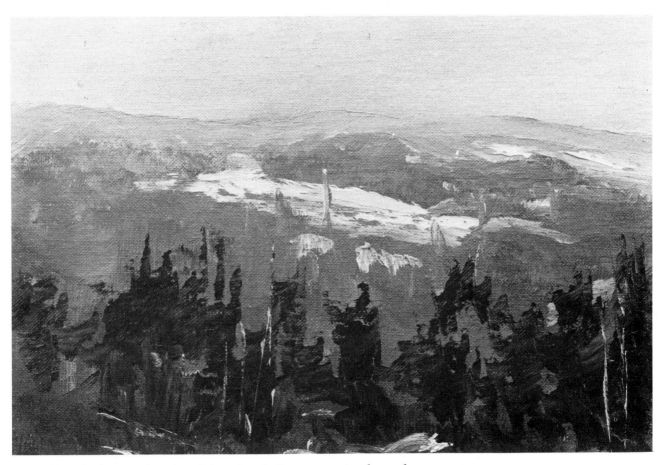

Figure 43. A few horizontal strokes of the palette knife can suggest a clump of evergreens.

PROBLEM FOURTEEN

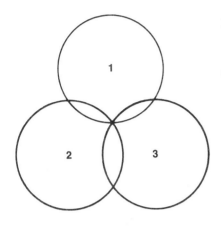

1 ULTRAMARINE BLUE AND
CERULEAN BLUE
2 ALIZARIN CRIMSON
CADMIUM RED LIGHT AND
RAW SIENNA
3 PERMANENT GREEN LIGHT
CADMIUM YELLOW LIGHT AND
YELLOW OCHRE

INCIDENT IN NATURE. In this problem, we'll continue to explore the colors of late spring: the warm skies, the delicate greens of the trees and the earth, the reddish touches in shrubs and foliage, and the subtle, clean blues of the far distance.

PALETTE. Let's use a fairly extended palette. There are two delicate cadmiums: *cadmium red light* and *cadmium yellow light*. *Alizarin crimson* mixes with *ultramarine blue* to form a clear, strong purple for the far distance. *Permanent green light* is the warm, spring green. *Yellow ochre* and *raw sienna* temper the more vibrant colors — a touch of ochre, for example, makes cadmium yellow less eye-catching.

COLOR POOL. We can work with three areas this time. The two blues form a dark section. The reds and raw sienna are cut into one side of this cool area; the warm yellows and greens are cut into the other side. These warm colors interact with the cool blues to form a large variety of greens. White can be added wherever you want to lighten the color, but just remember that white also cools the color slightly.

DEVELOPMENT. Spring lends itself to a "pointillistic" approach; that is, once the leaves have begun to come out, the season can be interpreted in terms of color dots: new leaves, buds, and tufts of grass. Don't block in the big masses this time. Instead, use short strokes, placing color next to color. Once a spot of color is down, try to touch it as little as possible. The more you touch it, the duller it will get.

Figures 44 and 45 are developed in this impressionistic way. In Figure 44, the technique is used "pure" — you can see each stroke. Nothing is pulled together. The canvas pulsates with "broken color" — strands of paint that are only partially mixed. In Figure 45, the technique is modified. There the shadows are an important element. So broken color is used where there's sunlight. But in the shadows— where your eye should be able to find peace and rest — the stroke is less obvious. You need that quiet spot; your eye, refreshed, can then continue on and enjoy the rest of the sketch.

Whether you use a pure or a modified impressionistic approach doesn't really matter. Everything depends on how you react to the subject. If you're impressed by the texture of the different grasses, then use a short, choppy stroke. If you like the large areas of shadow, then paint more broadly. Be open to the subject and paint it in a way that seems appropriate to you. Don't twist the effect or mood to fit a preconceived technique.

Plate 30 was done in a modified impressionistic manner. Warm and cool greens play over the hillside, while the sky is a mixture of blue and pink strokes. The foreground has been thrown into shadow to accent the sunlit distance. The greens in this shadow area are the same as those in the background — but here they're muted with red, ochre, and raw sienna. In some places, the red thoroughly mutes their color. In others, the green retains a little of its own identity. This interplay of color makes the shadow area interesting and tells you that it, too, is full of new growth.

CRITIQUE. An unusually dark shadow could ruin a sketch of this sort. This is a study in pastel colors; you don't want a lot of strong contrasts. Besides, the trees and shrubs of spring are only partially covered with leaves. Light passes through them, and they don't cast deep shadows. Light is constantly bouncing all over the place.

It's also important that you distribute your color. In Plate 30, the red in the sky reappears in the foreground. The green-blue in the sky relates to all the other greens in the picture. And the blue of the distant mountain is worked through parts of the foreground. The colors are again woven together, like a tapestry.

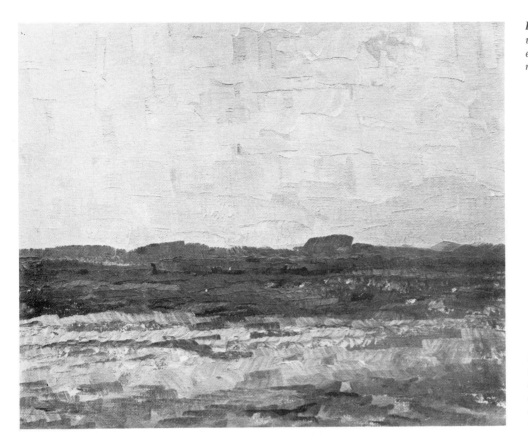

Figure 44. *The sketch is worked up in an impressionistic manner; each stroke is placed and then retouched as little as possible.*

Figure 45. *(Below) This sketch uses a modified impressionistic approach; the sunlit areas are done in broken color while the shadow areas are blocked in with broader strokes.*

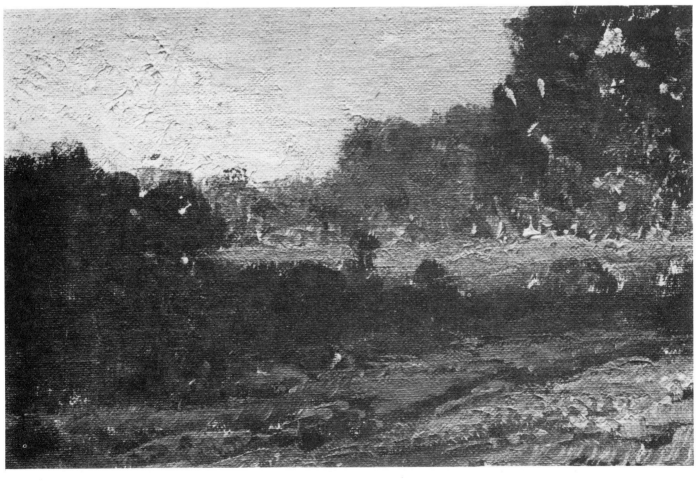

PROBLEM FIFTEEN

1 CADMIUM YELLOW LIGHT
2 CERULEAN BLUE
3 WHITE
4 ULTRAMARINE BLUE AND
 BURNT SIENNA
5 PERMANENT GREEN LIGHT
6 CADMIUM RED LIGHT

INCIDENT IN NATURE. Interesting effects can be obtained by playing with the pastel colors of spring and the shapes of the still leafless trees. The trees have a lot of design potential—particularly when used in silhouette. So let's look more closely at this question of silhouette. Find a spot in the woods with large trees in the foreground, which you can look through to the distance beyond. The distance is not meant to be of great interest. It's simply a foil to the pattern made by the trees.

PALETTE. *Cadmium yellow light* and *cadmium red light* can be modified with white to be delicate spring colors. *Cerulean blue* and *ultramarine blue* work well with the cadmiums to make purples and greens. *Permanent green light* is our warm, yellow-green. *Burnt sienna* grays the ultramarine blue.

COLOR POOL. Start with the familiar combination of ultramarine blue and burnt sienna to make a neutral dark. Add white to create a value range. As other colors are cut into this area, the neutral tempers them, assuring a subtlety and delicacy of color that fits the season.

DEVELOPMENT. Figure 46 is a clear example of the decorative use of silhouette. Its interest lies solely in the pattern made by the dark trees and bushes against the light background. Why are these silhouettes interesting to the eye? Your eye likes the variation in the size and thickness of the trees. They also lean in different directions. The thick tree trunk is contrasted to the delicate movement of its branches. Smaller trees are played against the larger ones. And the spaces between the trees (the so-called "negative spaces") are varied in size. Similarly the slope is made interesting by small shrubs that break up its silhouette — it isn't simply a straight line. In Figure 47 the same device—the outline of trees breaking up a light mass—is used, but texture also has been added to the land masses. The design no longer consists of merely a simple light/dark pattern. This texture adds further interest to the subject; the eye has more to look at.

In Plate 31, the trees are the center of interest; the background is kept light and pastel-toned. That area was brushed in first—in an impressionistic way, so that it wouldn't attract too much attention. Then the trees were worked over it. As long as the eye can't see definite shapes in the background, it will stay in the foreground, where we want it.

Remember that you won't find the scene neatly composed when you arrive at the site. Be prepared to move things around. In both Figures 46 and 47, for example, there are only three main trees. And these trees are surrounded by uneven numbers of thinner saplings. I consciously rearranged things to get these uneven groupings. There's something about a 1/3/5 arrangement that pleases the eye. Groupings based on 2/4/6 are static—they lack variety.

I keep stressing the importance of variety because it's one of the fundamental characteristics of good design. Just as no one likes to hear a speaker who talks in a monotone, his voice neither rising nor falling until you're eventually lulled to sleep, so no one enjoys looking at a painting that lacks variety. As you respond to the inflections of the speaker's voice and to his shifts in tone and volume, so the viewer reacts to the various tones and shifts of emphasis in your picture. Just as the speaker has something to say and knows how to say it, so should you, the painter, have a focal point and a definite reason for painting each scene. And as the speaker orchestrates his effects, uniting them into a harmonious whole, so should you.

CRITIQUE. Frequently you may paint small sketches so quickly that you don't have time to really think about what could be improved. In Plate 31, for example, the lower left-hand corner is blocked by a leaning branch. The branch is there for a purpose: it points to another branch that runs diagonally across the forest floor. That line is designed to keep the eye from moving rapidly down the foreground and out of the picture, and it works well enough—but the line leading to it is a problem. The heavy branch and the sides of the canvas form a closed triangle; the eye is trapped in the corner. How would you solve this problem? I'm not sure—it's a matter I'm still thinking about! But that's how a painter's mind should work. Don't worry about making bark look like bark and leaves look like leaves. Be more concerned about how the parts of your picture fit together.

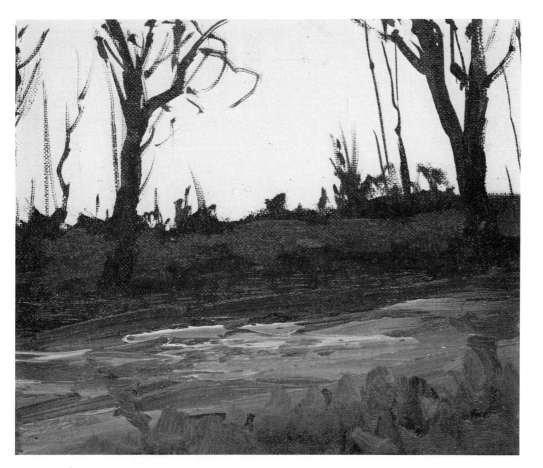

Figure 46. The careful placement of line and mass makes this sketch interesting to the eye.

Figure 47. (Below) A variety of strokes adds texture and interest to the sketch.

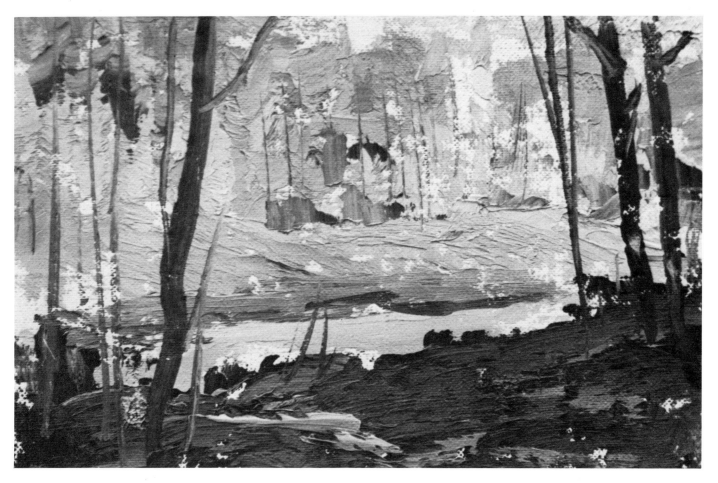

PROBLEM SIXTEEN

1 ALIZARIN CRIMSON
2 CERULEAN BLUE
3 WHITE
4 ULTRAMARINE BLUE
CADMIUM RED LIGHT AND
PERMANENT GREEN LIGHT
5 CADMIUM YELLOW MEDIUM

INCIDENT IN NATURE. We started this section with spring at its most sober point. Let's end it with a look at spring at its loveliest. An apple orchard is in bloom; the grass is the bright, yellow-green that always precedes the darker tones of summer. The mood is one of peace and quiet.

PALETTE. The palette is a simple one. *Cadmium red light* and *cadmium yellow medium* are both bright, clean colors. *Alizarin crimson* and *ultramarine blue* make a clear purple. *Cerulean blue* makes good, warm greens when mixed with yellow. And *permanent green light* is our warm green.

COLOR POOL. The pool starts with a mixture of ultramarine blue and cadmium red light; a touch of permanent green light is added to mute the red. Together, these colors form a subtle gray central pool that mutes the color and helps create the peaceful mood of a day in midspring. White is added, creating a value range. Other colors are cut into this gray as the need arises.

DEVELOPMENT. How do you paint foliage? Students have a terrible time with trees. But their problem is really one of attitude. They want to paint "leaves." If you worry about each leaf, you never see the most obvious characteristic: the big shape that the foliage makes against the sky.

Figures 48 and 49 should show what I mean. In Figure 48, the sky was quickly washed in. Then the masses of foliage were painted into it with a palette knife. Where the paint caught the tooth of the canvas, it looked like leaves. They're at the edges of the tree mass, where you usually can see a few individual leaves. The rest of the foliage was handled as a big mass. The trunks of the trees were then painted into this mass.

In Figure 48, the masses are fairly uniform in value, but in Figure 49, the paintbrush is used to break the mass up and so give it more marked form. You get the feeling that some leaves are in shadow, some in light; that some leaves are full-blown and some still in bud. Yet there isn't a single leaf in the sketch. Your eye and imagination take a few hints and turn them into concrete objects.

Figure 50 was painted at the same site as Plate 32. It was just an exploratory sketch, made to get acquainted with the area. Like all the sketches in this book, it's not meant to be—nor is it—a great work of art. It was just fun. Have a good time outdoors, and you'll find failure and success a lot easier to bear. (And believe me: success—with the self-confidence that comes with it—is often worse than failure!) Notice the sketchy way the tree trunks are handled in Figure 50. The mass of apple blossoms was established first; then a few strokes made the trunk and branches.

Figure 48. (Right) Foliage is easier to paint when you look for the mass rather than for individual leaves.

Figure 49. (Opposite page) Changes of value and stroke within the mass suggest sunlit leaves, shadowed leaves, full-blown leaves, and leaves in the bud.

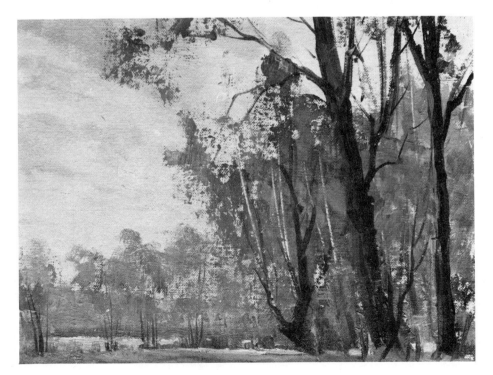

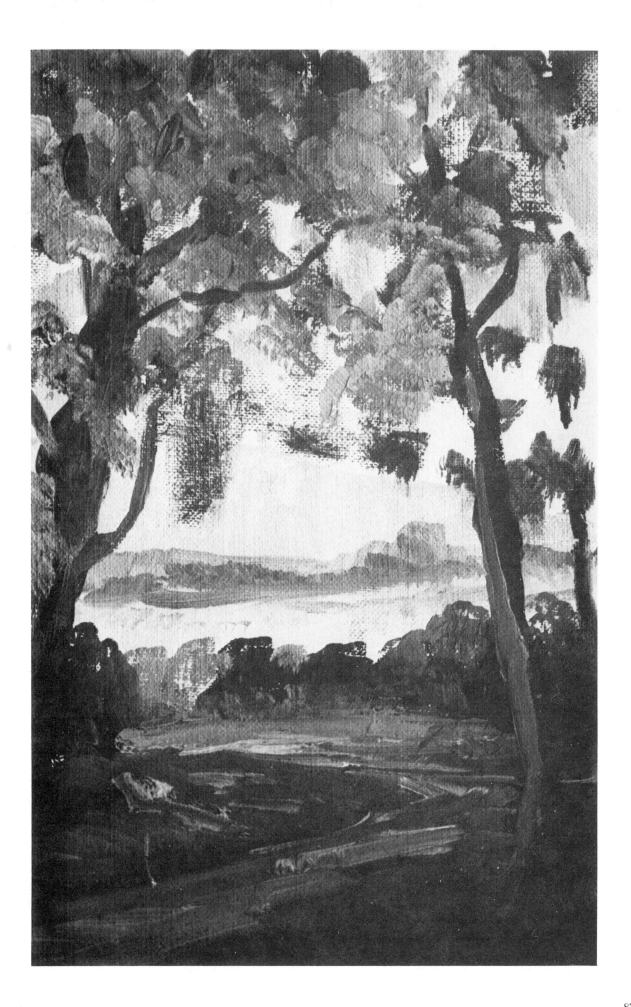

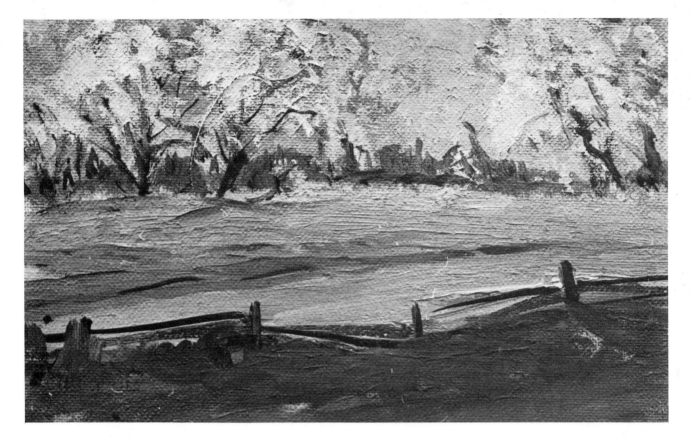

Figure 50. In this quick, exploratory sketch, the dark tree trunks are connected by the dark background mass.

There's an angularity to these strokes that fits the subject; constant pruning gives apple tree branches their special shape. Also notice the dark band that runs behind the trees in Figure 50. It ties the three tree trunks together so that they don't appear as isolated, unrelated darks.

CRITIQUE. Many students paint apple blossoms as if they were pure white. They treat snow in the same way—though we saw that it could be any one of a hundred different colors. Apple blossoms often look white in nature because they're seen against a blue sky or a similarly dark background. You see the contrast, not the color. But in reality, there are a lot of subtle greens and pinks running through the blossoms. In Plate 32, for example, the pinks and greens act like the greens and purples in a sunset; they're the colors that make color.

Three liberties were taken with the site of Plate 32. First, the rivulet was moved so that it helps break the sketch into three different-sized areas: (1) the foreground and stream, (2) the background and trees, and (3) the sky. Second, the sky was greatly simplified. Clouds would have competed with the whiteness of the apple blossoms. Third, all the trees at the actual site of Plate 32 were in bloom—as they are in Figure 50. Nothing stood out. A few yellow-green trees were added to frame those in blossom—and thus emphasize them.

Remember that when we talk about shapes and lines and balance, we're talking to each other as *painters*. You'll sometimes meet people who have no understanding of what you're trying to do. Such a person sees a spot in a corner—put there to balance another dark mass. "What's that?" he may ask. "Is that a bush? What kind of a bush is it? Oh—that isn't any good," he'll say. "That doesn't look like *that* kind of bush!" He's interested in accuracy and not in the really interesting part of the work—how you've organized nature to make a statement.

I remember helping to jury a show a number of years ago. We were presented with a picture that was flawless. There were detailed flowers in it, no bigger than my fingernail. And you could see the veins in all the leaves! But it didn't get into the show. Another juror said to me later that he couldn't fault the drawing—but what did you *feel* when you looked at the picture? Every inch was drawn with such care that you thought of a photograph—and nothing else. It was as if a bomb had exploded somewhere in the picture and burned up all the oxygen. The piece was drained of air—and life.

Plate 17. *When looking at a scene such as the one illustrated here, ask yourself two basic questions: What is the temperature of the color—is a particular area warm or cool? And what is the value of the color—is it dark or light?*

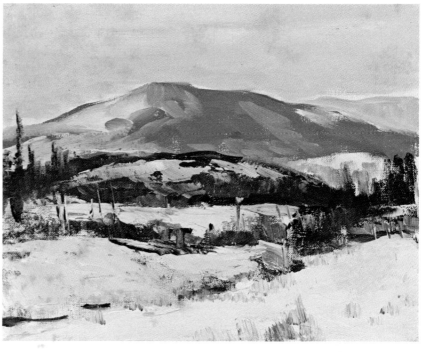

Plate 18. *(Below) On a misty day, the value of the color becomes a question of primary importance. The values are, for the most part, close together, and the edges are therefore "soft."*

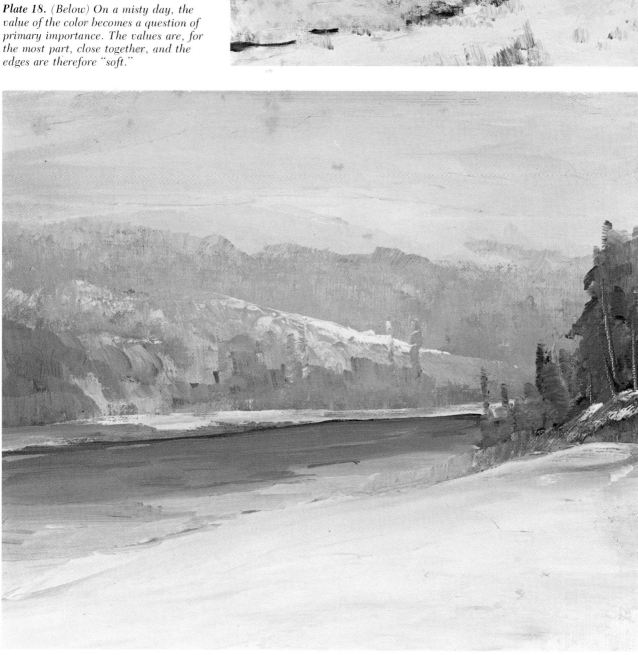

Plate 19. *When handling different materials—like snow and shrubbery—think in terms of paint texture. Here, for example, dense forest growth is painted roughly with a palette knife. The smoother foreground snow is painted with a brush.*

Plate 20. *Although you see trees and a bank, the real subject of this sketch is the movement of line and mass; the painter tries to strike a harmonious balance between vertical, diagonal, and horizontal movements.*

Plate 21. *What counts here is the placement of the large warm (light) and cool (dark) masses. The fundamental relationship between these masses was established first; then the color details were added.*

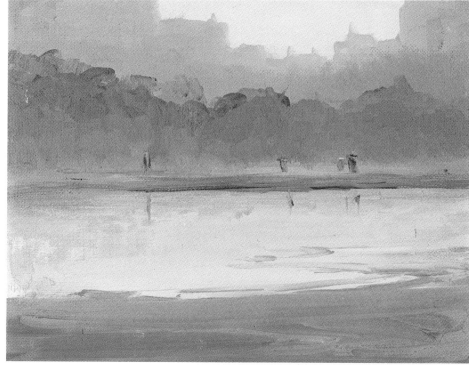

Plate 22. *(Right) By using big, simple areas of closely related color, you create the mood of a rainy day with a minimum of details.*

Plate 23. *The lines of the bridge, buildings, sidewalk, and street lights form a web that holds the picture together; in addition, these lines suggest the harsh, angular character of man-made objects.*

Plate 24. *(Right) Although this is a sketch of a quarry, the real subject is, again, the interesting interplay of vertical, horizontal, and diagonal lines. The character of these lines changes with the nature and texture of the material.*

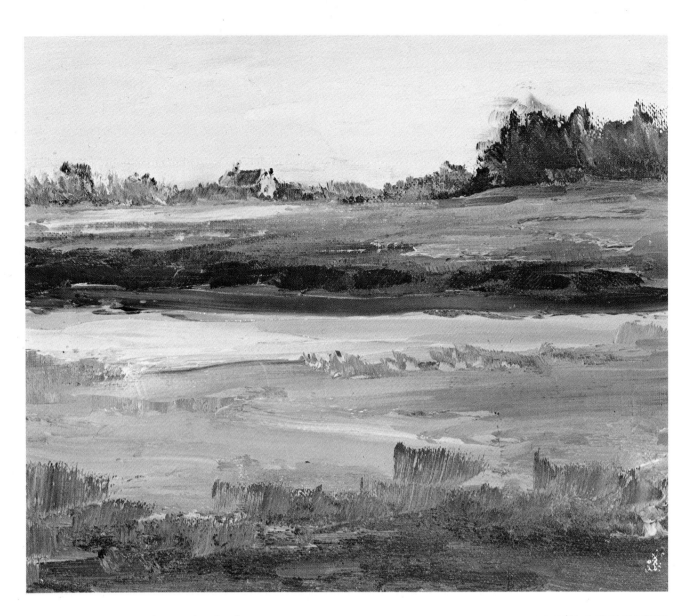

Plate 25. *Earth colors dominate this sketch and give it the sober coloring typical of that on days just before trees and grass return to life.*

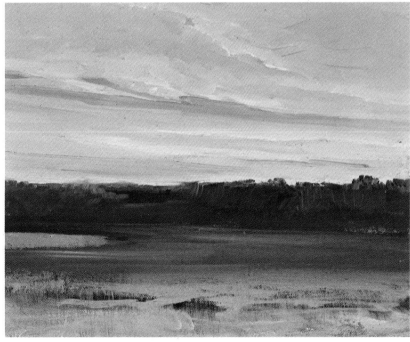

Plate 26. *(Right) Although warm colors stand out in the evening sky, the key to their vibrancy lies in the nearness of other analogous and complementary tones.*

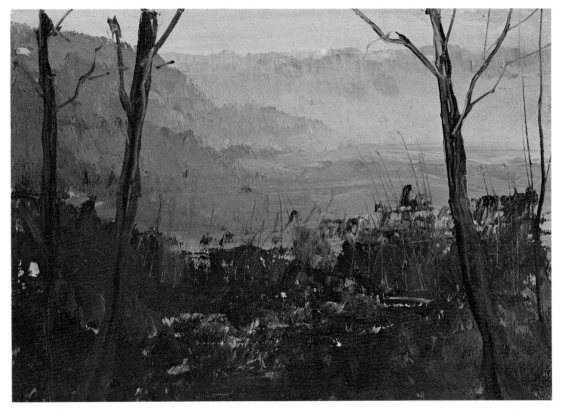

Plate 27. The shadow areas dramatize the distant light effect, while the cool valley fog emphasizes the warmth of the highlights.

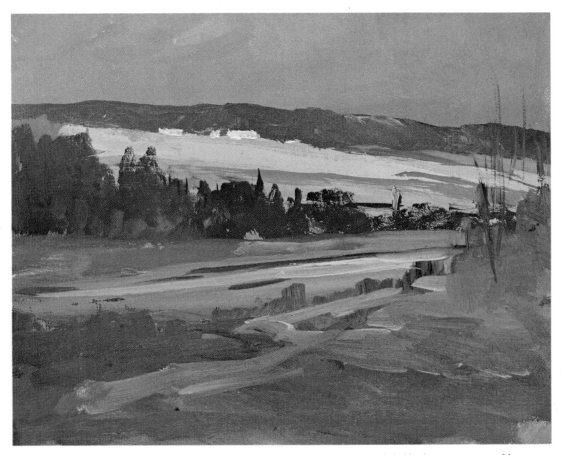

Plate 28. The dark sky and shadowed land mass accentuate the illuminated field; the suggestion of houses gives the eye a place to rest in its journey through the picture.

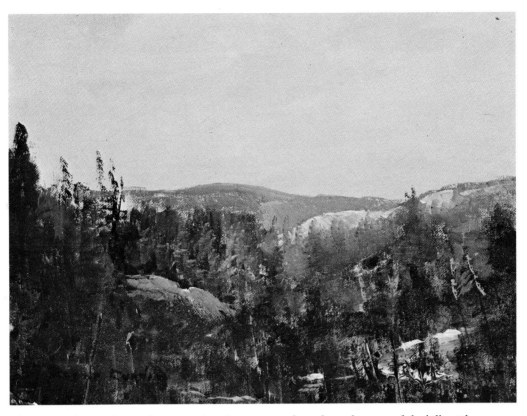

Plate 29. Reds, purples, and warm and cool greens run throughout the mass of the hill, with no one color being isolated. You see the forest, not individual trees.

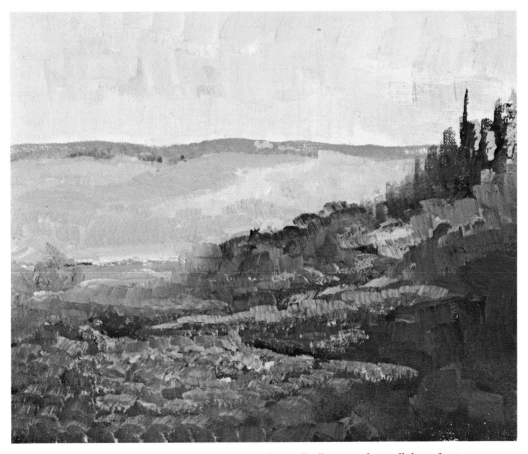

Plate 30. Spring buds and sprouting grass suggest a "pointillist" approach; small dots of paint create a vibrant, broken-color effect.

Plate 31. *By keeping the background colors soft and the foreground shapes large and simple, you focus the viewer's attention on the interesting patterns made by the silhouetted trees.*

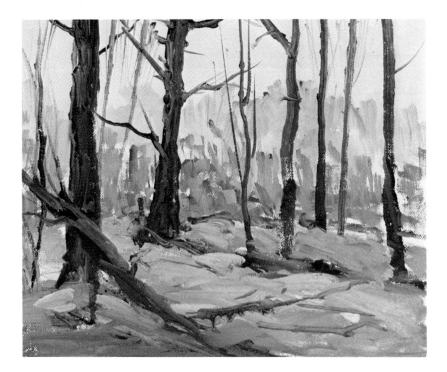

Plate 32. *(Below) A mass of apple blossoms is never white; the interaction of white, pink, and green are what gives them their unique character.*

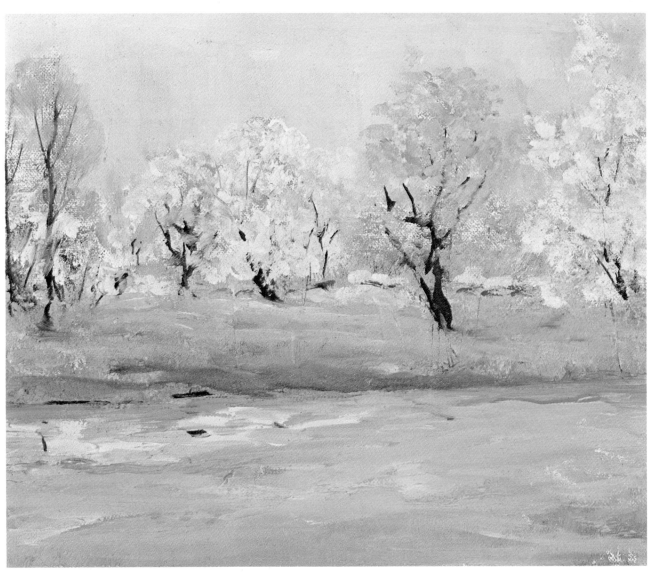

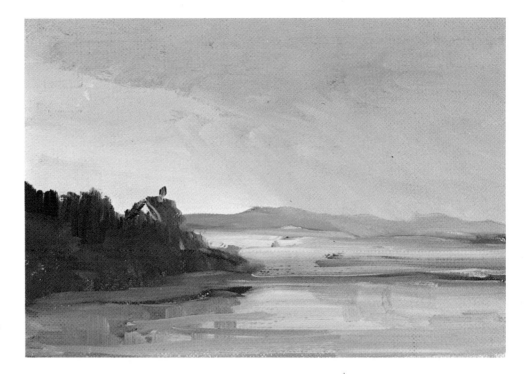

Plate 33. The drama of an approaching storm lies in the struggle between the warm sunlight and the cool low-hanging clouds.

Plate 34. *(Below)* To keep the sketch from breaking into warm and cool halves, the warmth of the sky was reflected down onto the purple mountain and the surrounding fields.

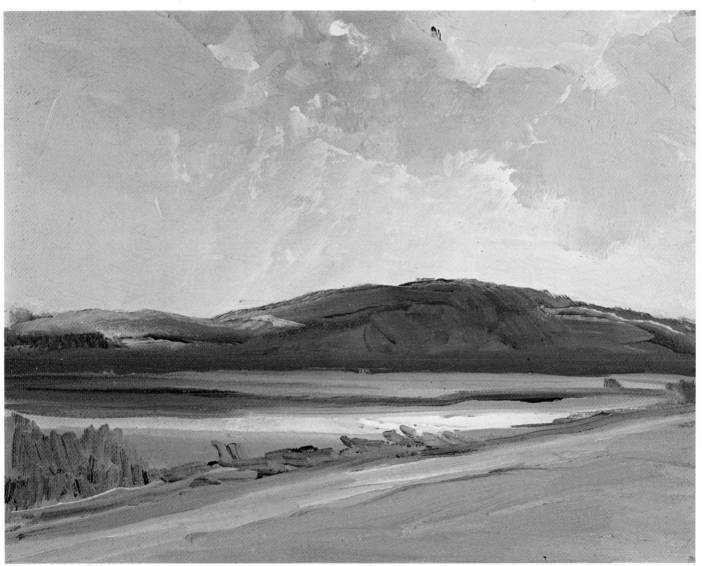

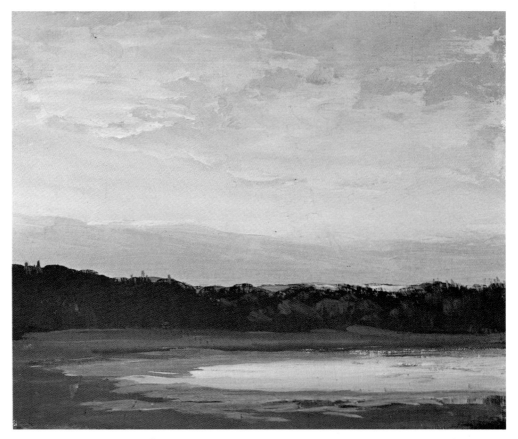

Plate 35. The palette knife pulls the areas of warm and cool sky color together; the results are "accidental" and much more subtle than those obtainable with a brush.

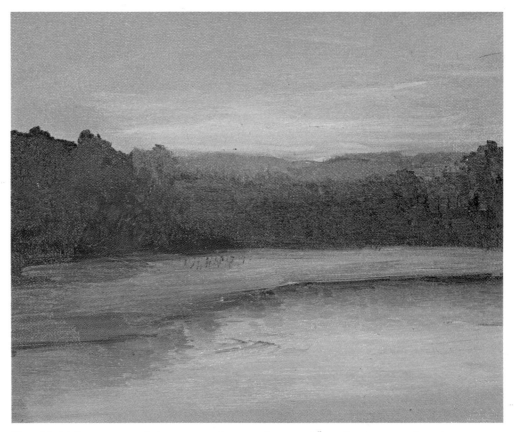

Plate 36. Without a strong light source, values are close together, colors are muted, and masses are large and simple. This simplicity is the key to the quiet, peaceful mood of twilight.

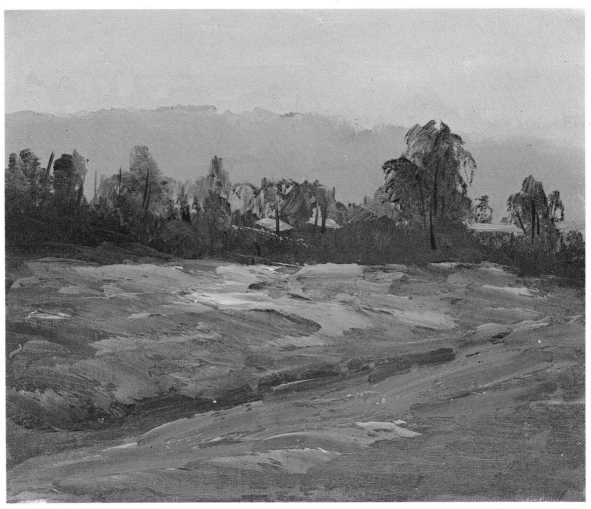

Plate 37. *The mistiness of a rainy day creates a series of flat shapes. We create depth by overlapping areas and by increasing the texture of the masses as they near us.*

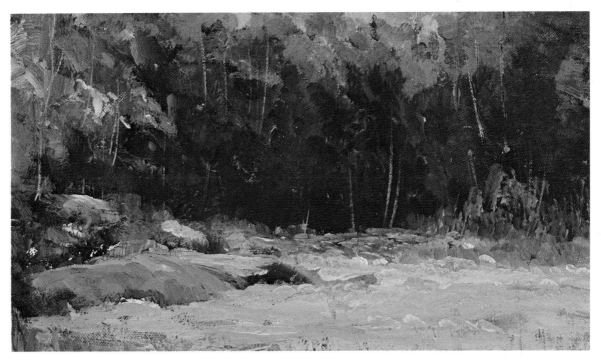

Plate 38. *The cool dark mass in this sketch accentuates the warm, sunlit one. Notice, however, that warm and cool colors are distributed throughout the design, thus helping to hold it together.*

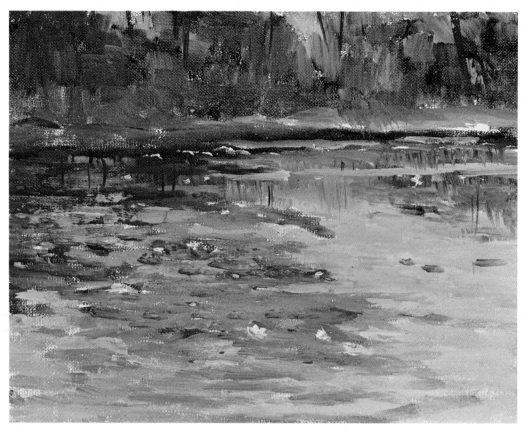

Plate 39. By using a few simple values and a minimum of details—notice the foreground blossoms—you can suggest the complexity of detail in a lily pond in early summer.

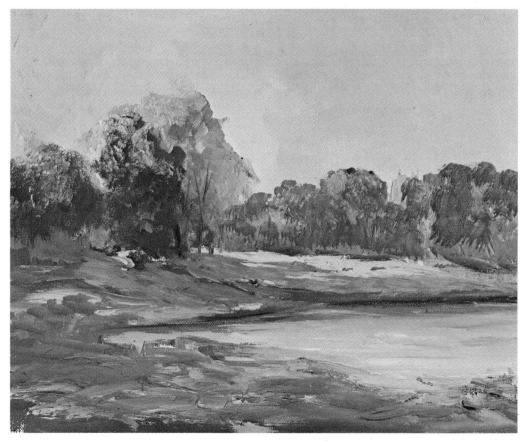

Plate 40. There's a great variety of greens in this sketch; summer trees are not merely one flat color. The greens become cooler and more muted as they recede into the distance.

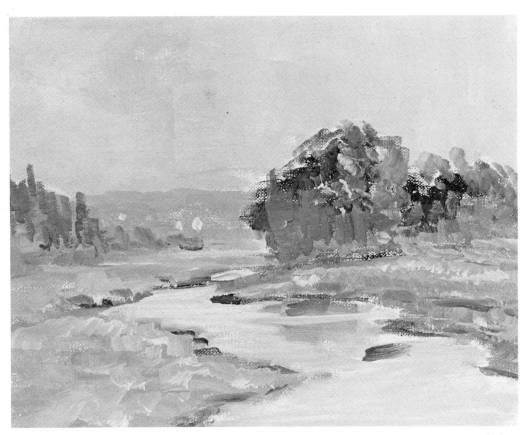

Plate 41. *The color of the cool morning light dominates this sketch. The bright light bounces off the ground and is reflected into the lower parts of the trees.*

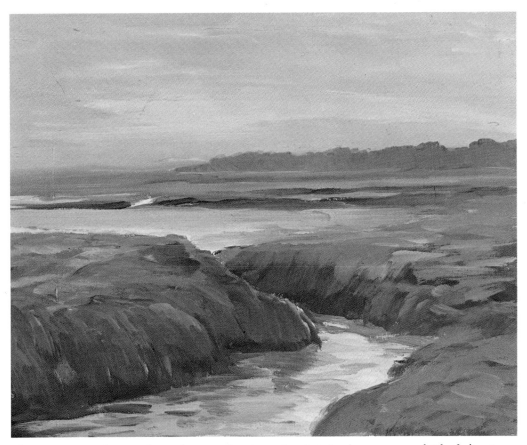

Plate 42. *Painting late in a hazy afternoon, I make my brushstrokes less pronounced. The feeling is one of an almost velvet-like softness.*

EL CAMINO COLLEGE LIBRARY

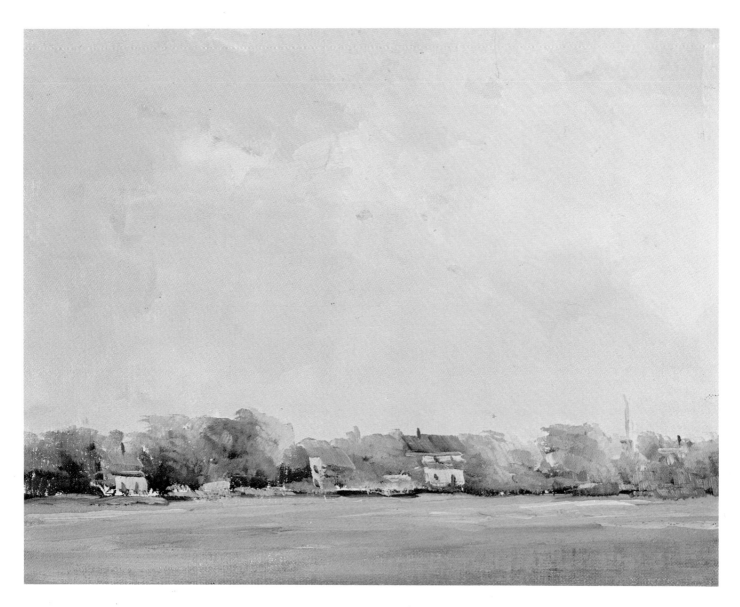

Plate 43. *The large, simple area of sky acts as a foil to the more complicated texture of the houses and trees.*

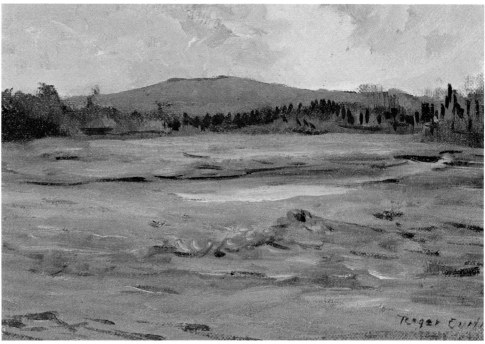

Plate 44. *(Right) The large, cool mass of the mountain accents the warmth of the subtly colored foreground.*

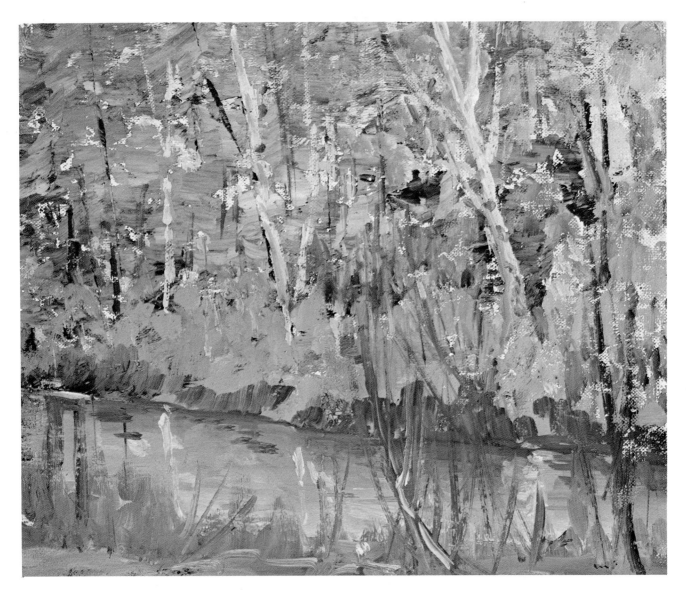

Plate 45. *Foliage masses become warmer as fall proceeds. Here, this warmth is set off by the coolness of the sky and the light birch trees.*

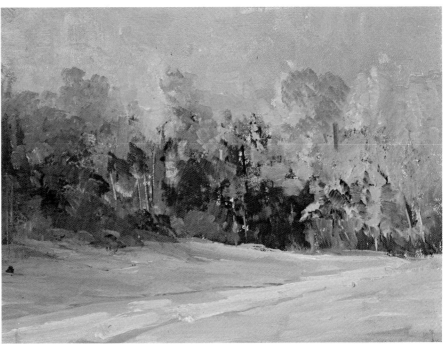

Plate 46. *(Right) By confining the brilliant tones to a few large masses, you keep your picture from breaking into spots of isolated color.*

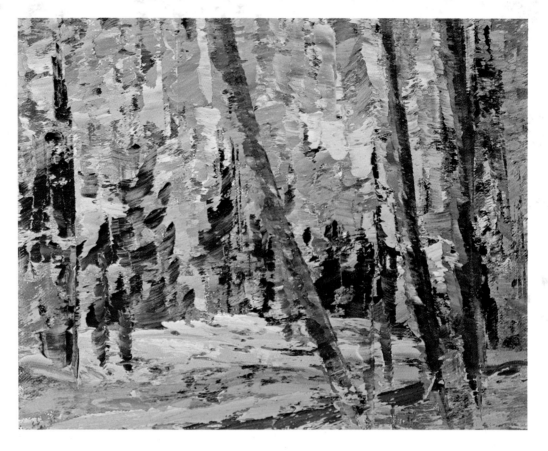

Plate 47. At the height of fall, the color takes on an abstract beauty. The palette knife can help capture the freshness and vitality of this season.

Plate 48. (Below) Once the explosion of fall color is over, the land sleeps through winter. The colors all become darker and more sober.

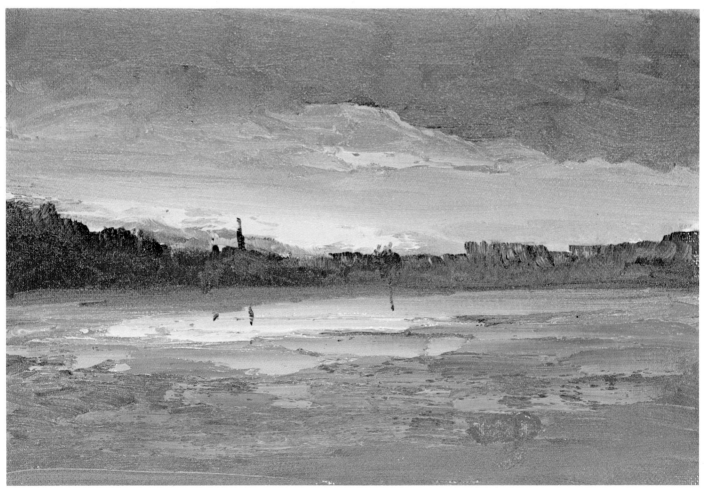

CHAPTER EIGHT

Summer

We saw that the color of spring is varied and broken. The world shimmers. In summer, there's still plenty of broken color, but you'll also find that the trees and fields again begin to form into large masses. The foliage is heavy and the shadows are solid and dark. The key to painting the season is to keep these masses in mind. Don't be distracted by interesting but unimportant details.

The greens of spring are all very warm and yellow. But they deepen as the summer wears on. Remember: there's no single "summer green," just as there's no single "spring green." Ignore color recipes. If you really look closely at the colors you see, you'll find summer an interesting time of year. Many people think it's too much one color: green. But that's really a part of its appeal. How does the color of the grass at your feet differ from that of the leaves over your head? How does that differ from the green of the distant field? And how does that differ from the green of a tree a mile away? See how much color you can find in this supposedly one-color season!

PROBLEM SEVENTEEN

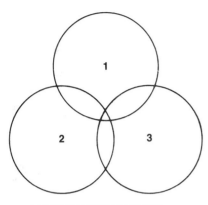

1 ULTRAMARINE BLUE AND
CADMIUM RED DEEP
2 WHITE
3 CADMIUM YELLOW MEDIUM

INCIDENT IN NATURE. Summer has always been famous for the drama and variety of its skies. So let's begin our study of the season by looking at the sky under a number of different conditions. We'll start with an approaching storm. Thunder clouds quickly pass over the sky, and the distance is hidden by rain and shadow. The scene is one of high drama: dark overpowers light as the wind twists the masses of billowing clouds.

PALETTE. Since storm effects change rapidly, we can make sketching easier by using a simple, restricted palette. Let's try one based on three pigment versions of the primaries: *cadmium red deep, cadmium yellow medium,* and *ultramarine blue.* (Compare this set of primaries with that used in Problem Four — how do your results differ?)

COLOR POOL. The red and blue mix to form a dark color. Adding white makes a value range. Yellow is then cut into this pool, mixing with the blue part of the pool to form a green. It also mixes with the purple (formed by the red and blue) to create a cool, a grayish tone for the thunderclouds. More red can be pulled into the green when you want to lower the value and reduce the vibrancy of the color.

DEVELOPMENT. The direction of your brushstrokes can play an important part in a storm picture. In Figure 51, for example, the clouds are painted with a series of sharply angled diagonal strokes. The sharpness of the angle makes you sense that the wind is very strong. Otherwise, the clouds would move in heavier, horizontal, less-textured bands — as they do in Figure 52. Do you see the difference in the stroke? Can you feel the difference in the weather?

Figure 53 is an even clearer example of how the brushstroke adds to the feeling of the scene. The distant clouds are painted with a diagonal stroke. The angle is repeated in the bending foreground grass, and in the movement of the tree's branches and leaves. Everything suggests that a strong wind is blowing from the right to the left. Plate 33 uses the same idea. The sunlit area of sky is brushed in with quiet, horizontal strokes. Then the mass of rain is pulled over the sky with quick, angled strokes. The brush handling tells the story.

As you're painting, don't forget that clouds are light and fluffy. On a gusty day, the edges of the clouds will be affected by the way the wind blows. In both Figures 51 and 52, for example, the clouds have few hard edges; they blend into the surrounding sky. Pay particular attention to this natural fact, and you'll avoid painting clouds that look as if they've been cut out and pasted onto the canvas.

Of course, you frequently have to take liberties with nature. You exaggerate to get an effect. In Figure 51, for example, the ground has been kept very dark in order to emphasize the breaking light. In Plate 33, the warmth of the sunlit field is exaggerated in order to emphasize the cold color of the approaching storm. The exaggeration enhances the desired mood.

CRITIQUE. If you were looking at a scene like that in Plate 33, you might be struck by an aspect of the scene that I hadn't noticed. I liked the light and dark contrast and the struggle of warm and cool color, whereas you might be impressed by the shapes of the storm clouds or by the reflections in the water. You'd then have to arrange the elements to emphasize what *you* felt was most important. Remember: when you copy exactly what's in front of you, you're not painting. A camera copies much better than you ever could. You have to go to the heart of what you see; and that takes compression, elimination, and exaggeration. You have to know your own mind and be prepared to make decisions.

I once talked with a person who wanted to get into an "advanced" painting class. He tried to prove his ability by showing me copies he'd made of postcards and calendars. They were competent copies. But he didn't realize that they weren't of much value. The important, *thinking* part of art had already been done for him — the problems were all solved. Placed before nature, he was helpless. He didn't have an opinion.

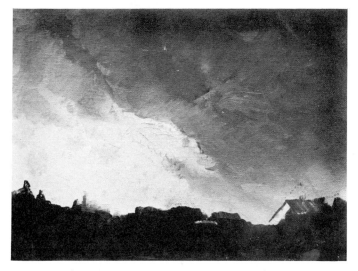

Figure 51. Diagonal brushstrokes in the clouds suggest the force and direction of the wind.

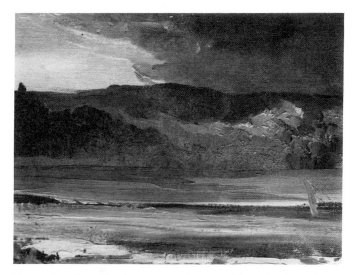

Figure 52. These clouds are painted more softly and at less of an angle; the viewer senses that the wind isn't as strong as it is in Figure 51.

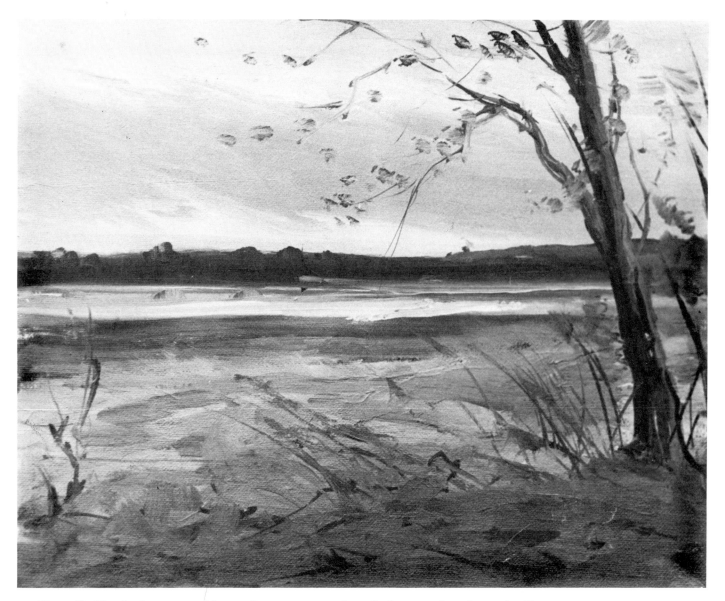

Figure 53. The clouds, grass, and leaves all move in a way that tells the viewer how the wind is blowing.

PROBLEM EIGHTEEN

1 CADMIUM RED LIGHT
2 WHITE
3 ULTRAMARINE BLUE AND
 BURNT SIENNA
4 CADMIUM YELLOW DEEP AND
 VIRIDIAN GREEN

INCIDENT IN NATURE. In the preceding problem, I emphasized the need to exaggerate in order to dramatize an effect. In this problem, let's look at another, strikingly dramatic effect in nature—the drama that occurs when a cloud passes in front of the sun. Again, it's a brief effect; it lasts for a few seconds and then disappears. You have to work fast and use your memory to hold onto your first impression.

PALETTE. The palette begins with our old complementary standbys, *ultramarine blue* and *burnt sienna. Cadmium red light* mixes with ultramarine blue to form a muted purple, a purple that can be toned and grayed by a touch of the burnt sienna. *Cadmium yellow deep* mixes with white to give us a good sunlight color. And *viridian* is a cool green, well fitted for the deep greens of summer. The yellow-greens of spring have begun to disappear. The colors get deeper and richer —a fact that we'll investigate later in the chapter.

COLOR POOL. Ultramarine blue and burnt sienna create our main dark. White forms a value range. Red is cut into the side of the pool, warming the neutral tone and making a variety of purples. Green and yellow are cut into the other side of the pool to create a series of warm mixes. The interaction of warm and cool color creates the basis for the sunlight and shadow of the final sketch.

DEVELOPMENT. When painting a fast-moving effect, you have to get right down to the subject. In Figure 54, for example, you could spend a lot of time trying to get the land mass just right—but by the time you finished with the details, the sky effect would have vanished. The easiest method is to quickly block in the ground area; that gives you an idea where you stand. Then move right to the sky.

Figure 54 illustrates this approach with particular clarity. The foreground trees were very rapidly placed with the palette knife. Then the sky was developed. And then—when the effect was established—the trees were designed to emphasize the main drama of light. Notice, for example, that the value of the tree mass lightens as it goes into the distance. You sense that the foreground trees are in shadow, while the background trees are affected by the rays of the sun. What would happen if all the foreground trees were a large, dark mass? You'd have contrast, of course—but there'd be no way for the eye to move *into* the picture and toward the light. It would jump back and forth between the sky and the trees, unable to decide which was the subject. The sunstruck area of trees acts as a transition; it gently leads you toward the dramatic sky.

The sketch in Figure 55 is a more elaborate study of clouds; but it also makes use of transitional values. In this case, the curved line of the river pulls you into the picture. Then the area of sunlit trees at the end of the river acts as a bridge for the eye to use as it moves into the sky. If the background were a solid, dark band, you'd feel that you had to jump over it to get to the sky. Remember that a picture without transitions is like a book that has a first and last chapter with nothing in between. It has no sense of continuity; you can't understand the story.

In painting Plate 34, the warmth of the sky was indicated first—notice that the blue sky is warmed by the sun to an almost greenish tone. Then the mass of the mountain was added. It's kept dark to accent the sun. But you can see that warm color has been worked into the top of the mountain. This breaks up the mass and relates it to the sky. In the previous figures, a change in value acted as the transitional element. Here, a change in color serves the same purpose. The warm touches in the purple mountain prepare you for the greater warmth of the sky.

Once the sky effect was approximated, the mountain was designed to accent it. It builds to a peak just beneath the main effect. At the actual site, the mountain peaks farther to the left; but in the sketch, that would have created a second focal point. The eye would be distracted from the subject. So I moved it to where it would do some good.

CRITIQUE. In Plate 34 there's a transition in color between the mountain and the sky. Do you think there should be more of a transition between the foreground and the mountain? How could you make the sketch less harsh—without impairing its dramatic impact? There's no "correct" answer to this question. Just think about it— and decide what *you*'d do if confronted by a similar scene.

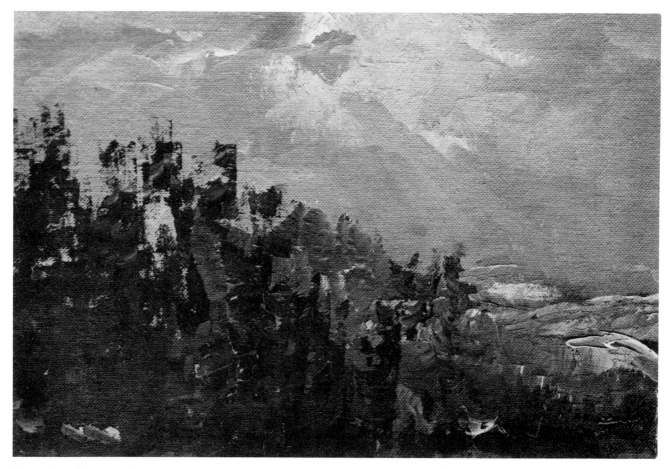

Figure 54. *The mass of trees lightens as it nears the sun; it thus leads the eye gradually to the dramatic cloud formation.*

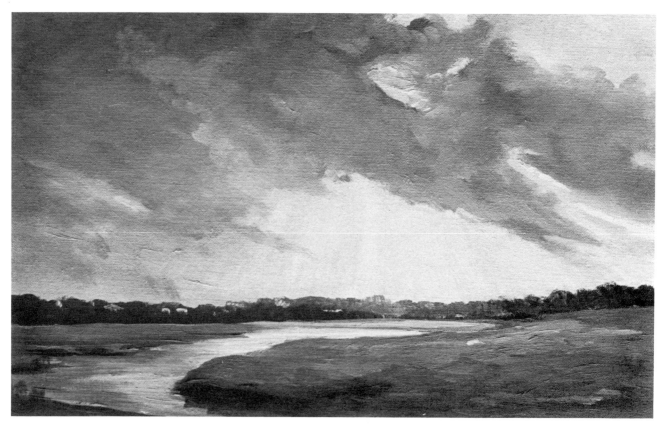

Figure 55. *The area of sunstruck trees acts as a transition between the land and the sky.*

PROBLEM NINETEEN

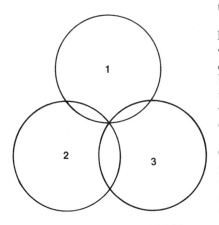

1 CADMIUM YELLOW MEDIUM
CADMIUM YELLOW LIGHT AND
WHITE
2 CADMIUM RED MEDIUM AND
CADMIUM RED LIGHT
3 ULTRAMARINE BLUE
CERULEAN BLUE AND
VIRIDIAN GREEN

INCIDENT IN NATURE. In Problem Ten, we studied a sunset at the moment when its color was at a peak. In this problem, we can investigate a much more subtle effect. The sun is low in the sky, warming some of the clouds and reflecting light into others. The colors are muted, and the contrasts are less noticeable than they were in the earlier problem.

PALETTE. Since warm color dominates the sketch, the palette will be rich in warm cadmiums. There's both *cadmium red light* and *cadmium red medium*—and a *cadmium yellow light* and a *cadmium yellow medium*. The added cadmiums broaden the range and subtlety of obtainable color effects. *Cerulean blue* gives us the greenish blue of the sky—and we can further warm the color with yellow, if we want. *Ultramarine blue* suggests cooler sky patches near the zenith. *Viridian* is our cool green.

COLOR POOL. Let's start the pool with the dominant warm color—the cadmium yellows and white. Red is cut into the pool, creating a series of analogous tones: yellow-red, orange, red-yellow. The blues and viridian green are cut into another corner. They work with the yellows to create a variety of greens, and they interact with the reds to make a variety of purples. As you know, by way of contrast, these cool greens and purples help to emphasize the warmer sky colors.

DEVELOPMENT. To get a variety of color and texture in your sketch, try mixing brush and knife passages. In the late afternoon sky in Figure 56, for example, the knife was used to smooth out the distant sky—a large, simple, clean area of light was needed as a contrast to the activity of the clouds. The clouds are done with a brush, but a few random palette-knife strokes break into the dominantly diagonal movement of the clouds and thus add interest to them.

In Figure 57, I've pulled some light and dark values together with the palette knife so you can see the effects that are created. At A, a light area has been thickly applied with the knife. It looks clean because a gentle pressure on the knife causes the paint to slide across the undercoat. Unlike the brush, the knife doesn't immediately break through the layers of color. Of course, the more pressure you apply to the knife, the more the colors will mix. At B, the knife mixes a light and dark area, forming subtle, "accidental" gradations that you could never get with a brush.

The usefulness of the knife is particularly evident in Plate 35. Both the warm and cool sky tones were first applied roughly with a brush. The areas of color were placed about where they'd be in the final sketch. But there was no rigidly preconceived idea about how the finished sketch should look. I was trying for an overall impression — a generalized statement of the color relations and character of the masses. Once the basic color was down, the area was swiped with the knife. Can you see the subtlety of the color mixes? If the first swipe with the knife looks good, leave it. If the warm or cool color still seems too strong, apply additional pressure to the knife and the colors will mix more thoroughly. If that doesn't work, use the knife for its original purpose: When in doubt, scrape out!

CRITIQUE. When you arrive on a site, your pockets are full of knowledge. But only a part of that knowledge is needed in any one picture. Students always want to show all they know in every picture. They try to do too much.

Learn to conserve your resources. Don't, for example, scatter light all over the place — even if it seems to be falling everywhere. In Figure 56 the light is kept toward the center of the sketch. It hits the ground in only a few places: on part of a field and on a couple of houses. The rest of the picture is kept in shadow and semi-shadow to play up the light effect.

Of course, it's possible to conserve your resources so successfully that the final picture has nothing to offer — it's too simple. Painting is like juggling; you have to have a good sense of balance.

A friend of mine who had never painted decided to try one day. He covered his canvas with black paint, dipped a bottle-cork into some red, and placed a round dot in the middle of the canvas. He called it "Traffic Light at Midnight" — or something like that. Why theorize so much, he once asked me — why work so hard? Look how easy painting is!

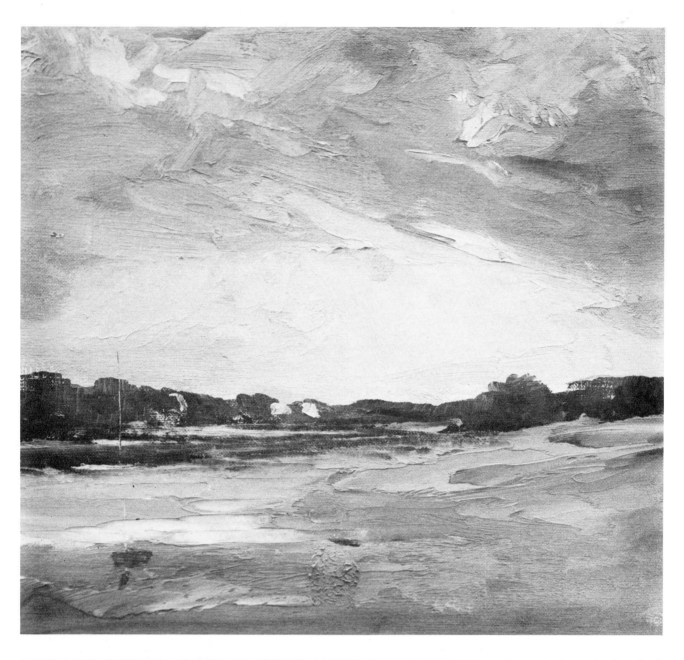

Figure 56. (Above) Palette knife and brushstrokes combine in this sketch to give the sky an interesting texture.

Figure 57. At A, a light stroke of the palette knife is used to lay on clear, pure color. At B, heavier pressure blends color together, creating in the process a series of subtle transitions.

111

PROBLEM TWENTY

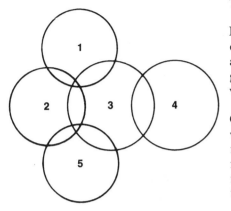

INCIDENT IN NATURE. We've studied an approaching storm, clouds obscuring the sun, and the late afternoon sky. Now let's go out at the very end of the day—the sun has disappeared over the horizon, leaving a few lingering traces of warm color in the sky. Before you paint, study the scene and try to feel its peacefulness. That's the feeling you want to get in your picture.

PALETTE. *Cadmium red light* matches the delicate pinks that appear in the sky during late in the day. *Ultramarine blue* and *burnt sienna* form a neutral that serves as the base color for the areas barely lit by the sun. *Permanent green light* suggests grass touched by the warm light reflected from the sky. *Cadmium yellow medium* warms the other colors and adds variety to the greens.

COLOR POOL. Ultramarine blue and burnt sienna are mixed first; the addition of white draws the pool into a value range. All the other colors are tipped into the neutral pool—and are made less brilliant in the process. They're tempered by the neutral pool. This muted color is particularly appropriate for a twilight picture. The mood is paramount, and you don't want strong individual colors to attract attention to themselves.

DEVELOPMENT. As the day ends, the sky goes through an interesting series of changes. We've seen the most brilliant color phases in the previous problems. Just after the sun disappears, the lower part of the sky is brightly illuminated for a few minutes (Figure 58). Light barely catches the top of objects. In Figure 59, for example, the sun is over the horizon but still warms the top of the foreground tree. You can see that the rest of the land is dark — in the distance, the lights have already been turned on. In Figure 60, night has fallen and the moon is up. There's a faint path of light shimmering on the water. Remember that all these different moods occur within a few hours of each other! Nature never stands still. It's always changing, always creating new, exciting, and unexpected effects.

Of all these effects, the one shown in Plate 35 is the most subtle. The sun has disappeared; all you see are the last traces of light. The values at this hour are close together — as they are on misty days — so the wet-in-wet technique can be used effectively. In the case of Plate 35, the sky and foreground were washed in quickly, and the dark land mass was pulled across the middle of the canvas. Once the basic masses are established, you can begin to refine them. The green area of land is

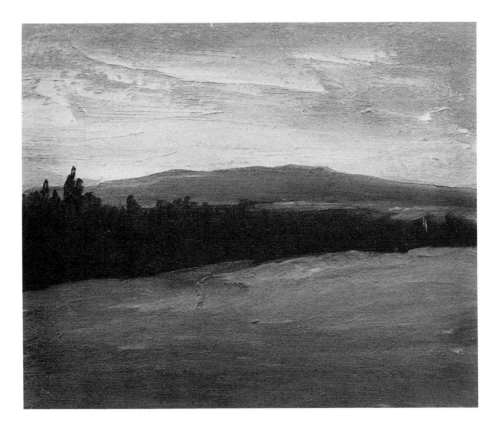

Figure 58. Late in the day, the sun lights up the lower part of the sky.

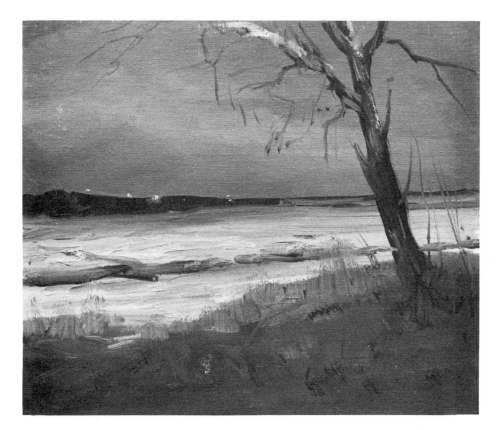

Figure 59. *The top of the tall tree catches the evening light, while the rest of the sky becomes darker and darker.*

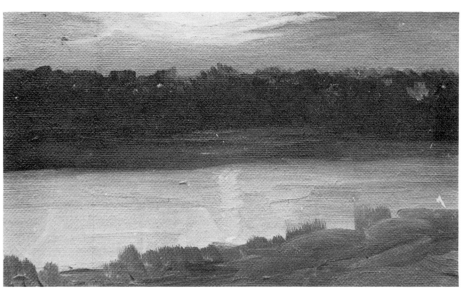

Figure 60. *Coming within a few hours of one another, sunset, twilight, and moonrise (illustrated here) all suggest the variety and richness of nature.*

pulled horizontally across the dark mass. Trees are indicated by a few vertical strokes. The distant mountain is suggested by a smoother stroke and the addition of more cool color. But this is all done after the placement of the masses. Remember: you build a foundation for a painting just as you build a foundation for a house. You don't build a house from the roof down.

CRITIQUE. There are few contrasts at twilight. The mood comes first. As you work, watch the canvas and eliminate spots that distract the eye. In Plate 35, the masses are very simple—and the horizontal quality of the design suggests calm and peacefulness. The only noticeable dark shape is made by the trees on the left-hand side of the sketch. Why are they there? Their darkness accents the sky, and their irregularity gives added interest to what would otherwise be a monotonous mass. Cover them up and see what happens. Everything becomes too regular—too predictable. You want a quiet mood—but not one that puts you to sleep!

PROBLEM TWENTY-ONE

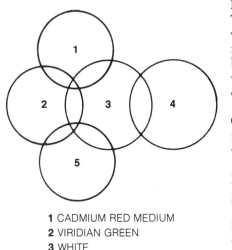

1 CADMIUM RED MEDIUM
2 VIRIDIAN GREEN
3 WHITE
4 COBALT BLUE AND
RAW UMBER
5 RAW SIENNA

INCIDENT IN NATURE. Now that we've looked at a variety of skies, let's go out on a rainy summer's day. The haziness of the day mutes the colors—mood is again our main concern.

PALETTE. *Cadmium red medium* and *raw sienna* are our two main warm colors. The raw sienna is less violent than the powerful cadmium yellows—and it mixes with *cobalt blue* to make interesting, tempered greens. Cobalt is a soft blue, just right for those days when the coolness of the air doesn't *feel* like an ultramarine blue or a cerulean. Cobalt falls between these two blues. It also makes a soft purple when mixed with red. *Raw umber* is a dark earth color. And *viridian* gives us a cool, dark green.

COLOR POOL. Cobalt blue and raw umber form a dark. White makes a value range. Raw sienna, red, and viridian are cut into the pool, creating a variety of warm and cool mixes that match the mood of the day.

DEVELOPMENT. Values, colors, and lines of direction all pull the eye into a picture. But depth is also created by the placement of one object in front of or behind another. Figure 61, for example, shows an arrangement of two clearly defined overlapping planes. There's the light distant hill with its group of evergreens, and there's the foreground plane of trees growing along a wall. One plane overlaps another. The plane, however, is restricted; the eye doesn't move deeply into the picture. The interest is in the pattern made by the dark foreground trees against the sunlit slope. The design is flat and "decorative."

The sketch in Figure 62 also uses overlapping; but the depth of the scene is greatly increased. The dark tree in the foreground overlaps the rock mass and trees behind it. There's no doubt that one area is near you and the other farther away. The whole foreground mass overlaps the house on the lower right. The house, in turn, cuts across the background trees. And that mass overlaps the mountain — which overlaps the sky. The process is logical, even obvious. But few students take advantage of it. It's as if once they'd painted an area, they're afraid to mess it up by pulling a part of the foreground across it. Foreground, middle ground, and background remain separate. They fail to weave the parts of the picture together.

In Plate 37, overlapping is used in a more subtle way. The paint imitates the facts of nature. The mountain was painted over a flatly textured sky. The trees were painted over the mountain in a somewhat heavier impasto. And the mass of foreground growth was slashed over the bottom part of the trees with thick palette-knife strokes. The eye sees one stroke lying over another; it feels that one area is behind another. Again, the stroke helps tell part of the story.

CRITIQUE. The color in Plate 37 is concentrated toward the center of the piece; it gives the eye a focal point. But do you feel, as I do, that the small area of grass is too bright? The untempered touch of viridian attracts the eye—it's out of key with the rest of the picture. It looks as if it belonged in a sunny day sketch! A touch of raw umber or raw sienna would have knocked the brilliance down, and thus made the color take its place in the overall design.

Before we leave this subject, I'd like to say something about attitude. The day we've been discussing is rainy and cold. There's a chill in the air, and most people would prefer to sit at home and take it easy. But not a painter! Learn to get out and see what nature's doing. I'm reminded of a friend of mine who was famous for his snow scenes. He confessed to me that there were plenty of days when he'd have preferred to stay indoors. But he *forced* himself to go out every day, no matter what the conditions. He knew that once he'd stayed in, he'd never have been able to pry himself away from his nice, warm fire!

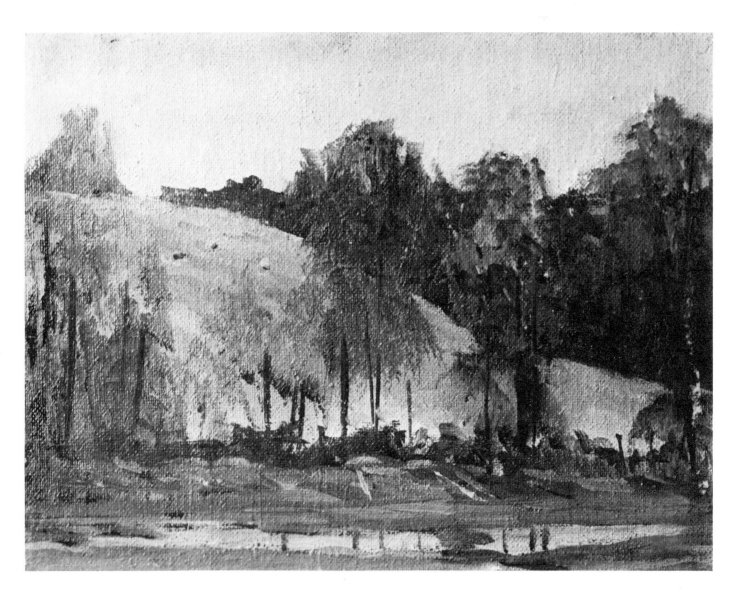

Figure 61. (Above) *The foreground and background of this sketch are two clearly defined, overlapping planes.*

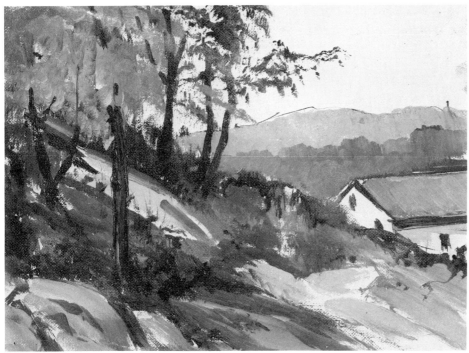

Figure 62. *Depth is created in this sketch by placing one object before or behind another.*

PROBLEM TWENTY-TWO

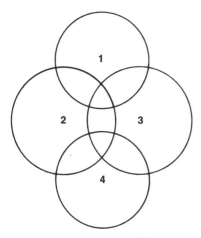

1 CADMIUM YELLOW LIGHT
2 WHITE
3 ULTRAMARINE BLUE
CADMIUM RED DEEP AND
ALIZARIN CRIMSON
4 VIRIDIAN GREEN

INCIDENT IN NATURE. We risked catching cold in the previous problem; now let's go out on a sunny summer day. As a change of pace, try to find an area with a lot of contrast—and a minimum of sky. Look at the edge of a forest, for example. The land mass is in full sunlight, while the large masses of foliage are in partial shadow.

PALETTE. *Cadmium red deep* and *cadmium yellow light* are strong, warm colors that help to create a forceful light/dark contrast. *Ultramarine blue* mixes with *alizarin crimson* to make an interesting lavender; it also mixes with yellow to make green. *Viridian* is our cool, dark, summer green.

COLOR POOL. Blue and the two reds combine to form a partially mixed group of dark purples. White creates a value range. Viridian green and yellow are cut into the pool. The red-purples temper the viridian, while the yellow mixes with the blue-purples to form additional, rich greens. These complementary colors will be contrasted on the canvas for maximum sunlight effects.

DEVELOPMENT. As I've already noted, many students overdo their lights, placing them all over the canvas and thus confusing the viewer. Figure 63 contains a simple example of how a dark mass can be used as a foil to a few carefully placed lights. In this case, the hills and heavily foliaged trees function as one large accent. Against this simple dark, a few light, quickly drawn, vertical lines suggest stands of birch trees.

In Figure 64 this idea is carried a step further. Here, a larger area of light is framed by dark tree masses. Instead of light lines being pulled across a dark, as in Figure 63, a few dark lines are now pulled across the light mass. These dark lines not only suggest trees, they also show you how bright the sunlit area is. In addition, they break the area up and make it more interesting. Notice that the values are varied within the surrounding mass of foliage—but not enough to detract from the central unified area of light.

In Plate 38, a large, simple tree mass acts as a foil to an area of sunlit marsh grass. The dark foliage is broadly painted; the sunlit area is handled in broken color. In the previous problem, the rain and mist pulled the masses together. Now sunlight breaks them up. The technique is different in each picture—but it's always a technique that arises naturally from the subject.

CRITIQUE. Remember that you don't want to overplay your effect. In Figure 64, the light values in the center of the piece also appear in the upper right, along the rock wall, and in the trees on the left. These touches keep the light from being completely isolated—as you recall it was in my friend's painting, "Traffic Light at Midnight."

In Plate 38, the sunlit grass is strong in color. But look closely, and you'll see that it's controlled by touches of a light, complementary lavender. A similar lavender is used in the tree masses. Notice that the yellow-orange of the marsh reappears in the sunlit foliage. To complete the color distribution, the sky (a mixture of ultramarine blue, viridian, and white) reflects its color down onto the foreground grass. Although there's a maximum of contrast in Plate 38, the color holds the parts of the picture together.

Figure 63. (Top right) The hillside acts as a dark foil to a group of carefully placed vertical lines.

Figure 64. (Right) Lights and darks move the eye around this sketch; the viewer's eye isn't caught in the center.

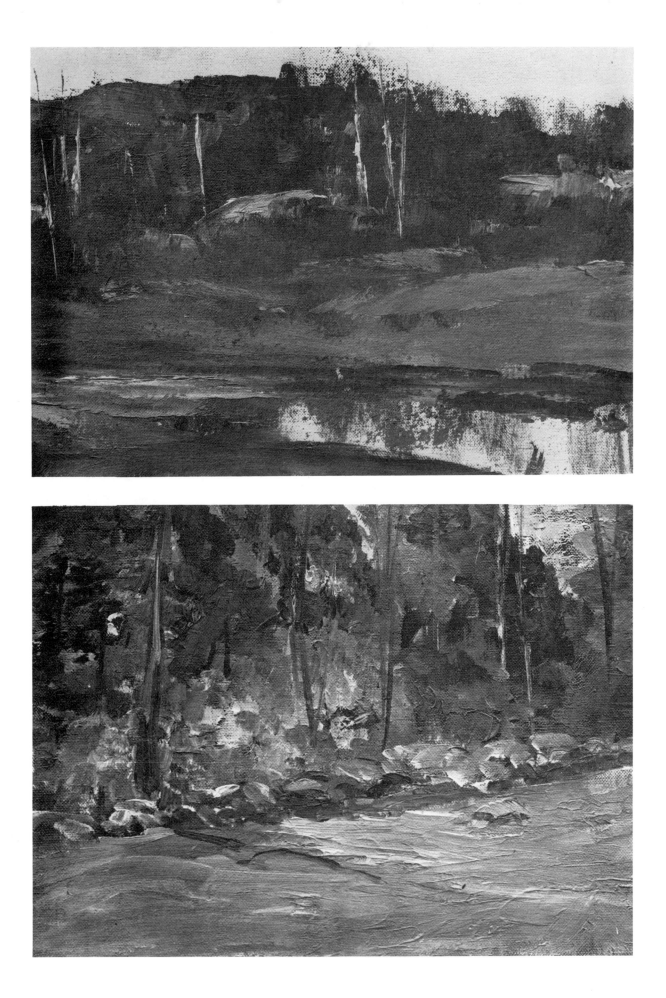

PROBLEM TWENTY-THREE

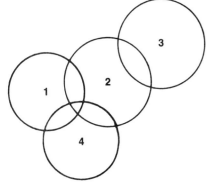

1 CADMIUM RED MEDIUM
2 WHITE
3 ULTRAMARINE BLUE AND
CADMIUM YELLOW MEDIUM
4 VIRIDIAN GREEN

INCIDENT IN NATURE. Summer is, of course, famous for beautifully colored flowers. Let's look at a lily pond. Such a site is always interesting: you can work with the reflections, the patterns of the lily pads, and the delicate colors of the lily blossoms themselves.

PALETTE. We can use a simple, all-purpose palette for this scene. *Cadmium red medium, cadmium yellow medium,* and *ultramarine blue* are the primary colors. *Viridian* is a cool, summer green.

COLOR POOL. Since there'll be a lot of green in this summer sketch, the pool starts with a partial mixture of blue and yellow. White pulls the color out. Then viridian and red are cut into the pool, modifying the color and giving it added variety.

DEVELOPMENT. Think of a lily pond in terms of its main masses. I keep repeating this idea — but it's an important one. It's really the key both to a successful sketch and a successful painting. Don't try to draw each lily pad. You'll just have a collection of little circles. The viewer may be impressed with your patience, but he won't see the big picture. He'll see bits and pieces. Nothing will hang together.

In Figure 65, a lily pond is represented by a few areas of value. Here and there, spots of light color suggest lily blossoms. Not a single lily pad is painted in the sketch — but your eye knows what it's looking at. It can take a hint.

Although Figure 66 is done in more detail, the same principle is at work. The pads form one large value area. Dark water breaks through the mass; but the water never disrupts the mass as a whole. As long as that mass remains a unit, your eye can easily understand it. A few shifts of value within the area, a few rounded edges — and the illusion is complete. The eye sees a multitude of lily pads.

In Plate 39, the pads are handled in the same simple way. In the foreground, a few blossoms have been done in detail; you can even see a suggestion of petals. These few detailed blossoms explain the other spots of similar color. Your eye knows that the dots in the background are also lilies. (Notice by the way, that these blossoms are pink, not white. They're like the apple blossoms we discussed in Problem Sixteen. People just think they're white because they see them in contrast to dark pads or dark reflections in the water.)

While you're outdoors, also make a careful study of the greens that appear in the summer foliage. In the spring, the greens were new, tender, and very warm in color. But as summer proceeds, they get darker and cooler. In Plate 38, for example, there's a lot of variety in the foliage. The wind shows the differently colored sides of the leaves; the sun warms some leaves and throws others into shadow. But many students fail to see this variety. They paint the trees one flat green color. The final picture looks as if it came out of a paint-by-numbers kit.

In Plate 39, the greens from the pool were worked into one another; maximum advantage was taken of accidental, but pleasing, mixes. In addition, the greens were given an extra snap by the use of a few scattered touches of its complement, red. In terms of "reality," these spots represent lily buds. But that's not their main purpose. A concern for reality only comes after you've satisfied the color needs of the sketch.

CRITIQUE. Don't let the strength of the summer greens get the better of your canvas! In Plate 39, for example, the background greens are varied — but they're much too vibrant. They detract from the main subject. I'm reminded of the man who painted his house white and then added bright red shutters. You didn't see the house anymore — just those vivid spots of red. In this case, I should have thought more about the effect of the atmosphere and the sky. Both would add cool color to the distant trees. If the mass were cooler, it would stay back in the picture; and its added coolness would also harmonize with the coolness of the water. You'd sense a greater unity within the sketch.

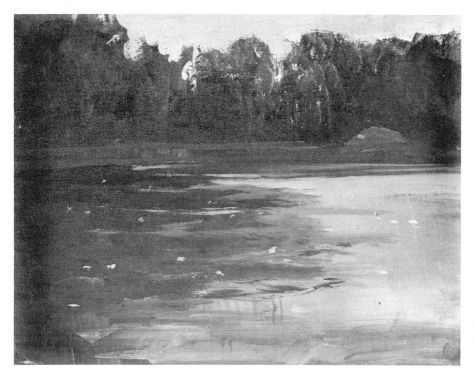

Figure 65. A lily pond can be suggested by a few simple shapes and values.

Figure 66. (Below) Although the lily pads are broken by areas of dark water, they still remain an easily understood unit.

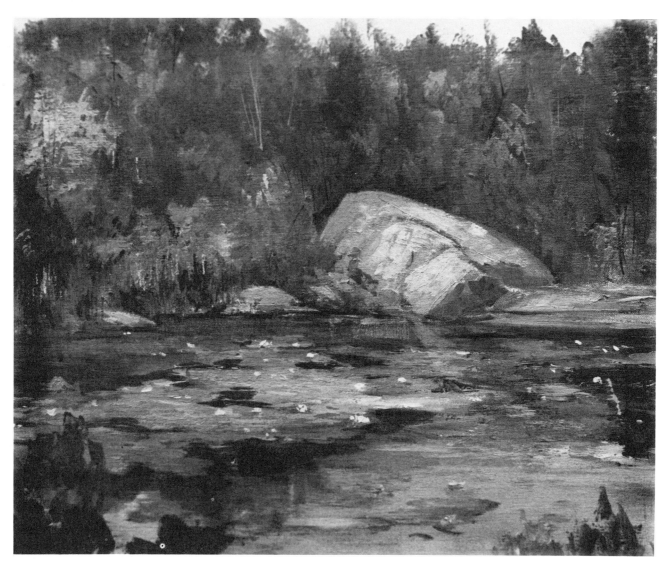

119

PROBLEM TWENTY-FOUR

1 CADMIUM RED LIGHT
2 VIRIDIAN GREEN
3 WHITE
4 ULTRAMARINE BLUE AND
 BURNT SIENNA
5 CADMIUM YELLOW MEDIUM

INCIDENT IN NATURE. Let's conclude our study of summer by looking more closely at its varied greens. Find some green trees in a green field. If you look for it, you'll find a lot more color there than you might expect.

PALETTE. *Cadmium yellow medium* and *cadmium red light* are our warm colors. *Viridian* is our cool, dark green. *Burnt sienna* adds a rich warm to the greens and to foreground mud and earth. *Ultramarine blue* mixes with the yellow to make green and with red to form muted purples.

COLOR POOL. The dark section of the pool starts with a combination of ultramarine blue and burnt sienna. This dark mutes the color and creates mixes that fit the mood of a partially overcast day. The addition of white creates a value range. Viridian, yellow, and red are then cut into this basic area. Burnt sienna mutes the greens and adds richness to them.

DEVELOPMENT. As you recall, when we painted leafless trees in the winter and spring, we carefully varied the widths of the tree trunks and the distances between them. We didn't want them to look like toy soldiers. Use the same principle when you work with clumps of heavily foliaged trees. In Figure 67, you can see a group of trees as they might well appear in nature. The sketch is "true"—but is it interesting? It's just a copy of nature; no attempt has been made to organize the trees in a way that would make a viewer want to look at them.

In Figure 68, however, liberties have been taken with a site. The masses of foliage are varied in height, size, and thickness. The sky breaks through the mass, making it more interesting in shape. The trees are still unified—but you have variety *within* the unity.

In Plate 40, the top of the right-hand tree mass is broken and interesting. It tapers in the direction of the main effect—it leads the eye to the spot where light breaks through an overcast sky and sharply illuminates a distant field. The large tree on the left—the largest shape in the picture—also attracts the eye toward the main effect. I established this overall movement before I gave much thought to the color of the foliage.

To get a good idea of the variety of green in summer, isolate a small section of a tree by cupping your hands and looking through them. Forget that you're seeing leaves in light and shadow and just study the color. It's beautiful—like a subtle abstract painting. And it's in balance. Nature is always harmonious—even when you look at a small, isolated part of it.

In Plate 40, the nearest tree has the warmest highlights and the darkest shadows. In the distance, the highlights are more subdued and the shadows lighter. You sense that one clump is closer, and the other farther away. Cool purple-reds temper the background greens, while a warm yellow light falls on the distant field. To accentuate this warmth, a lot of cool color appears in the nearby shadows. The shadowed foreground is quickly painted with greens and burnt sienna. The eye easily jumps over this area of muted color and heads toward the main subject.

On a day like the one illustrated in Plate 40, you'll find that light often flickers all over the landscape. Use these spots of light to direct the eye around the picture. In Figure 69, for example, the areas of light form an S-shaped, serpentine path into the sketch. Your eye moves from the right, to the area of sunlit water on the left. It then follows the area of light into the distance, goes up the transitional area of sunlit trees, and moves into the sky. Most of the trees and the land are in shadow; the path of light is thus easy for your eye to see and to follow.

Light (and warm color) also leads your eye through Plate 40. There's a suggestion of warm, sunlit color in the foreground bank. Warm color is then spotted further along the bank and across the cool shadow in the center of the picture. Step by step, your eye is led toward the subject: the sunlit field.

CRITIQUE. As you develop heavily foliaged trees, remember to keep the masses simple. Don't put in every trunk, branch, and leaf.

I remember a student who once came to class with binoculars. He planned to use them when he worked on the background; he didn't want to miss anything! Some pictures look as if they were painted with binoculars — and microscopes. The painter saw too much. Try to hold on to your first impression. Remember what you saw with your *first glance* at the subject.

At the same time, keep looking for color. You don't have to have your paints along with you. If you're driving and see an interesting effect, try to translate it into a palette. Decide what colors you'd use. You won't see much color at first. But with practice, you'll see more and more. Look at the professional baseball player; he's learned to see the spin on a ball as it comes toward him! The artist is like that. He sees what most people only look at. He tries to understand what others take for granted. That's why, as one of my friends once said to me, artists are "another breed of cat."

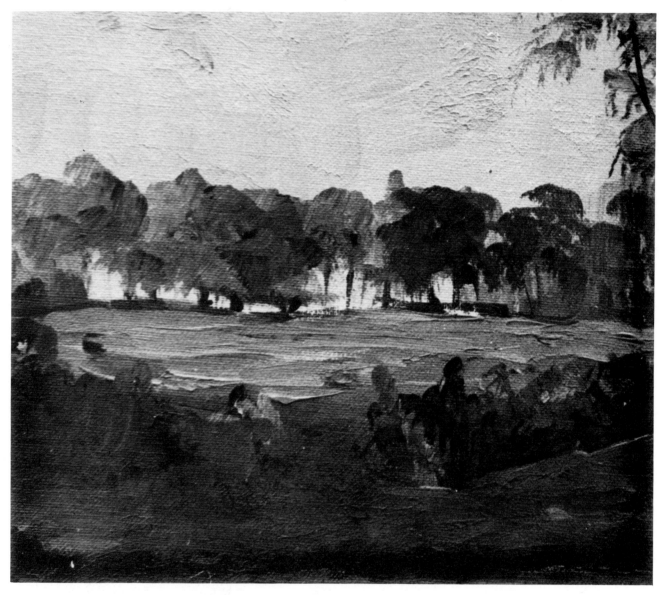

Figure 67. This is how trees frequently appear in nature. The picture is "true"—but not very interesting.

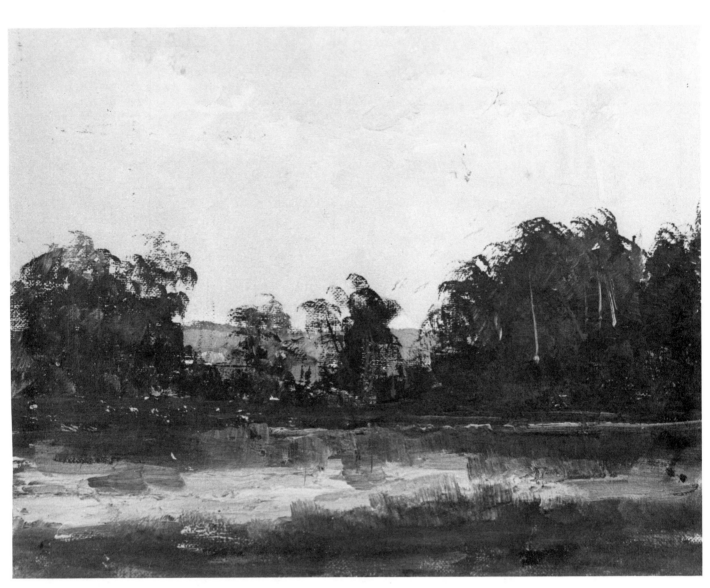

Figure 68. *By varying the sizes and shapes of the foliage masses, you add interest to your sketch.*

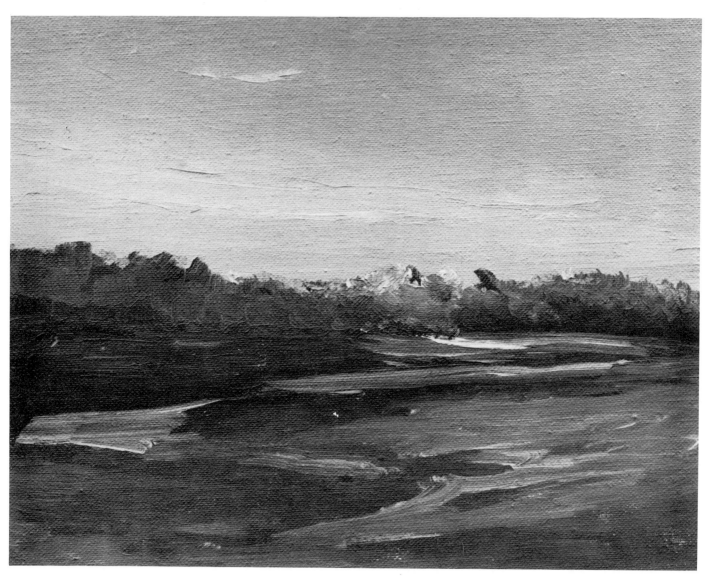

Figure 69. *The eye follows an S-shaped, serpentine path of light through this simple composition.*

CHAPTER NINE

Fall

Fall is probably the most varied of all the seasons. It begins with the deep, dark greens of late summer. Then there's a sudden explosion — and for a few weeks, we're in the midst of a color symphony. Then the brilliance slowly dies out, and the world goes back to sleep. This variety is what makes the season so interesting to the painter. There are moments of great peacefulness—and there are moments of great excitement.

As we explore the season, we'll also discover that its color has a great abstract beauty. Don't let the word "abstract" bother you. A good, realistic painter has much more abstraction in his work than many contemporary critics recognize. Nothing, in fact, is more abstract than nature itself. We'll see how true this is in some of the following problems.

PROBLEM TWENTY-FIVE

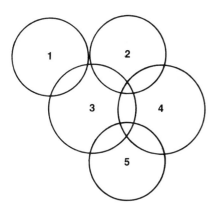

1 YELLOW OCHRE
2 CADMIUM RED MEDIUM
3 WHITE
4 ULTRAMARINE BLUE AND
 CADMIUM YELLOW MEDIUM
5 BURNT SIENNA

INCIDENT IN NATURE. Let's start our study of fall by looking at the behavior of reflections. Try to find a large clump of trees near a small river. The simpler the arrangement, the easier it will be for you to study it.

PALETTE. *Cadmium red medium* and *cadmium yellow medium* start the palette. They're bright colors, but not garishly so. *Ultramarine blue* harmonizes well with *burnt sienna* to create delicate grays. It also mixes well with the red to form a variety of purples. *Yellow ochre* is again used to mute the cadmium yellow and thus keep it under control.

COLOR POOL. Ultramarine blue and cadmium yellow are mixed to form the dark, sappy green of foliage just before the onset of the warm fall coloring. White draws out the color. Red, yellow ochre, and burnt sienna are cut into different sides of the pool; they mute and enrich the greens, and create complementary grays.

DEVELOPMENT. Figure 70 is a simple illustration of how a reflection works. The reflection of an object falls directly beneath it; it doesn't behave like a shadow. You may have seen paintings where the reflection slants off to one side or the other— but that never happens in nature. To prove the point, move around a site before you start to paint; see how the position of the reflections shift as you walk.,

Also try, if possible, to look at the reflections from different heights. When you're on a level and look straight across at the river's edge, you see more of its reflections; when you're high in the air and look down on the subject, you see less of its reflections. A reflection is never static. Everything depends on the object's nearness to the water—and on your own position.

Students frequently think that the only way they can get a reflection right is by copying its every complex wiggle. But the reflection changes with each slight movement of the water. The student soon gets frustrated—and he finally gives up. He's trying to do the impossible: he wants to turn paint into water. In Figure 70, however, the reflection is indicated by a simple shorthand. A few horizontal strokes suggest the surface of the water; the roughness of the stroke gives you an impression of ripples, without my having to draw every one. Similarly, in Figure 71 the reflection is suggested by dark vertical accents. A wind disturbs the water; you can see how a few horizontal lines suggest the pond's broken surface. The more wind there is, the more the reflections are broken up—and on a very windy day, you can't see them at all.

In Plate 41, you can tell by the behavior of the reflections that there's a slight breeze. Notice also that the day is heavy with atmosphere; there's a lot of moisture in the air and it veils the distances. The atmosphere also throws a lot of cool blue into the large tree in the foreground. In addition, the sun bounces warm marsh grass color up into the lower part of the same tree. Be on the lookout for such interesting color effects. Remember that outdoors your objects are surrounded by light and air. On a sunny day, for example, a tree is never a flat, cutout shape. There's a sunlit side and a shadow side—and reflected light is bouncing all over the place.

CRITIQUE. Make sure that your determination to paint "wet" water doesn't get in the way of the compositional needs of the canvas. At the site of Figure 70, for example, the reflections actually came right down to the foreground bank. What if I'd copied it that way? The dark reflection would have cut the pond in half. The areas of light water to the left and right of it would have been isolated; they'd have attracted attention to themselves. By breaking some light water through the reflection, you hold the pond together as a unit. Then the few tufts of light grass in the foreground of Figure 70 act as a transition; they connect the pond to the land.

A similar technique is used in Plate 41. Note also that the dark line along the bank is handled in a "lost and found" manner. It accents the light on some occasions, while on others, the sunlit grass and water simply flow into one another. Such a variation is not only more like nature—where there are very few hard edges —it's also more interesting to look at.

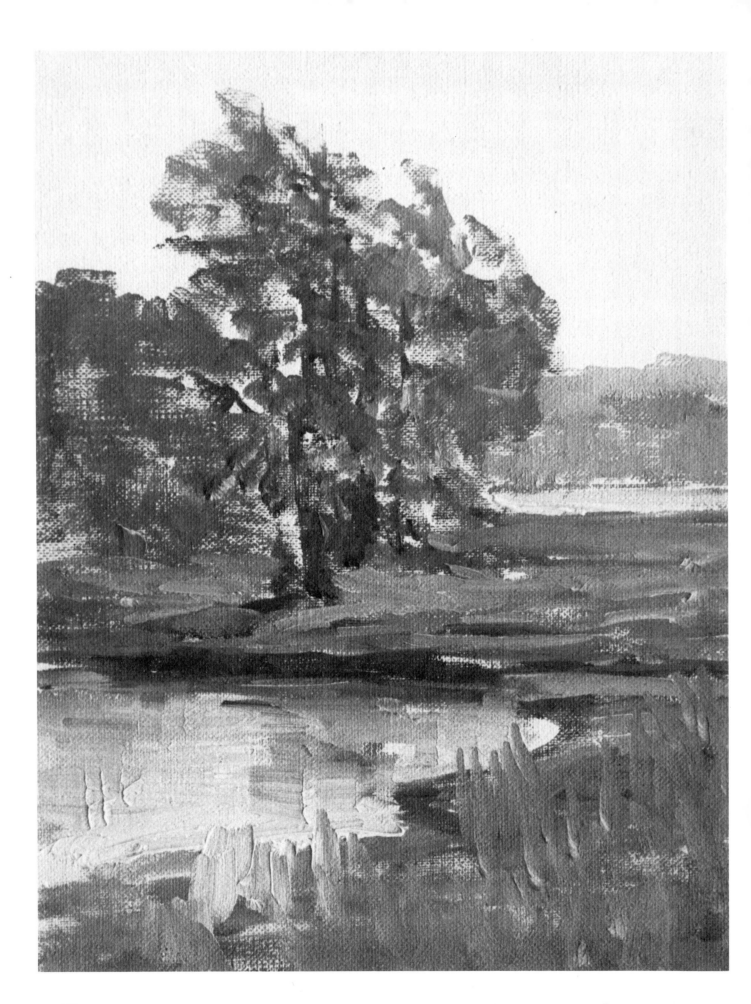

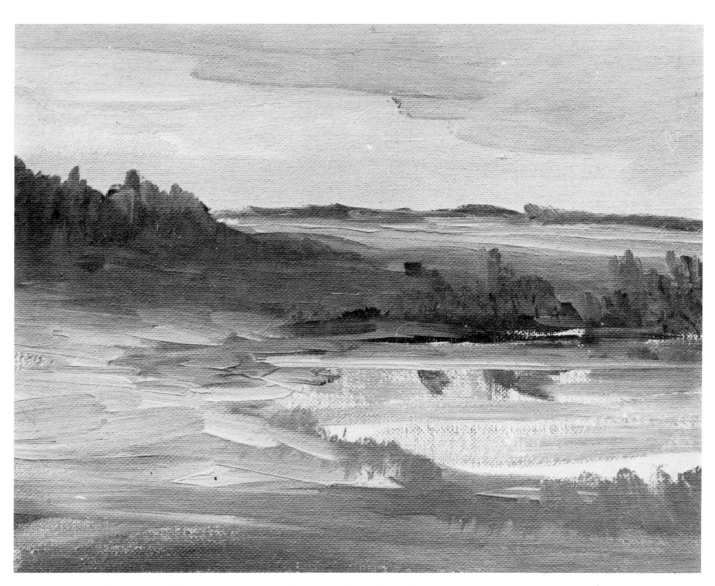

Figure 71. A few horizontal lines can suggest wind breaking the surface of a pond.

Figure 70. (Left) The reflection of an object always falls directly beneath it.

PROBLEM TWENTY-SIX

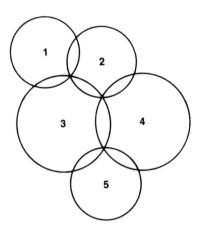

1 BURNT SIENNA
2 CADMIUM RED LIGHT
3 WHITE
4 VIRIDIAN GREEN
 ULTRAMARINE BLUE AND
 RAW SIENNA
5 YELLOW OCHRE

INCIDENT IN NATURE. Let's remain at the water's edge and continue our study of the relationship between the brushstroke and the form of an object. Trees, the bank, the water—they can all be reduced to a few, characteristic strokes. But first you have to analyze what your eye sees. Once you understand a thing, you can usually paint it.

PALETTE. *Cadmium red light* is good for delicate, warm sky tints; it also gives an added warmth to sunlit areas along the river bank. *Ultramarine blue* is our basic blue. *Viridian* is a cool green that helps suggest the dark grasses near the river. It also mixes with *raw sienna* and *yellow ochre* to create a variety of rich mellow greens. *Burnt sienna* is an earthy color; it's useful for representing muddy areas— and to further mute the greens.

COLOR POOL. Viridian green, raw sienna, and ultramarine blue mix to form the greens of the marsh grass. The ultramarine blue gives body to the mix, deepening the tone and adding to the variety of color. White brings out the value range. Red and burnt sienna are cut into one corner of the pool to mute the greens and suggest the depth of the fall tones. Yellow ochre is cut into the other side of the pool to create warmer, sunlit tones.

DEVELOPMENT. In Figures 72 and 73, different strokes are used to emphasize different aspects of a subject. In Figure 72, the interest is in the flatness of the marsh. The whole design is based on crisscrossing, horizontal strokes. In the distance, the strokes are nearly straight across; you can't see much detail that far away. At your feet, however, you can look down on the grass—and so the stroke that represents the foreground grass has more variety to it. The brushstrokes follow the contour of the land. They tell you where the land bulges, where it lies flat, and where it sinks into small depressions.

In Figure 73, the interest is centered on the river bank. Strong vertical and diagonal strokes are used to show the haphazard way the grass hangs down over the eroded edge of the stream. The sketch is roughly done, so you can clearly see the nature of the strokes. Notice, also, how a horizontal stroke mimics the flatness of the stream, while the distant trees are all indicated by quick, vertical strokes.

Plate 42 uses the same devices in a more subtle way. Again, the stroke varies to match the texture. The day is hazy, and everything has a soft, velvety feeling—the strokes, too, are subdued. The structure of the area is suggested without the technique calling attention to itself. The sky was handled much like that in Problem Nineteen. Warm and cool colors were pulled together with the palette knife— greater pressure was applied, however, so that they mixed more thoroughly.

CRITIQUE. As I painted Plate 42, I kept remembering a sixty-year-old picture by another artist. It had a soft, delicate quality that I liked when I first saw it, and I tried to get a similar feeling in my own picture. This doesn't mean that I was "copying" the other man's work. On the contrary, there was little if any similarity in color or composition between the two pictures. The similarity was in the quality of the light and the delicacy of the colors, in the overall feeling.

The other man's sketch had given me a point of view—and that's one of the values of studying as many good pictures as you can. Take a positive attitude. Try to see what the painter himself saw—and you may discover a new, different, and exciting way to look at nature. Don't copy someone else's technique. Try, instead, to understand where he found beauty—then see if you can find it there, too.

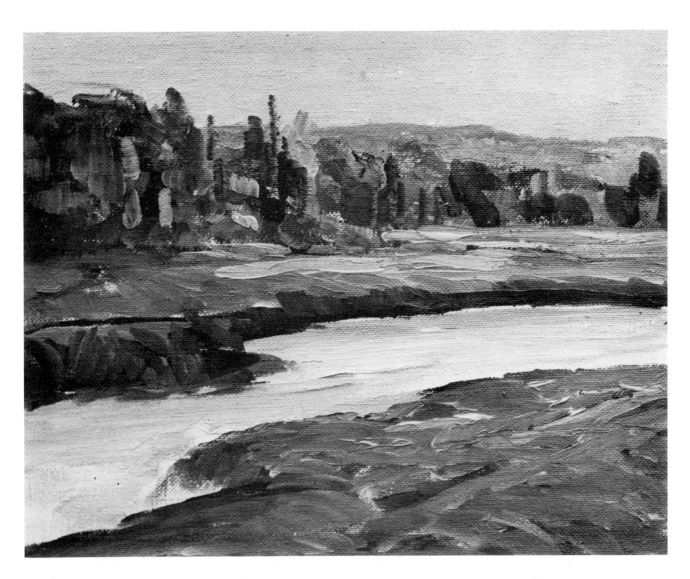

Figure 72. (Above) Horizontal strokes correspond to the shape of the land.

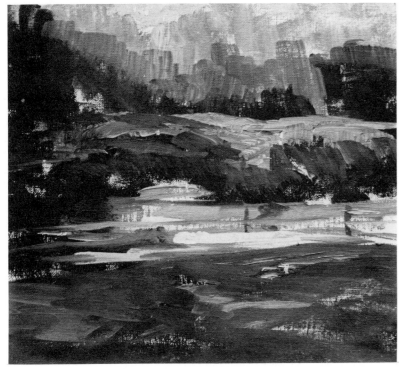

Figure 73. The interplay of vertical and diagonal strokes suggests the way grass grows over an eroded river bank.

PROBLEM TWENTY-SEVEN

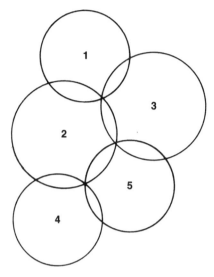

1 YELLOW OCHRE
2 WHITE
3 CERULEAN BLUE AND
 CADMIUM YELLOW MEDIUM
4 VIRIDIAN GREEN
5 CADMIUM RED MEDIUM

Figure 74. All the eye needs to make sense of abstract lines is the suggestion of a house in the upper corner—the busy mass is suddenly transformed into a forest.

INCIDENT IN NATURE. We've seen how the brushstroke applies to reflections and to grass. Let's see how it works in relation to a man-made object, such as a house. Go out some morning and find a spot where a number of houses can be seen among a mass of trees. Analyze the site, and decide how you can suggest those houses—without showing every nail and clapboard.

PALETTE. Since this is a morning picture, *cerulean blue* makes a good, clean sky color. Morning light is cooler than afternoon light. The sun is still low in the sky, but it does have some warmth, and cerulean blue has a little more yellow in it that some of the other blues. *Cadmium red medium* and *cadmium yellow medium* mix to make the subtle red-yellows, yellow-reds, and oranges that you find in early fall foliage. The red and *ultramarine blue* also form good lavenders and purples. (The complementary oranges and purples can be mixed to form delicate, pearly grays.) *Viridian* is a good basic green. *Yellow ochre* warms the greens and mutes the cadmium yellow to make it look more like sunlight.

COLOR POOL. The dominant coolness of morning light leads us to temper all our colors with its blueness. Therefore, we begin the pool with cerulean blue. Yellow is added to create a green. White pulls the color out. The other tones are cut in, creating a variety of warm oranges, cool purples, and warm and cool greens.

DEVELOPMENT. First, you have to analyze your subject. I keep repeating this point because it's one you must understand if you're to stop copying what you see—and start painting it. You don't need to tell the eye much—only the basic facts. Figure 74, for example, is just a bunch of squiggly lines. But at the very top of the illustration, there's a suggestion of a gable and a small window. The eye sees that slight suggestion and uses it to make sense of the whole abstract collection of strokes: it sees a house among a mass of trees. Figure 75 uses the same idea. A dot here and there in the distance and you're looking at a cluster of houses.

In Figure 76, the idea is carried a step further. The houses are still just dots. There aren't any windows in them — with curtains in the windows and candles burning on the sill. What information the viewer receives, he receives through the stroke. The walls are upright; the stroke is vertical, too. The roof slants at an angle —and so does the stroke.

Plate 43 applies the idea to a panoramic view of Concord, Massachusetts. There had just been a rainfall, and the sky was airy and translucent. The sky was brushed in with a series of random strokes—and kept simple, so that it would be a foil to the more complicated pattern of the trees and the houses. Notice that I first had to make a decision: should I feature the light in the sky or the light on the houses? I decided to keep the sky light — the white houses are subordinated to the sunlit clouds. If both had been a brilliant white, the eye would have jumped back and forth between them, unable to find the dominant note.

When you paint a group of houses, pay attention to the way the shapes flow together. In Plate 43, for example, the sizes and shapes of the houses are varied and rhythmical. Concord, Massachusetts — the subject — was redesigned to make an interesting pattern. On the right-hand side of the sketch, there's the strong vertical accent of the church. As your eye moves to the left, there's a dot for a house, followed by a larger, more detailed mass. Then there are a few more light spots—a horizontal one, a vertical one, another horizontal one—and finally a more detailed mass. The shapes are varied, as are the spaces between them.

Study Plate 43 for another second. Forget now that you're looking at houses and trees; just see how one shape leads to another. Notice how your eye plays over the varied masses, and how dark accents are used to hold these shapes together. If you can make your masses interesting to the viewer's eye, he'll enjoy your picture — even if he doesn't know exactly what each dot and dash represents.

CRITIQUE. A scene like the one discussed here is always in danger of breaking into a bunch of small, unrelated shapes. You have to interconnect your masses. The trees in Figure 76, for example, form a big dark mass, with the houses worked into it. One house—and only one—catches the light; the others are lower in value and so remain part of the dark mass. They don't attract attention to themselves. What would be the effect if each house were as bright as the one toward the center? All you'd see would be a collection of bright little dots.

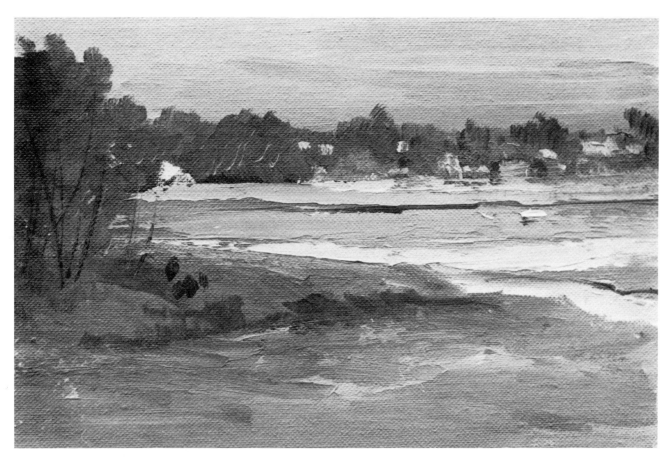

Figure 75. *A few dots in the distance suggest a cluster of houses.*

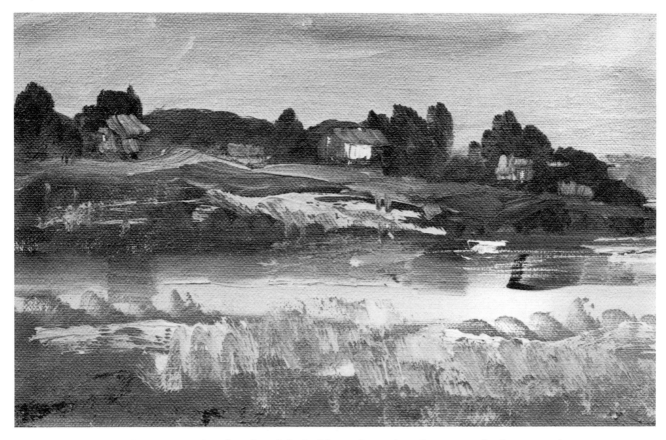

Figure 76. *Vertical strokes correspond to the sides of the buildings; diagonal strokes suggest the slanting roofs.*

PROBLEM TWENTY-EIGHT

1 CADMIUM RED LIGHT AND
 YELLOW OCHRE
2 WHITE
3 ULTRAMARINE BLUE AND
 BURNT SIENNA
4 PERMANENT GREEN LIGHT

INCIDENT IN NATURE. In the previous problem we discussed the question of emphasis, deciding what is the subject of a picture. We subordinated the sunlit houses, for example, in order to accentuate the light in the sky. Let's look more closely at this question of emphasis. Go out on a cloudy day and try to find a panorama: some fields, a few trees, and a distant mountain.

PALETTE. *Cadmium red light* is a red without the intensity of the deeper cadmiums—it's good for indicating the diffused light of a cloudy day. *Yellow ochre* is a restrained yellow, one that can be easily controlled. *Ultramarine blue* is a solid blue. *Burnt sienna* modifies the complementary color blue, and is also useful in capturing the reddish-brown color of dead grass. *Permanent green light* is a yellow green that mixes well with the other colors.

COLOR POOL. Begin the pool with the basic complementary mix of ultramarine blue and burnt sienna. Add white to draw the color out. Red and yellow ochre are pulled into one part of the pool. Permanent green light is worked into the other side. A variety of muted greens result as the ochre and blue mix and as the permanent green is modified by the burnt sienna.

DEVELOPMENT. Figures 77 and 78 are views of a field and a distant mountain. In Figure 77, the mountain is clearly a subordinate area; the main interest is in the way the light plays over the houses, fields, and trees in the middle distance. The mountain mass is a foil for these brilliantly lit areas.

In Figure 78, on the other hand, the middle distance is of much less interest. You can see how simple it is. A few areas of sunlight indicate spots where the light breaks through the clouds. But the viewer's eye lingers only momentarily on these areas. It goes right to the dramatic lighting of the distant mountain.

The subject of Plate 44 is really the subtle interaction of color in the open field, not the mountain or the distant trees. The mountain is just a cool mass, a foil to the warm color in the foreground. The foreground was developed using a technique similar to that used for the marsh in the previous problem: a simple series of criss-crossing strokes were worked all over the area (Figure 79). Complementary reds and greens were pulled into each other. In some areas, the colors are muted. In others, they have more of a broken-color effect.

A mountain like that shown in Figure 78 would clearly be out of place in the background of Plate 44. Why? The eye wouldn't know whether the mountain or the field was your subject. Frequently, a student begins a sketch with his interest centered on a particular spot. But he gets so involved in trying to make the background, middle distance, and foreground perfect that before he knows it, he's painted three pictures on the same canvas. Remember: you occasionally have to step back from your work and look at it as a whole. You can't always paint with your nose scraping the canvas!

CRITIQUE. At the site of Plate 44, there was a large number of aquatic birds. When I mentioned that fact to a student, he asked me why I hadn't put them all in. "Well," I told him, "they *are* there. You just can't see them because they're hidden behind the tufts of grass!" Seriously, of course, I couldn't put them all in — the sketch would have been much too busy.

The same point applies to the clouds in Plate 44. The sun was actually hitting all of them. But I only emphasized one, and threw the rest into shadow. You're told enough to let you know where the light is coming from, but not so much that you become confused as to the center of interest.

There's also a lesson to be learned from looking at the fence in Figure 77. At the actual site, it ran straight across the foreground. In the sketch, however, I left out some of the slats so your eye could get through the fence and into the distance. If those slats weren't missing, the viewer would feel subconsciously that you didn't want him in your picture. I once saw a painting of a wall and a fence at a show. The fence ran across the bottom of the piece and a "NO TRESPASSING" sign was tacked on it. There was no way you could comfortably get into that picture—so you left it and moved on to something more congenial.

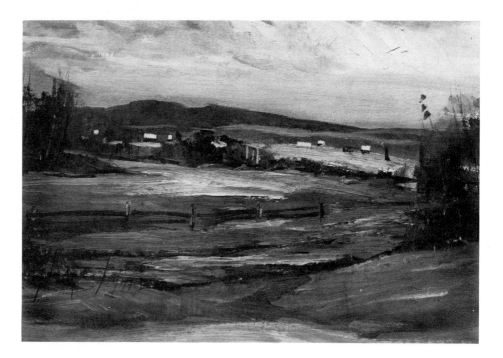

Figure 77. *The background mountain is kept low so that the eye naturally goes to the play of light on the nearby field.*

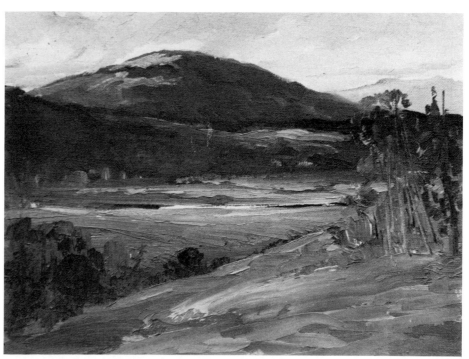

Figure 78. *In this sketch, the mountain is large; the eye moves from the fields to the dramatically lit mountainside.*

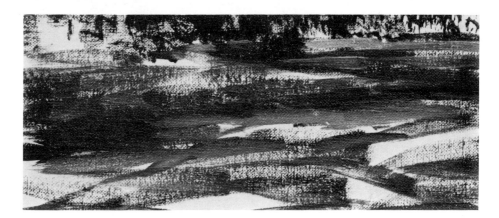

Figure 79. *Crisscrossing strokes can be used to build up a grassy foreground.*

PROBLEM TWENTY-NINE

1 CADMIUM RED MEDIUM
2 WHITE
3 PERMANENT GREEN LIGHT
CADMIUM YELLOW MEDIUM AND
YELLOW OCHRE
4 ULTRAMARINE BLUE

INCIDENT IN NATURE. Let's look at a spot where the leaves have just begun to turn: a few birch trees, a stream, and a mass of foliage. Some of the leaves are yellow-green and some are well on their way toward a vibrant mixture of orange, yellow, and red. We have the opening chord of what will be a symphony of color.

PALETTE. *Cadmium red medium* and *cadmium yellow medium* have depth of color — yet they can also be lightened and mixed to form brilliant warm tones. *Ultramarine blue* is a good color for the sky. It adds atmospheric depth to a picture that might otherwise be rather flat and decorative in character. *Permanent green light* suggests green leaves that are just beginning to turn yellow. *Yellow ochre* mutes the greens and also helps control the bright cadmium yellow.

COLOR POOL. The pool is started with a mixture of green and the two yellows, the colors that dominate the early fall foliage. White pulls the color out. Red is cut into one side of the pool to mute the greens; it also mixes with yellow to form a variety of vivid oranges. Blue is cut into the other side of the pool. When it's lightened and used to indicate patches of sky, the blue will have picked up a slightly greenish tinge, a tinge that relates it to all the other greens in the picture. If the ultramarine were applied pure, it would be an isolated color—it would look as if it belonged in another canvas.

DEVELOPMENT. Students think that there must be a "trick" to painting birches. Maybe it's the kind of brush the painter uses, or the makeup of his medium, or the way he holds his knife. People often become so convinced that these tricks exist that they don't believe you when you say that there's only one way to learn to paint: see objects in their simplest terms. When we painted a quarry in Problem Eight, we looked for linear relationships. We didn't think in terms of "rocks." Try to see a birch tree as a simple shape. It's light in value and has textured bark. Those are the "facts" that should interest you—not how each dark stripe appears on the bark.

Figure 80 is an example of the texture of birch bark. On the right, you can see a few swipes of the palette knife. That's the basic stroke; its horizontality corresponds to the horizontal way the bark grows. On the left, the same stroke is used more subtly. Light and dark colors are pulled into one another, and the rough interaction of paint layers suggests the nature of the material. A few dark streaks are then scratched into the paint surface with the tip of the knife.

In Figure 81, this basic method is used in a variety of ways. On the left, the trees are large and you can see the streaked bark and branches. Toward the middle of the sketch, the trees are smaller and details don't show. A series of quick, horizontal palette-knife strokes does the trick. Throughout the design, details are held to a minimum; you see the grove before you see the individual trees. The subject is the pattern created by these interrelated vertical and diagonal elements.

In Plate 45, the birch trees simply serve as light, cool foils, balancing and accenting the warm greens, yellows, and reds of the sketch. All these strong colors are kept near the center of the canvas. The simplicity of the dead, dark color along the bank further emphasizes the vibrancy of the foliage areas.

You can also use birch trees to catch the eye and direct it through a picture. In Figure 81, for example, the trees on the right slant into the picture. The eye senses the angle and drifts with them toward the center of the sketch. The saplings in the middle move in various directions, and the large birches on the left lean back into the picture. The eye moves from right to left, is stopped, and retraces its path. Variations in the angles, thickness, and character of the birches make the journey all the more interesting. Can you see how a similar method is at work in Plate 45?

CRITIQUE. Remember as you paint that the movement of your masses should always be your main concern. Begin to paint "things," and you're lost. I'm reminded of a story a portrait painter once told me. He was painting a woman who wore her hair pulled straight back into a bun. Not a hair was misplaced. But in the portrait, that severe hairline drew attention away from her face. The painter decided to take one strand of hair and break the line with it. It curved over her forehead and helped lead the eye toward the woman's features. But when her husband saw that stray hair, he insisted that it be painted out. He was so concerned with the picture's being an accurate view of his wife—"she never has a hair out of place"—that he couldn't see how his request ruined the painting as a work of art.

Figure 80. *By interplaying light and dark values with the palette knife, you suggest the rough texture of birch bark.*

Figure 81. (Below) The various widths and angles of the birch trees make the grove interesting to the eye.

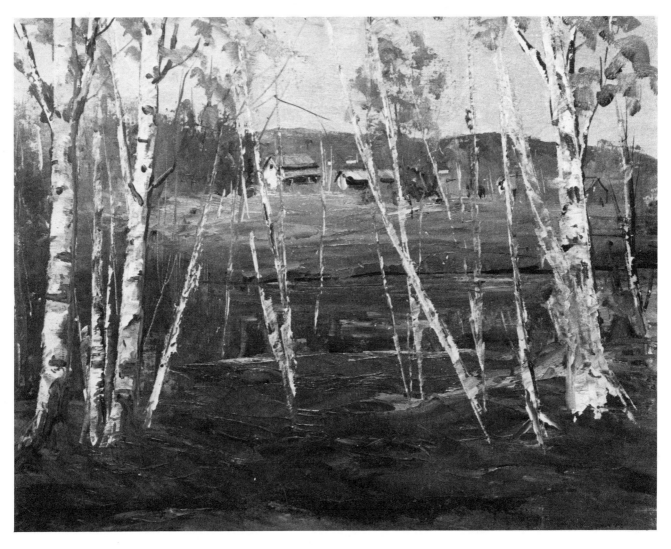

PROBLEM THIRTY

1 CERULEAN BLUE AND
 ULTRAMARINE BLUE
2 CADMIUM RED LIGHT AND
 CADMIUM YELLOW LIGHT
3 ALIZARIN CRIMSON
4 WHITE
5 YELLOW OCHRE
 BURNT SIENNA AND
 RAW SIENNA

INCIDENT IN NATURE. Now let's investigate a scene somewhat later in the season. Let's pick a simple stand of trees so that you won't have to worry too much about composition and so can devote your attention to color relationships.

PALETTE. *Cadmium red light* and *cadmium yellow light* are bright colors that mix to form a vibrant orange. *Cerulean blue* is a clean blue for use in distant hills. *Ultramarine blue* mixes well with *alizarin crimson* to form a muted purple. *Burnt sienna* and *raw sienna* are both warm tones which temper the oranges and keep them from being too garish. *Yellow ochre* is a general modifier; small touches of it mute both the warm and cool colors.

COLOR POOL. We'll start with both a warm and cool area within the pool. All the blues are in the latter; the cadmium red and yellow are in the former. They're all only partially mixed. As the two areas are worked into one another, complementary greens and purples are created. White pulls the color out. Alizarin crimson is cut into one part of the pool to accentuate the purple tone. Yellow ochre and the siennas are added to the other side, warming the mixes.

DEVELOPMENT. Until now, almost all the sketches we've looked at have been horizontal in shape. That's a convenient shape, but it's not the only one for a sketch. The shape you choose for your canvas depends on which aspect of your subject you want to emphasize. Figures 82 and 83, for example, are both of a clump of autumn trees. In Figure 82, the emphasis is on the horizontal length of the foliage mass; it slowly tapers toward the sunlit field. There's the horizontal line of the mountain in the background and of the river in the foreground. The movement of the masses obviously demands a horizontal canvas.

In Figure 83, however, the subject is the height and bulk of the trees. They rise high in the air and a few trunks catch the sunlight, emphasizing the feeling of height. The subject clearly demands a vertical canvas. Can you see how the feeling I had for each subject naturally determines the form the subject takes?

In Plate 46, the trees form an interestingly shaped horizontal unit. Notice, though, that the interest isn't spread equally over the mass. Toward the edges of the canvas, the color is subdued; the main area of color is in the middle of the piece. The eye may drift to the sides, but it always comes back to the focal point.

Plate 46 was developed through a simple color note method: warm analogous tones were spotted over the canvas first — reds, yellows, and oranges. Then the

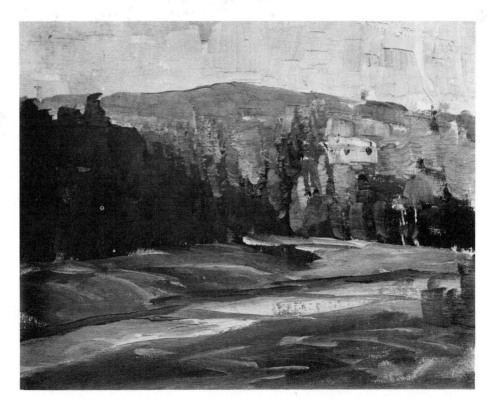

Figure 82. The horizontal movement of the trees, mountain, and river naturally fits a horizontal canvas.

136

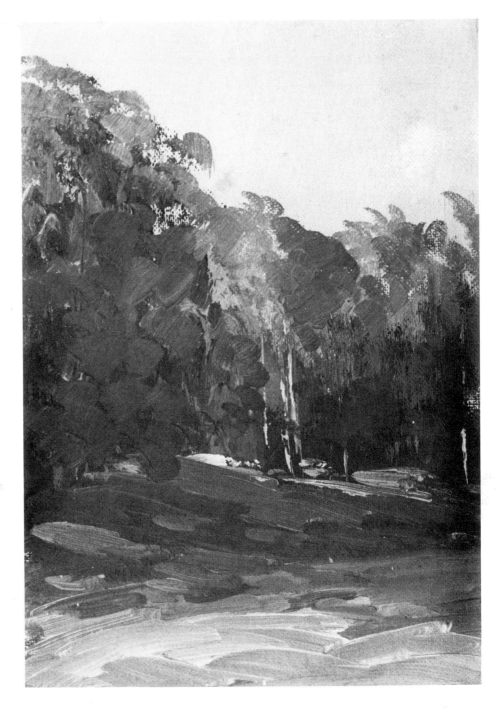

Figure 83. Here the main interest is in the height and bulk of the trees; the sketch naturally fits a vertical canvas.

complementary greens and purples were worked into the mass. These colors act much as the complements did in our study of sunsets. When placed near the warm tones, they accent them. When mixed into the warm tones, they mute them.

The shadows are painted in a way that gives depth to what might otherwise be a flat, decorative piece of color. They're not black holes. Instead, there are a variety of colors and values in them. You feel that you can look *into* the shadows—without knowing exactly what's hidden there. That's up to your imagination. If you saw definite objects, you'd be distracted from the main point of the sketch: the interaction of warm and cool color.

CRITIQUE. Remember to keep your colors lively — but also to keep them in a mass. Don't dot the greens and oranges around like so much confetti. Since a picture of a clump of trees has little depth and almost no leading lines of direction, color can be used to move the eye. In Plate 46, for example, the eye first picks out all the greens and follows them through the sketch. Then it investigates the oranges, then the cool colors. It explores the forest—not the individual trees.

PROBLEM THIRTY-ONE

1 VIRIDIAN GREEN
2 CADMIUM YELLOW MEDIUM
3 WHITE
4 CADMIUM RED LIGHT
5 CERULEAN BLUE AND
ULTRAMARINE BLUE

INCIDENT IN NATURE. At its height, the color of fall is very abstract in effect. Go into the woods during this period and try to do a quick sketch—no more than ten minutes at most. Make the sketch all suggestion, with very little finish. Explore the color and texture of your subject.

PALETTE. Reds, yellows, and other warm analogous colors dominate the palette at the height of the fall season. *Cadmium red light* is a brilliant warm color. *Cadmium yellow medium* makes subtle greens when mixed with both *ultramarine blue* and *cerulean blue*. It also creates rich oranges when mixed with red. *Viridian* is a green whose color accents the warmth of the fall foliage.

COLOR POOL. Start the pool with the most obvious color first: red. Work the yellow, viridian, and the blues into it—put the color on in volume. Then pull white into the mix to lighten it. In a picture of this sort, only the preliminary color mixing is done on the palette. Most of the mixing occurs accidentally on the canvas, as color is pulled into color.

DEVELOPMENT. In order to make the painting process quicker, and to keep you from getting too involved in detail, let's try to paint this picture exclusively with a palette knife. The knife gives you the clean, clear color that we associate with fall at its peak. Sometimes color will be pulled into color; sometimes a stroke can be placed and left alone.

Figure 84 is a simple example of how a few diagonal palette-knife strokes can suggest masses of foliage. Here, the strokes are placed and not touched again. In Figure 85, the method is carried further. The masses are pulled together, as one stroke is worked into another. Then, as in Figure 84, a few vertical strokes are added to suggest the trunks of trees — they're hints designed to make sure the viewer understands what he's looking at. The trunks don't have branches and knotholes — the main interest in the picture is the almost abstract interrelation of color and texture.

Plate 47 uses this same method. You can see how the knife pulls color into color, without overmixing. The dominant reds were placed first. Then yellows, greens, and a few patches of blue sky were added. The latter emphasizes the warmth of the rest of the color and gives the sketch a suggestion of atmosphere. In order to keep this cool color from being isolated in the upper part of the canvas, it's repeated in the immediate foreground. The viewer sees a stream; the painter sees the distribution of color.

Have fun as you paint. See how one layer of paint interacts with another. Apply pressure to the knife in some places; in other spots, let the knife slide over the surface of the canvas. Play with your materials — have a good time. Keep a spontaneous mood running through the piece. A loose, vibrant handling of the knife will match the liveliness and vibrancy of the season's coloring.

Compare Plates 46 and 47. The first was done with a brush; the second with the knife. Notice how much more controlled the first sketch is. It's representational art — what most people would call "realistic." But both sketches capture an aspect of the season. In Plate 46, the color is strong, but its restrained handling gives you a feeling of quiet and repose. The dark, flat sky increases this impression. Plate 47 captures some of the excitement of the season. Neither sketch is a definitive statement. I felt different each day, so the sketches naturally differ.

CRITIQUE. How much should you integrate and harmonize your colors? That's always a matter of personal taste. Plate 47 was left rough. The color effect looked good — so I decided to go no further. Figure 86 started with the same abstract masses of color, but some detail was added to pull the sketch together. Notice, however, that the buildings aren't finished in any way. If they were done carefully, they'd look as if they belonged in another picture. In each painting, there should always be a certain consistency of technique.

Figure 84. (Right) A few diagonal palette-knife strokes indicate areas of heavy foliage.

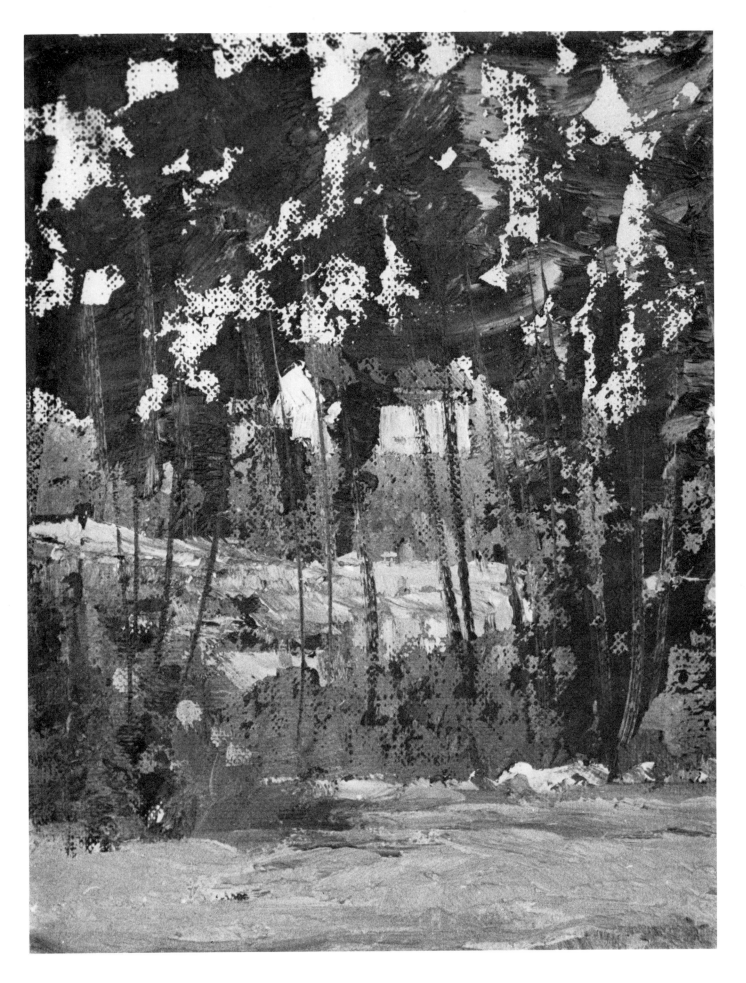

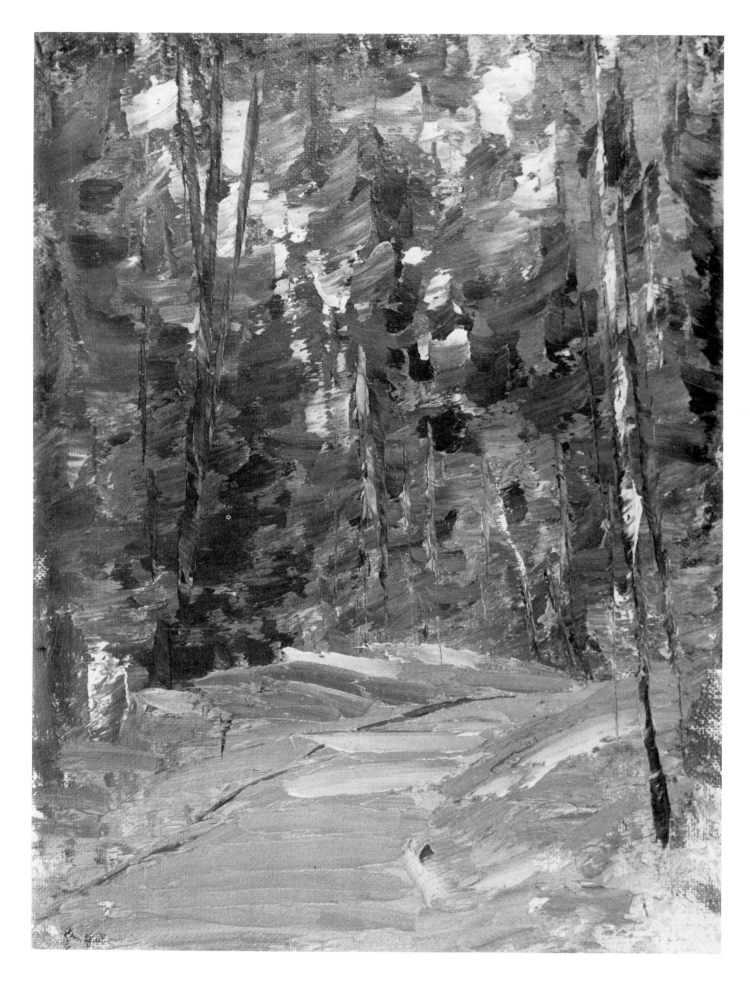

Figure 86. *This sketch is unified by an overall sketchiness of handling.*

Figure 85. *(Left) By working color into color, you suggest the texture of masses of multicolored leaves.*

PROBLEM THIRTY-TWO

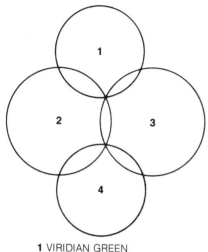

1 VIRIDIAN GREEN
2 WHITE
3 ULTRAMARINE BLUE AND
 BURNT SIENNA
4 RAW SIENNA

INCIDENT IN NATURE. We've worked our way through all the seasons and are now back at the point where fall and winter meet. The earth has again begun to sleep. Let's go out toward the end of the day and bring our study of the fall season to an appropriate conclusion. The sun is low in the sky, and dark clouds are beginning to cover the land. A chilling fall rainstorm is in the offing.

PALETTE. *Burnt sienna* suggests the reddish-brown coloring of earth and dead grass. *Ultramarine blue* works with the burnt sienna to make a dark. *Viridian green* is selected to suggest the grayish green light we sometimes see in the late evening sky. *Raw sienna* mixes with white to form a muted suggestion of sunlight.

COLOR POOL. Blue and burnt sienna form our basic dark. White draws the color out. Viridian and raw sienna are then cut into different sides of the pool. The color is mixed fairly thoroughly to form the warm, subdued colors of late fall; there are no really vibrant colors in the scene.

DEVELOPMENT. It will be easier to paint a late evening effect if you think of it as a series of value relationships. Figure 87 is a quick sketch at the end of the day. It simply tries to answer a few painterly questions: How dark are the clouds compared to the mass of trees? How light is the sky compared to the clouds and the earth? What light/dark contrasts are there within the cloud and tree masses?

Plate 48 was developed by relating a few large value areas to one another. The major light and dark masses were established first; then warm color was worked into the clouds and the foreground area of reflected light. The upper part of the sky and the lower foreground are both kept simple; they don't compete with the light from the dying sun.

CRITIQUE. It's impossible to critique a piece like Plate 48. It's not a planned sketch; it's a spontaneous color note. And, to tell you the truth, I really don't know how I did it. The hand and eye just work well on some days—everything comes easy. On other days, you won't be able to do anything, no matter how hard you try.

Nor will you find it easy to duplicate the successes of those memorable "good" days. I've tried copying my favorite sketches and have never done an acceptable job. Your hand, eye, and mind never work the same way twice. That's what makes painting an adventure. You never know what's going to happen till you get out the paints and start to work!

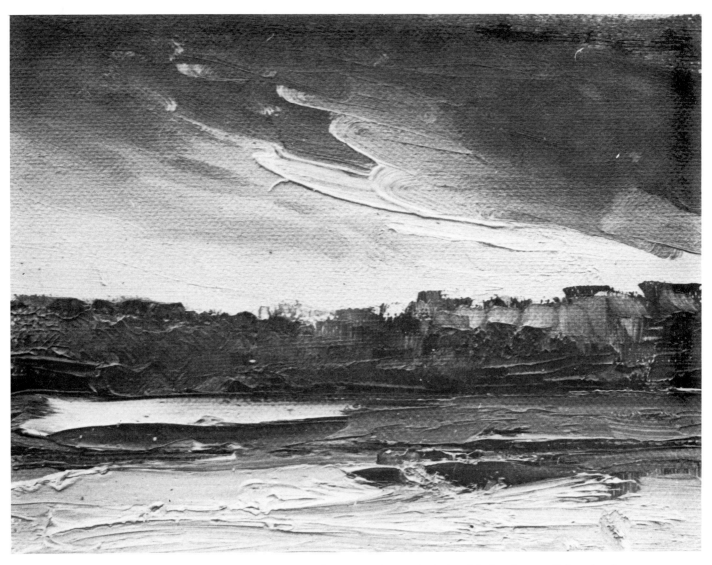

Figure 87. *This quick sketch is a study in value relationships. How does each dark and light relate to all the others?*

Conclusion

We've investigated the four seasons and seen how each offers something of interest. The more you experiment with color and explore nature through the medium of the quick sketch, the more you'll learn to appreciate the world around you — and to understand your own likes and dislikes. The more you know about painting, the more you'll want to know. In a lifetime, you'll barely scratch the surface.

MEMORY SKETCHES. Of course, you won't be sketching from nature all the time. Sometimes you'll see fleeting effects that you couldn't possibly paint on the spot. Once you've begun to understand your materials, try to paint such effects from memory. You won't recall the unimportant details, but you'll recall the essentials — the qualities that first attracted you to the subject. Painting from memory also makes you bolder. You're not intimidated by the "facts," and so you push the parts around to fit your theme. This ability will be valuable when you go back to nature.

COMPOSITES. Your outdoor sketches can also be valuable sources of information when you work up larger pieces in your studio. Indoors, you have a chance to work out your problems; you're not rushed by the quickly changing light. Figures 88 and 89 were both painted in the studio, with small sketches serving as my "research" material. They probably look familiar to you—and they should. Figure 88 is based on the sketches that appear in Problem Eight. Figure 89 is based on those in Problem Twenty-Five. The sketches sparked my memory; they formed the nucleus of the final design idea.

OVERCONFIDENCE. Few painters ever do a picture that really satisfies them. There may be moments of excitement just after completing the painting, but the thrill of success doesn't last. And that may be to our advantage as painters. Satisfaction can be the painter's worst enemy. It closes your eyes and ears; criticism doesn't have any meaning. When you're depressed, however, your eyes and ears are open. You sense that something's wrong, and you work to find out what it is. Although it may be cruel, a teacher often has to be rough on his students for their own good— not all the time, but when they've won too many awards, sold too many paintings, and begun to forget the fundamentals.

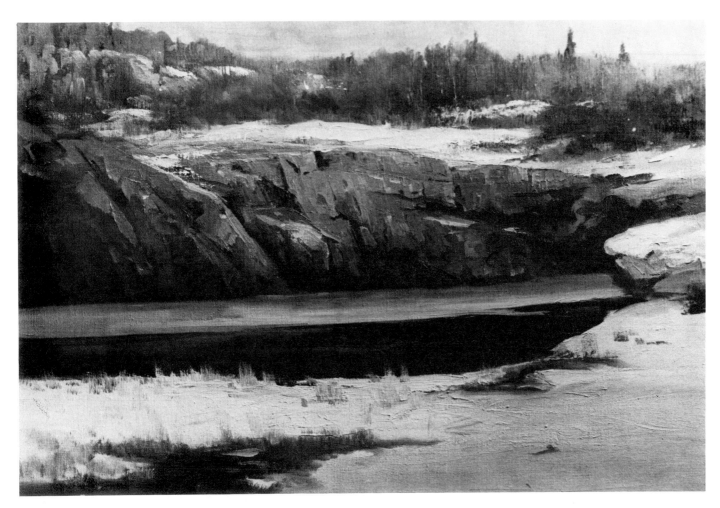

Figure 88. This large studio painting was developed from a number of sketches made outdoors. In the studio, I freely rearranged the elements to emphasize the starkness of the quarry and the snow-covered land.

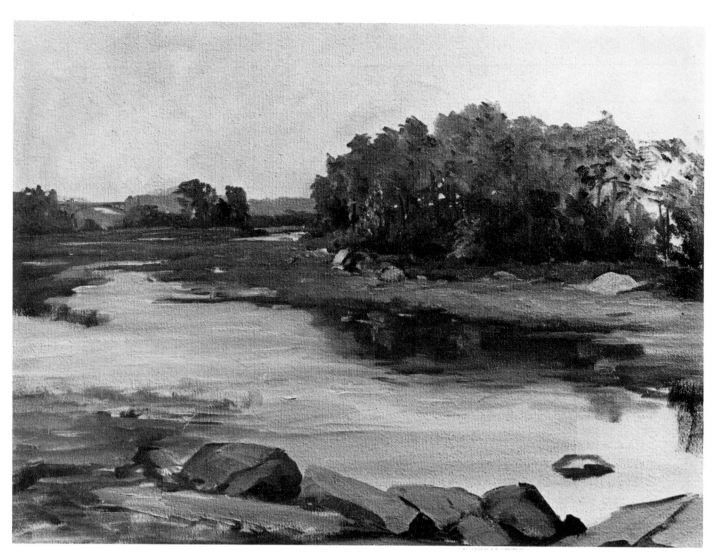

Figure 89. This painting was also developed from a variety of quick outdoor sketches. The sketches sparked my memory and helped me to re-experience the emotions I had felt at the site.

CRITICISM. I've a friend—a fellow-painter—who won't criticize until asked, and then only when he's sure you're serious. Once you've convinced him, however, you can't afford to be thin-skinned: he won't spare your feelings! And for that reason, his fellow professionals like to hear what he has to say. They know he'll be honest. As a student, you should take the same attitude. Learn to appreciate sincere criticism and understand that criticism of your painting isn't necessarily a criticism of yourself. Step back and look at your work objectively.

Take a similar attitude when you look at the work of other people. It's easy to find what's bad in another's work. That boosts your own ego—but it doesn't help your painting. Instead, try to strip a canvas bare in your mind and then see if you can rebuild it. Try to understand why the painter did what he did, regardless of whether it's what you would have done. Ignore the trees, houses, and barns of the painting—its "pretty picture" aspect—and look for the idea behind it. Why did the painter put it together the way he did? Discover his intent; find out what his problem was, and see how he solved it. The more artists you study in this way, the more techniques and ideas you'll come to understand—and the less stilted your own paintings will be. By appreciating the work of others, you broaden your own outlook.

PROGRESS. Also learn to evaluate your own capabilities. You have to know what you can do—and what you can't. Students always ask, "When are we going to learn how to finish a picture?" But that's the wrong attitude. Ask yourself first, "How can I improve a picture?" Then, as you work, you'll learn to finish as far as you know how. When you don't know what to do next, you'll stop—and then go a little further with your next effort. That's all a painter does when he signs his name to a work and sends it into the world. "Here's my work," he says; "this is as far as I wanted to take it. It might not be as far as you'd like—but try to understand my point of view!"

When you do a picture you like, keep it—and evaluate it. Decide just *why* you like it. You can make great progress if you pay close attention to your own likes and dislikes. Paint to satisfy the inner person. A painter is like a glutton—a man who eats and eats and is still hungry. He's never satisfied. See painting as a challenge, and you'll always aim for progress—not to impress others.

SINCERITY. Finally, try not to tie yourself down. Don't say that you want to be a landscape painter, or a surf painter, or a still-life painter. Try everything. Force yourself, if necessary, to do some subjects, even if you think you won't like painting them. Do woods, beaches, buildings, animals—everything. As a student, your aim is to have as wide a variety of experiences as possible. Think positively, and you'll see subjects everywhere.

Above all, paint feelings, not subjects. Have a personal opinion about what you see. That's the real difference between the painter and the artist. The painter is a workman, and his work can be judged competent or incompetent. The artist, however, inhabits a different world, a world of poetry and interpretation. The painter is to the artist as the piano-player is to the pianist.

When your paintings are lined up on a wall, they should be full of variety; they shouldn't look as if they were turned out by formula. I remember a painter who put on a show in a department store. He had a brush for each color and finished a picture every few minutes. These little sketches were decorative, but there wasn't any heart in them. A great artist, on the other hand, is like a great actor; he has to be able to interpret countless different moods. Try to remember that as you paint. Get more deeply into a picture than the short distance from your shoulder to the end of your brush. Paint what you understand. Paint what you feel. Then your work, no matter how finished or how rough, will always have the finest attribute of all: it will be honest work, the result of a sincere effort to express a heartfelt emotion.

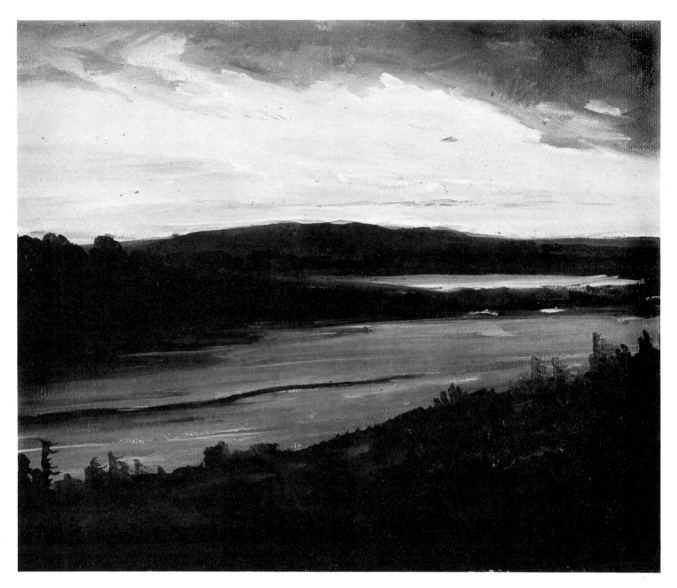

You can tell that the storm is passing, not approaching, by subtle clues as to the wind's direction. Look, for instance, at the movement of the swaying trees in the foreground and at the puffy edge of the clouds rolling back on itself like the edge of a curtain going up.

Suggested Reading

The following books are not how-to-do-it volumes. They present various interpretations of the fundamentals of art and should be useful to anyone interested in *understanding* art rather than simply "painting pictures."

Barron, John. *The Language of Painting: An Informal Dictionary*. New York: World Publishing Co., 1967. (O.P.)

Dewey, John. *Art as Experience*. New York: G. P. Putnam's Sons, 1958.

Fabri, Ralph. *Color: A Complete Guide for Artists*. New York: Watson-Guptill Publications, 1967. London: Pitman Publishing, 1975.

Graves, Maitland E. *Art of Color and Design*. New York: McGraw-Hill, 1951.

Gruppé, Emile A. *Gruppé on Painting: Direct Techniques in Oil*. New York: Watson-Guptill, 1976.

Hawthorne, Charles W. *Hawthorne on Painting*. New York: Dover Publications, Inc., 1938.

Henri, Robert. Ryerson, Margery A., Ed. *The Art Spirit*. Philadelphia: J. B. Lippincott, 1960.

Loomis, Andrew. *The Eye of the Painter*. New York: Viking Press, 1961. (O.P.)

Luckiesh, M. *Color and Its Applications*. New York: D. Van Nostrand, 1915. (O.P.)

Reynolds, Sir Joshua. Mitchell, Stephen, Ed. *Discourses on Art*. New York: Bobbs-Merrill, 1965. London: Collier-MacMillan, 1961.

Ruskin, John. *The Elements of Drawing*. New York: Scholarly Press, 1970.

———. *The Lamp of Beauty*. London: Phaidon Press, 1959. (O.P.)

Index